BURGOYNE DILLER

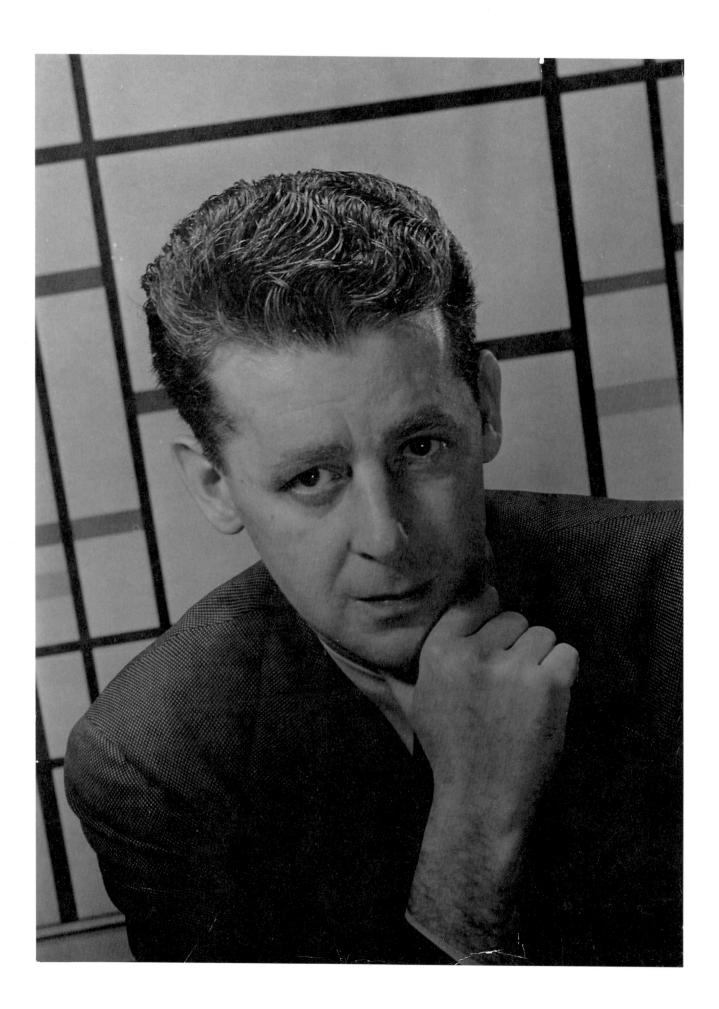

BARBARA HASKELL

BURGOYNE DILLER

WHITNEY MUSEUM OF AMERICAN ART, NEW YORK

Dates of the Exhibition
September 13–November 25, 1990

Library of Congress Cataloging-in-Publication Data

Haskell, Barbara.
 Burgoyne Diller / Barbara Haskell.
 p. cm.
 Includes bibliographical references.
 1. Diller, Burgoyne, 1906–1965—Exhibitions. I. Diller,
Burgoyne, 1906–1965. II. Whitney Museum of American Art.
III. Title.
ND237.D47A4 1990 90-39415
759.13—dc20 CIP

 ISBN 0-87427-071-5

Front cover: *First Theme: Number 10*, 1963
(Fig. 156)
Back cover: *First Theme*, 1963-64
(Fig. 159)

Frontispiece: Burgoyne Diller, c. 1955

**Research for this publication was supported by income from
endowments established by Henry and Elaine Kaufman, The Lauder
Foundation, Mrs. William A. Marsteller, The Andrew W. Mellon
Foundation, Mrs. Donald A. Petrie, The Primerica Foundation, The
Samuel and May Rudin Foundation, Inc., the Simon Foundation, Inc.,
and Nancy Brown Wellin.**

**The production of the catalogue was supported by a generous grant
from Fayez Sarofim.**

**This exhibition is sponsored by The Equitable with additional funding
from the National Endowment for the Arts.**

Printed in Hong Kong by South China Printing Co.

CONTENTS

FOREWORD

Burgoyne Diller matured as an artist in the 1930s, when Regionalism and American Scene painting dominated contemporary art; abstraction appeared irrelevant to the pressing social and economic concerns of that decade. Although Diller achieved a measure of critical and financial success in the 1940s, by the early 1950s his work was once again overshadowed, this time by the grand gesture, large scale, and expressionist character of the New York School painters. Out of step with prevailing styles for three decades, Diller's art has often been overlooked by critics and institutions. Although the Permanent Collection of the Whitney Museum of American Art now contains six works by Diller, ranging in date from 1938 to 1963, the first of these was not acquired until 1958, only seven years before his death. His work was not included in a Biennial until 1952.

This exhibition and catalogue—the first comprehensive publication on Diller since his death in 1965—will provide an opportunity to explore his achievement. We extend our thanks to the lenders of the exhibition who have enabled us to present a broad overview of Diller's work. We are especially grateful to The Equitable and to the National Endowment for the Arts for their generous support of the exhibition. At a moment when the NEA is threatened with extinction, its support of an exhibition which is not flashy and will not attract large crowds highlights the critical role it plays in encouraging scholarship.

Jennifer Russell
Acting Director

7

"How does one express the creative moment? . . . or the creative life? . . . the times of trial and error . . . of hope and despair of sweating work and quiet seeking. Times when you play tricks on yourself to get working . . . you tidy up the studio . . . wash your brushes, clean the palette . . . make little drawings . . . find yourself getting interested, then . . . (off you go?) . . . to work. How much time there is . . . how little time there is . . . how much has been done . . . how much there is to do. Now there is no time . . . now minutes seem like the slow dripping of cold honey. There is no past . . . there is no future . . . there is only now. Time is the past, present, and future . . . now . . . and time is understood. Space is realized . . . the image is clear."

—Burgoyne Diller

ACKNOWLEDGMENTS

By all accounts, Burgoyne Diller was an imposing figure. Associates remember him in mythical terms: as a natural aristocrat, a prince; a movie idol; a knight. Yet behind his strikingly handsome appearance and quiet charisma, little was, in fact, known about his life. I am immensely grateful to the many people whose willingness to share their memories of Diller allowed a more complete picture of him to emerge. In this regard, I would like to thank Will Barnet, Milton Brown, Dorothy Dehner, Hananiah Harari, Robert Henry, Murray Israel, Martin James, Jacob Kainen, Lillian Kiesler, Ibram Lassaw, Eleanor Marko, George McNeil, Silvia Pizitz, Irving Sandler, Leon Polk Smith, Sidney Tillim, and Selina Trieff. Among those who graciously provided information or documents pertaining to Diller and his family are Veronique Burke, Morris Dorsky, Francine Wells Foley, David Gale, Jeanne Gerloven, David Hoyt Johnson, Philip Larson, Florence Maisel, Francis Penny, Esphyr Slobodkina, and Betsy Wade. I am particularly grateful to Lawrence Campbell for tirelessly answering questions about Diller and the Art Students League, and to Grace Diller's family, especially Jean and William LaCrone, for generously making the Estate files available to me. Most important, I would like to express my gratitude to Kenneth Prescott, who selflessly turned over to me the results of his research on Diller and thereby enabled this project to build on his efforts.

Meredith Long and the staff of his gallery—particularly Jenny Murphy—contributed most significantly to the success of this project. I deeply appreciate their support. Also helpful in supplying photographs were Kim Eagles-Smith of Harcourts Modern and Contemporary Gallery and the staff of the André Emmerich Gallery.

Crucial to the successful completion of this project was the commitment and thoroughness of my staff at the Whitney Museum. Leslie Nolan prepared the initial phase of the bibliography and exhibition history. This undertaking was completed by Kari Steeves and Jane Niehaus who contributed in every way to the research and assembly of this publication. I owe a deep level of gratitude to them and to Leon Botstein for his help in clarifying aspects of the manuscript.

I would also like to express my thanks to my colleagues at the Whitney Museum for supporting a project that promised neither to be glamorous nor popular, but rather one which upheld a tradition at the Museum of showcasing artists whose work, while eluding widespread public acclaim, had contributed undeniably to the course of American art.

Barbara Haskell
Curator

"I never went to Europe. I went to the Art Students League."

—Burgoyne Diller

BURGOYNE DILLER

In the 1930s, a small group of American artists with vanguard aspirations sought to over-turn the aesthetic values of realism—which to them seemed bankrupt and false—with a new set of propositions based on modernity and progress. Burgoyne Diller was central in this movement. His early emulation of European modernism epitomized the choices made by younger American artists who strove to break free of the parochial conventions of Ameri-can realism. His more specific desire to eliminate aesthetic ambiguity in favor of clarity and immutability led him to adopt a strict Neoplastic vocabulary based on right angles and primary colors. For Diller, Neoplasticism offered an international, egalitarian language whose simplicity and precision would yield universal truths—paradoxically, without forfeit-ing the potential of individual expression. Moreover, he believed that Neoplasticism's capac-ity to communicate across boundaries of race, social class, and political persuasion made it a singularly appropriate language of twentieth-century democracy. This belief in the con-junction of democracy and abstraction empowered him to respond forcefully to the call for social action that pervaded artistic discourse in the thirties. As supervisor of the WPA/FAP mural division in New York City, his espousal of abstraction was crucial in encouraging the development of an American abstract art.

Diller and his fellow abstractionists had just begun to experience success in the early 1940s when the emergence of Abstract Expressionism swept aside public approbation of their achievements. To all but a handful of supporters, they became shadowy and forgotten figures. It was not until Minimalism ushered in a renewed enthusiasm for geometric abstrac-tion in the 1960s that their work again began to receive serious attention. Diller, however, was excluded from this widespread reevaluation by an unhappy confluence of circumstances that limited his gallery exposure and prevented the mounting of a full retrospective.[1] Yet he was always taken seriously by artists and critics.[2] Now that geometric abstraction has once again found favor with a community of younger artists who are looking back at past models, it is a timely moment to examine the full range of Diller's contribution and to assess the moral and spiritual imperatives which gave birth to his work.

Early Years

By his own account, Diller started painting as a child.[3] Born in New York City in 1906, the son of a violinist and conductor, he may have been pushed toward self-contained and soli-tary activities by a childhood illness that kept him out of school until his eighth year.[4] By then, Diller had already experienced the death of his father and separation from his older

brother, Robert, who had been forced by strained family finances to leave home in 1910 and move in with his maternal grandfather in Buffalo.[5] Although Diller and his mother joined Robert in Buffalo only three years later, the reunion was short-lived. In 1919, following the remarriage of Diller's mother, Mary Burgoyne, to Adrian Adney, an engineer, Diller moved with his mother and stepfather to Battle Creek, Michigan.[6] Raised a Catholic, Diller had always attended parochial schools;[7] but in Battle Creek he entered the public school system for junior high and high school.[8]

At Battle Creek High School, Diller was known for his art aptitude and his achievements as a track star—endeavors which required intense concentration, discipline, and the capacity to work alone. The personal journal he started in 1924 is striking in its lack of frivolity or attention to social pursuits.[9] Filled with factual information about the track-and-field competitions in which he excelled and with detailed notes about painting, it substantiates the characterization of Diller in his senior yearbook: an intense, idealistic youth, focused on perfecting accomplishments within circumscribed areas and emotionally detached from the daily events around him.

Due probably to illness, Diller completed Battle Creek High School in five rather than the normal four years.[10] He entered Michigan State College, East Lansing, in the fall of 1925 with a relatively diverse course load.[11] But by his second term, he was taking only two academic subjects along with his physical education credits and three drawing courses; he received a D and an F for the two academic courses. Apart from his almost exclusive focus on art and track, Diller was not unlike other freshmen: he joined the Sigma Alpha Epsilon fraternity and participated in the ROTC program—as was required of every male student.[12] By working during Christmas and summer recesses, he financed his tuition and modest living expenses.[13] Money was nevertheless a continuing problem and he debated incessantly about staying out of school for a term in order to accumulate some reserves.[14] By the close of the spring term, with his scholastic record impaired, he opted to work during the summer and the fall term and return to school in January 1927. That semester, however, his grades of F in military science and B in physical education reflect a lack of attention to even non-academic subjects.

With only nine credits earned in the spring term of 1927—six of them in art—Diller realized that he was deriving little benefit from college. Returning home to his mother and stepfather in Battle Creek appealed to him far less than the prospect of living with his maternal relatives in Buffalo, with whom he had remained in frequent contact. By July, he had reestablished himself in his grandfather's home in Buffalo. His expectations about ready employment were soon disappointed in the pre-Depression economy of Buffalo. Jobs were scarce and layoffs were frequent. What employment Diller did find lasted only a few

Fig. 1.
Arnold G. Sheele
The Restless Sea, n.d.
Oil on canvas
19½ × 23½ (49.5 × 59.7)
Michigan State University,
East Lansing

Fig. 2.
Calogero Scibetta
Dwarf Trees, c. 1926
As reproduced in *The Buffalo
Arts Journal*, 8 (November 1926),
p. 37.

months.[15] Through family connections, he finally landed a janitorial position in the Buffalo post office. His salary from this, coupled with occasional sales of his artwork, provided a modest living. Ultimately, his success in selling a few paintings encouraged him to go to New York and devote himself full-time to his art.[16] By January 1929, he had moved into a walk-up apartment on West 49th Street and enrolled in the Art Students League.

Diller's paintings prior to his move to New York are known only from descriptions in his journals and later recollections. For two years while at Michigan State, he had studied privately with A.G. Scheele and, during his subsequent eighteen months in Buffalo, with Calogero Scibetta, a local adherent of the Barbizon School of landscape painting whose association with the Buffalo Advertising Artists Co. led to Diller's short-lived employment with that firm. Yet nothing in the work of either artist (Figs. 1, 2) provides insight into Diller's precocious appreciation of the formal language of painting and his apparent journey during this period from Impressionism to Post-Impressionism and finally to Cubism. Indeed, Diller's journal from 1924–25 confirms that his early embrace of advanced art was self-generated.

Although Diller's later accounts may have been skewed to suggest a more ineluctable sequence than actually existed, there is nonetheless in his development as an artist a distinct sense of a logical movement toward a purposeful end. His earliest seminal impression was of Seurat's *A Sunday Afternoon on the Island of La Grande Jatte*, which he saw at The Art Institute of Chicago on one of his visits to his brother, who had moved there in the early 1920s. At the Art Institute, too, he encountered his first Cézanne painting which, although it initially struck him unfavorably, ultimately led to a revelation about the potential of color to create volume.[17]

Given Diller's later structural style, it would seem natural that Seurat and Cézanne interested him for their awareness of the geometrical forms underlying natural phenomena.

Yet he was first attracted to Seurat for the Frenchman's systematized approach to color. By 1924, Diller had begun experimenting with Seurat's Pointillist technique, using small methodical dots of color to create formal design. In his journal from that year, he had painstakingly documented the success or failure of his various color combinations as they pertained to landscape or portrait subjects.[18] Diller's early affinity with Cézanne was likewise primarily as a colorist. Cézanne's work showed Diller that the creation of space need not depend on perspective or modeling, but could result from the juxtaposition of color.[19] He realized that Cézanne, by making volume a function of color rather than of light and shade, created a compact space in which foreground and background were fused into an active curtain of color. The possibility that color could serve as the vehicle of structure made a deep and lasting impression on Diller.

The Early Thirties and the Art Students League

How soon Diller convincingly incorporated these insights about color into his own efforts is unclear. By the time he arrived at the Art Students League in 1929, he had passed through Impressionism and was beginning to assimilate the implications of Cézanne's work. Already he appreciated that one of the questions facing him as an artist was whether the content of his art would be external reality or non-objective formal issues.[20] Notwithstanding Diller's indecision regarding these questions, his level of achievement in January 1929 was sufficient to earn him a scholarship at the League.

The League in those days was a vital center of artistic energy in New York City. Founded in 1875 as an alternative to the artistically moribund National Academy, it had remained artist-run and therefore, in principle, responsive to new currents. In practice, the League had become the self-perpetuating bastion of American Social Realism, as practiced by Ashcan artists such as Robert Henri and John Sloan and their successors, the American Scene painters of the late 1920s and 1930s. Several years after Diller arrived at the League, John Sloan, whose viewpoint in art was catholic notwithstanding his realist style, would be ousted from the board presidency over the question of hiring teachers who expressed contemporary tendencies. The victory of Sloan's adversary, Jonas Lie, represented the emergence of the conservative Kenneth Hayes Miller as a dominant voice at the League.[21] Nevertheless, the mixture of styles that had been the hallmark of the League persisted: jobs had been offered to Hans Hofmann as early as 1928 and to Wassily Kandinsky in 1931; although Kandinsky had decided against accepting a position and Hofmann would not do so until 1932, Hofmann's student, Vaclav Vytlacil, gave a series of lectures on modern art at the League in 1928–29. These were followed by the appointments of Jan Matulka in 1929 and Stuart Davis in 1931.

Enrollment in classes at the League was monthly, with students free to transfer to different instructors every month. Faculty would generally teach two days a week, with the remainder of the sessions run by student monitors who would time the models and perform a few studio duties. Having studied anatomy at Michigan State, Diller initially enrolled in the class taught by George Brant Bridgman, whose book *Constructive Anatomy* he had read and admired in 1925.[22] Bridgman was described later by Rosalind Bengelsdorf Browne as having taught his students to reduce the figure to basic geometric forms, thus facilitating their understanding of space.[23] Despite this seemingly attractive structural orientation, Diller left Bridgman's class after one month and spent the following eight months studying sporadically with three other teachers: Boardman Robinson, whose employment at the League was terminated that spring; William von Schlegell; and Kimon Nicolaides, whom Diller left after only a few weeks.[24]

In his first eight months at the League, Diller established himself as a serious and promising student. His work was often selected by teachers to be hung in informal student shows and, in June 1929, he was given a scholarship job in the League bookstore.[25] In addition to allowing him to attend classes tuition free, the job provided him with a modest income of $13 per month.[26] As a student, Diller was less interested in learning virtuoso techniques than in probing essential aesthetic questions. The desire for clarity which marked his personality no doubt helped propel him toward the rational side of art as against the emotional. This orientation was apparently intractable by the time he arrived at the League. When Nicolaides advised him to postpone trying to solve aesthetic problems until he was older and learn instead how to "feel," he replied that he was not interested in autoerotic gratification.[27]

Despite Diller's precocity, it was not until the League hired Jan Matulka in the fall of 1929 that Diller discovered a teacher with whom he could work. In Matulka's class, which was attended by a small coterie of loyal students—David Smith, Dorothy Dehner, George McNeil, Edgar Levy, and Irene Rice Pereira, among others—Diller embarked on a career as a modernist. Matulka developed a camaraderie among himself and his students. His passions, friends, and experiences became part of the students' daily life. He had been in Paris between 1919 and 1924, and had developed an appreciation of postwar Cubism, especially as practiced by Picasso and Braque. The variant of Cubism he had evolved emphasized flat, abstract patterning, and he passed on to his students his enthusiasm for defining forms by means of decorative elements such as stripes and cross-hatched lines and for building up and varying the surfaces of his paintings by mixing sand and other materials with paint. Even more important, Matulka helped his students appreciate the wide variety of postwar Parisian art developments. Through critiques and discussions that often continued long af-

Fig. 3.
Female Upper Torso, c. 1929
Oil on canvas
12¾ × 10¾ (32.4 × 27.3)
Meredith Long & Company,
Houston

Fig. 4.
Untitled, 1930
Watercolor and ink on paper
10½ × 14 (26.7 × 35.6)
Meredith Long & Company,
Houston

ter class, and by admonishing his students to attend contemporary art exhibitions and to pour through copies of the European art magazines available in America, Matulka provided the link between late twenties decorative Cubism and the geometric art that would explode in America in the 1930s. As David Smith later wrote, "It was from [Matulka] that for the first time I learned Cubism and Constructivism. Then the world kind of opened for me . . . Matulka was the most notable influence on my work. . . ."[28]

Diller's work did not immediately reflect the flat, planar space and still-life subjects to which Matulka introduced his students. Instead, from 1929 through 1931, he seems to have explored various modes of figure painting. By 1930, he had progressed from modeled, spatially illusive portraits and figure groupings (Figs. 3, 4) to a more two-dimensional, linear style that relied on flowing contour lines to describe volume and form (Fig. 5). Although these latter works recall the whimsical circus drawings and caricature portraits that Alexander Calder was executing simultaneously, it is unlikely that Calder influenced Diller; Calder's drawings had not been exhibited in New York since 1928, a year before Diller arrived. More likely is the shared derivation of the style: both Diller and Calder studied at the Art Students League with Boardman Robinson, whom Calder later credited with teaching him to "draw with a pen in a single line."[29] That the technique was popular at the League is suggested by David Smith's similarly calligraphic contour drawings (Fig. 6).

Fig. 5.
Listening to the Concert, 1930
Ink on paper
15 × 11 (38.1 × 27.9)
Meredith Long & Company,
Houston

Fig. 6.
David Smith
Untitled, 1933
Ink and colored pencil on paper
23¾ × 18¾ (60.3 × 47.6)
M. Knoedler & Co., Inc.,
New York

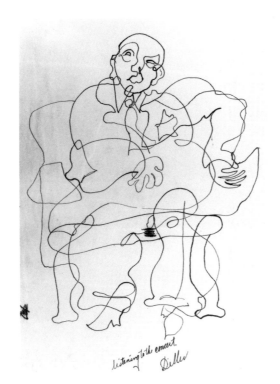

By 1930, Diller was beginning to shift to a less descriptive approach to form. At first, his apparent enthusiasm for a more abstract style exceeded his assimilation of it: the geometric wall reliefs he depicted in several drawings from 1930 imply a sympathy for Constructivism that was at odds with his lingering employment of traditional compositional space (Fig. 7). However, in the following year, Diller coalesced the forms in his line drawings into abstract planes of strident color that interlocked within a shallow picture space (Fig. 8). Black contour lines continued to describe figures, but within these figures, facial features and delineating details disappeared. In their stead were abstract divisions of space, which Diller created by means of bifurcated color planes and simulated textures. These imitation textures and arbitrary spatial demarcations, while ultimately of Cubist derivation, came to Diller through Matulka (Fig. 9).

Under Matulka's tutelage, Diller began to flatten out volumes and to weave together figure and ground (Figs. 10, 12, 13). By 1932, his still lifes displayed the same organization of flat shapes on the picture plane—even the same tilted tabletop—that characterized Matulka's work and that of his European progenitors. Diller was especially impressed by Braque, even adopting his typical device of pictorially bifurcating objects—a reformulation of the faceting and sectioning in the analytic phase of Cubism (Fig. 11). At first, Diller stopped short of fusing motifs into one overall image where shapes interlock to create a

two-dimensional, abstract pattern. Rather, his shapes retain their character as independent objects situated in a shallow but nonetheless receding space. Even when he separated an image into different color zones, he never sacrificed the motif's integrity for a purely pictorial effect. What differentiated even Diller's earliest experiments with Cubism from other American articulations of the style was his unerring sense of structural clarity.

Diller moved quickly toward a more overall, planar treatment of space. His initial motifs were architectural landscapes, which shared a subject matter with American Precisionism (Figs. 14, 15). Paradoxically, given Diller's later enthusiasm for impersonal execution and strict geometric forms, his compositions eschewed the architectonic structure and machinelike aesthetic of such Precisionist antecedents as Charles Demuth and Charles Sheeler (Fig. 16). In marked contrast to their uninflected color areas and sharply demarcated forms, Diller created an overall decorative surface by modulating his paint and patterning his color zones. It was as if, coming of age in the late twenties, Diller had ignored the aesthetic roots that seem synonymous with his own interests. Yet, in doing so, he was very much part of the generation of American modernists that came to maturity in the early thirties. Perhaps disaffected by the American retreat from abstraction after World War I, these artists all bypassed the legacy of earlier twentieth-century American abstractionists in favor of a direct appropriation of contemporary European models.

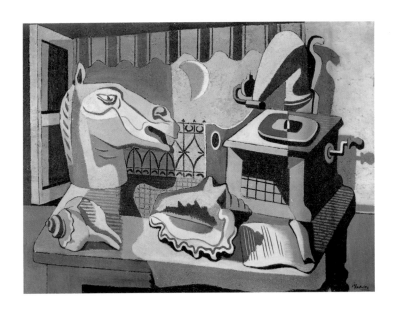

Clockwise, starting upper left:

Fig. 9.
Jan Matulka
*Still Life with Horse's Head and
Phonograph*, c. 1930
Oil on canvas
30 × 40 (76.2 × 101.6)
Art Students League, New York

Fig. 10.
Still Life, 1932
Lithograph
12 × 9 (30.5 × 22.9)
Meredith Long & Company,
Houston

Fig. 11.
Georges Braque
Still Life: The Table, 1928
Oil on canvas
32 × 51½ (81.3 × 130.8)
National Gallery of Art,
Washington, D.C.; Chester Dale
Collection

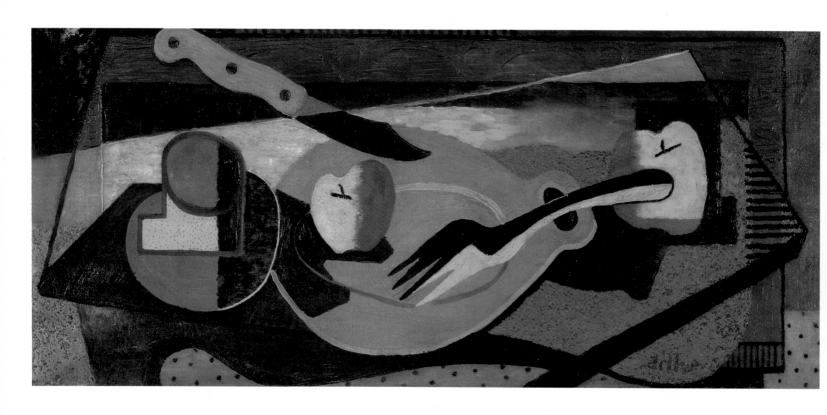

Fig. 12.
Still Life, 1932
Oil on canvas, 18 × 40 (45.7 × 101.6)
Collection of Victoria M. LaCrone

Fig. 13.
Still Life, 1932
Oil on canvas, 20¼ × 16 (51.4 × 40.6)
Art Students League, New York

Opposite page
Clockwise, starting upper left:

Fig. 14.
Untitled, 1932
Watercolor on paperboard
8 × 8¾ (20.3 × 22.2)
Collection of Michele and Rodney
Traeger

Fig. 15
Untitled, 1932
Oil on canvas
24 × 30 (61 × 76.2)
Harcourts Modern and
Contemporary Art, San Francisco

Fig. 16.
Charles Demuth
*Buildings Abstraction,
Lancaster, 1931*, 1931
Oil on panel
27⅞ × 23⅝ (70.8 × 60)
The Detroit Institute of Arts;
Founders Society Purchase,
General Membership Fund

For a time, these models had come to Diller through the filter of Matulka. But, as salaries at the League became more dependent on tuition during the Depression, Matulka began to feel the effects of low enrollment. In the spring of 1931, his position was eliminated when registration fell three or four short of the requisite seventeen per class.[30] For Diller, the class had been an important nexus, and he took an active part in attempting to revive it by locating a studio on West 14th Street in which Matulka could conduct a private seminar twice a week.[31] This off-campus class lasted for fifteen months, after which many of the students left to study with Hans Hofmann, who began to teach at the League in October 1932.

Diller, too, joined the Hofmann class, but although he benefited from it in many ways, he was not, retrospectively, as loyal to Hofmann as to Matulka and never acknowledged Hofmann as an important influence. He later even denied having taken regular painting classes at the League during this period and claimed to have been essentially painting on his own.[32] This refusal to identify Hofmann as a mentor may have been due to the demarcations that became increasingly pronounced between Hofmann's expressionist style and Diller's subsequent hard-edged, geometric work. Hofmann's overt denigration of geometric abstraction anticipated the acrimonious discord that later developed within the Abstract American Artists between the Hofmann students, who abstracted from natural forms, and the purists who believed that a painting's formal resolutions had value independent of their analogy to physical experience.[33]

Nevertheless, in the early 1930s, Diller cherished Hofmann's expertise enough to keep meticulous notes on Hofmann's lectures—which he never did with Matulka's—and to allow his 1932 lithograph (Fig. 10) to accompany Hofmann's article "Plastic Creation," which appeared in *The League* (Winter 1932–33). Hofmann, for his part, was at the time an ardent supporter of Diller: he wrote an introduction to the catalogue for Diller's one-artist show at Contemporary Arts in 1933, recommended him for a Guggenheim Fellowship in 1935, and offered to waive tuition for Diller at the private school he established after leaving the League in 1933.[34] In his Guggenheim recommendation, he identified Diller as "one of the most interesting and vital artists in the younger American generation. . . . Painting is for him a matter of consciousness and all his actions are dominated through an absolute conviction in his artistic destination and mission. . . . his efforts are . . . free from every superficialities [*sic*] and false geniality."[35]

Hofmann was important to Diller in reinforcing the centrality of formal issues over literary or social concerns. Hofmann's initial influence on Diller was to intensify the younger artist's exploration of planar structure. Hofmann had taught that planes, not lines, built volume and that negative space—so-called "vacant" or "unfulfilled" space—was as much an

Fig. 17.
Gospel, 1932
Oil on canvas
30½ × 25½ (77.5 × 64.8)
Meredith Long & Company,
Houston

Opposite page
Clockwise, starting upper left:

Fig. 18.
Pablo Picasso
Painter and Model, 1928
Oil on canvas
51⅛ × 64¼ (129.9 × 163.2)
The Museum of Modern Art, New
York; The Sidney and Harriet
Janis Collection

Fig. 19.
Untitled, c. 1933
Ink and crayon on paper
9½ × 7¼ (24.1 × 18.4)
Meredith Long & Company,
Houston

Fig. 20.
David Smith
Untitled (Billiard Players), c. 1936
Oil on canvas
47 × 52 (119.4 × 132.1)
Collection of Barney A. Ebsworth

Fig. 21.
Arshile Gorky
Organization, 1933-36
Oil on canvas
49¾ × 60 (124.5 × 152.4)
National Gallery of Art,
Washington, D.C.; Ailsa Mellon
Bruce Fund

object as "fulfilled" space and possessed an equally effective three-dimensionality.

For Hofmann, each medium had its own exclusive laws and essence. Since the essence of painting was the picture plane, it was incumbent upon the artist to stress this aspect. This did not entail eliminating pictorial depth. Indeed, Hofmann argued that the vitality of painting owed to the dualism between the two- and the three-dimensional—a dualism he believed was analogous to the basic dichotomy between vision and experience.[36] Given that the mind interprets in three dimensions what the eye presents in two, the painter could depict pictorial depth without violating the two-dimensional quality of the picture surface. This perceptual analogy made it possible for Hofmann to reconcile the flatness of the picture plane with his demand that space not be static or inert. "[Pictorial] space," he wrote, "sways and resounds; space is filled with movement, with forces and counter forces, with tensions and functions, with the tone of colors and light, with life and rhythm. . . ."[37] Such movement need not be achieved by illusory gradation, but by exploiting the properties of color to advance or recede in relation to the picture surface. Hofmann's commitment to the two-dimensionality of the picture plane and his use of color as a vehicle for establishing spatial movement within that plane eventually became fundamental to Diller's work; but it would be several years before these precepts fully took hold.

Diller responded to Hofmann's admonitions with a series of works in which all areas of space are treated with equal importance. He flattened his backgrounds into predominantly

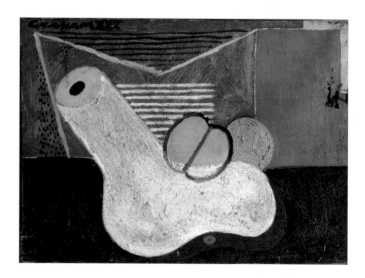

rectangular planes, which he enlivened with squiggles, stippling, and, occasionally, fragmented words or phrases (Fig. 17). Simulated textures and words contributed not only to the variety of forms and surfaces, but also activated the surface of the painting, thereby integrating foreground and background and dispersing the focus of attention over the entire field. Taking his cue from the geometric linearity in Picasso's *Painter and Model* of 1928 (Fig. 18), Diller experimented with the black outlines and open constructions that would engage the imagination of many of his contemporaries in the 1930's. Like these contemporaries, he used linear silhouettes and tonal gradients to establish an equilibrium between receding frontal planes and advancing rear planes (Fig. 19). Although Diller showed more reluctance to discard the vestiges of figuration than did artists such as Arshile Gorky and David Smith (Figs. 20, 21), his work nonetheless effected an equally successful fusion of the biomorphic with the geometric.

By the time Diller left Hofmann's class and the Art Students League in 1933, the influence of Biomorphic Surrealism could already be felt in New York (Figs. 23, 24). Picasso, ever protean, had already introduced an incipient Biomorphism into his work in the 1920s (Fig. 25). The public attention given this new direction, coupled with exhibitions of Miró's work at the Valentine and Pierre Matisse galleries in 1930 and 1932, respectively, and of Calder's at the Julien Levy Gallery in 1932, subtly began to loosen the exclusive grip of Cubist angularity and open up new possibilities for compositional arrangement.

Like many of his fellow artists in the 1930s, Diller accommodated Biomorphism by uniting it with Cubist geometry. What was unique about Diller's initial solution to this union was his depiction of sculptural amalgams of organic forms against architectural or stagelike settings (Figs. 27, 28). Diller positioned his Biomorphic "protagonists" in front of backdrops

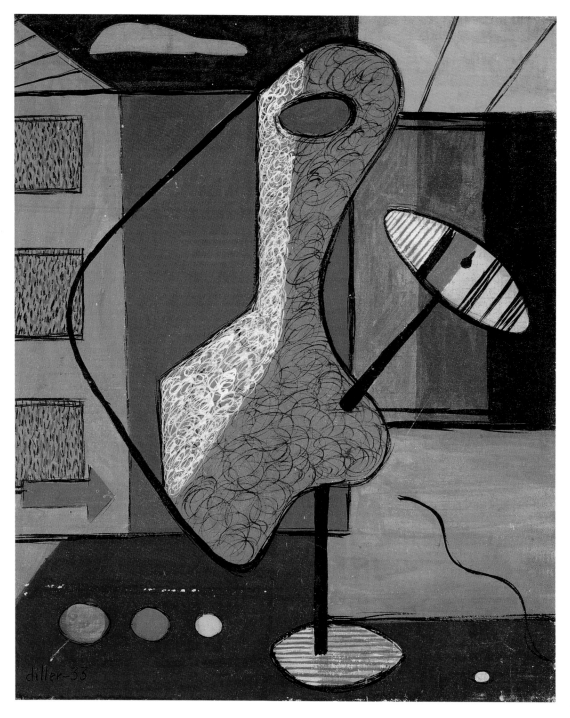

Fig. 27.
Untitled, 1933
Oil on canvas, 22 × 18½ (55.9 × 47)
Meredith Long & Company, Houston

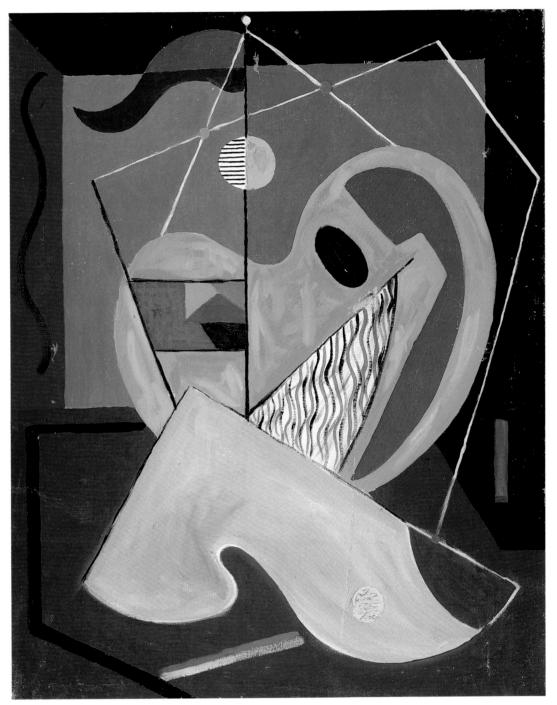

Fig. 28.
Untitled, 1933
Oil on canvas, 30 × 24 (76.2 × 61)
Meredith Long & Company, Houston

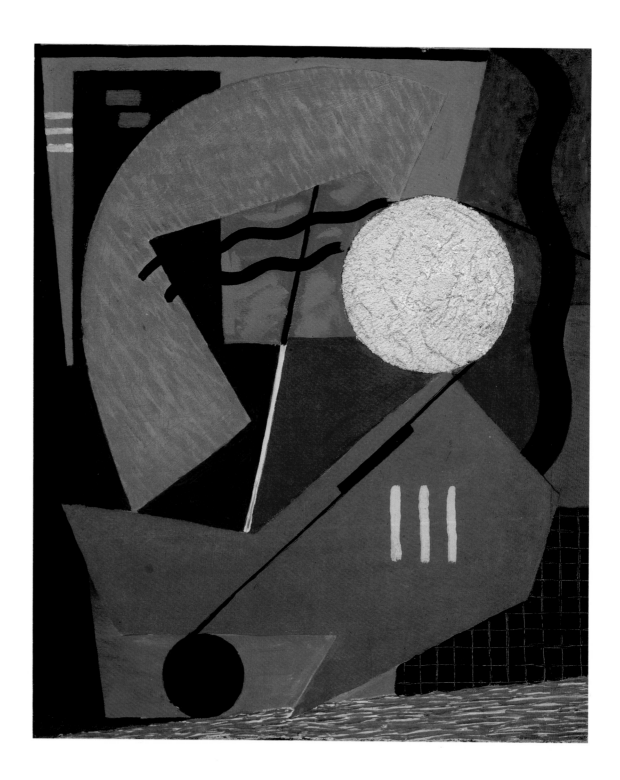

Fig. 29.
Untitled, 1933
Oil on canvas
30 × 24 (76.2 × 61)
Meredith Long & Company, Houston

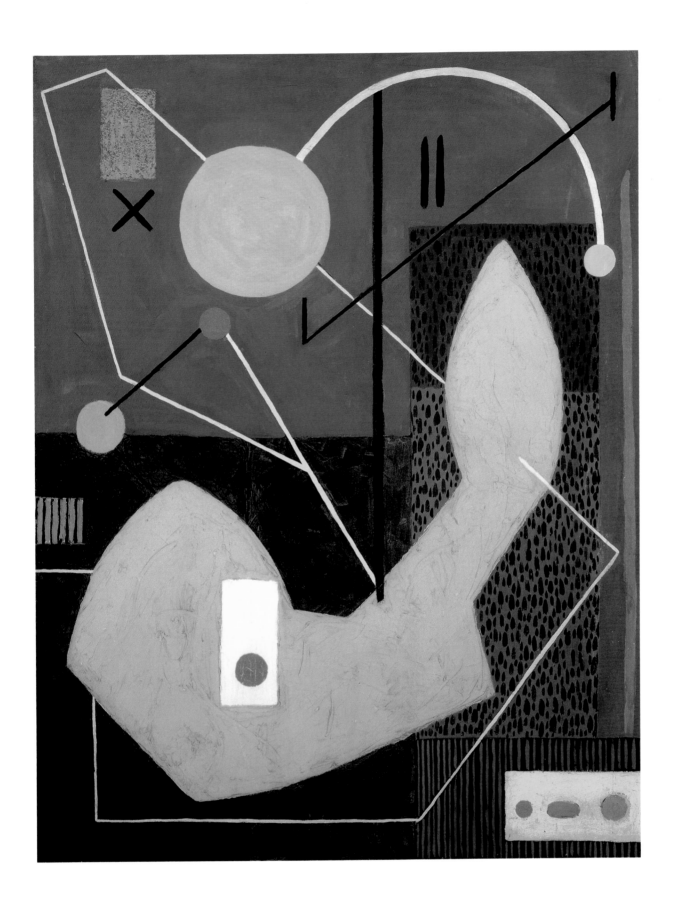

Fig. 30.
Untitled, 1934
Oil on canvas, 36 × 28 (91.4 × 71.1)
Albright-Knox Art Gallery, Buffalo; Gift of Seymour H. Knox

Fig. 31.
Untitled, 1934
Oil on canvas, 30½ × 24 (77.5 × 61)
Collection of Fayez Sarofim

Fig. 32.
Abstraction, 1934
Oil on canvas, 20 × 34 (50.8 × 86.4)
Collection of Jane and Ron Lerner

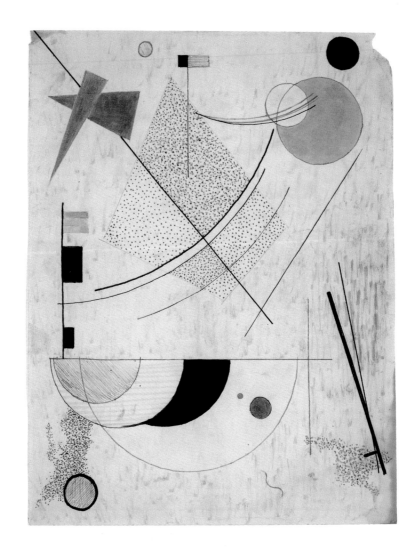

organized into abstract zones of near-Cubist rectangular planes—sometimes monochromatic, sometimes embellished with dots, squiggles, or strips. As before, these patterned areas enliven the surface, but they are not so profuse or so bold as to overwhelm the structure and decentralize the composition. What dominates the compositions are Diller's sculptural personages, which seem to have provided him a transit from figuration into Biomorphism. Indeed, among his first expressions of Biomorphism were drawings of sculptures whose irregular, curving silhouettes recall the protoplasmic concretions of Jean Arp and David Smith as well as the three-dimensionally modeled "bone" forms that populated Picasso's paintings of 1927 and 1928.

Diller's architectural settings soon gave way to an increasingly flat picture space (Figs. 30–32). The architectural conceit lingered, however, and these works can be read more as compartmentalized spaces than as integrally flat, unified fields. The rectilinear units of the background space, coupled with the discreteness of individual forms, yielded a geometric severity. This effect was markedly distinct from the composite, sprawling organisms in the paintings of Arshile Gorky and John Graham, which Diller would have known through Matulka and through the one modernist exhibition held at the Art Students League in this period—the December 1931 show that featured Matulka's work along with that of Gorky, Graham, and Stuart Davis.

Whereas Diller had earlier identified line with contour, he here completely disassociated it from imagery so that it functioned as a fully autonomous element. Rather than lock forms to the picture plane, as did the open constructions in Picasso's work, Diller's lines suggested movement which had only temporarily been arrested. In some works, his linear arteries served to connect otherwise disparate areas of the composition—just as earlier artists exploited telephone wires or the riggings of ships' masts to connect sky with ground. In general, however, the structural function of Diller's line generated a more rhythmic image.

Diller's declaration of line as an autonomous pictorial element owed to the example of Klee, Miró, and Kandinsky, whose experiments of the twenties combined free, improvised, irregular forms with circles and straight lines (Figs. 33, 34). In a group of watercolors of 1933, Diller extended the repertoire of devices he borrowed from these artists to include open fields and free-floating linear tracery (Fig. 35). Under the influence of these mentors, he abandoned the dense opacity of Cubist background in favor of atmospheres of semitransparent, modulated color. Within these diaphanous skins of color he floated seemingly weightless forms. Space became a shallow, indeterminate field through which objects buoyantly drifted rather than a backdrop against which they were deployed.

By 1932, Diller had begun to emerge as a spokesperson for modernism at the League. He had been a student leader in the controversy at the League that ultimately led to the hiring of Hofmann and George Grosz, and he was instrumental in organizing a 1933 exhibition of vanguard student work—one of the first group presentations anywhere of emerging, post-war American Cubists.[38] To fellow students, Diller and the small group of friends who gathered around him seemed "very far out."[39] "They awed me," recalled Rosalind Bengelsdorf Browne of Diller, Harry Holtzman, Albert Swinden, and Albert Wilkinson. "To a youngster . . . they seemed aloof and way up on some transcendental plane."[40]

Even within the group of artists receptive to European modernism, Diller seemed particularly enlightened. Holtzman, a later follower of Mondrian and heir to his estate, credited Diller with being "more sophisticated [in the early thirties] in his knowledge of what was going on in Europe. I found out about Europe from him."[41] It was Diller who urged Holtzman to see Mondrian's paintings at A.E. Gallatin's Museum of Living Art; Diller who had copies of *Cahiers d'Art* at his house;[42] and Diller, about whom fellow artist Samuel Tucker wrote to Juliana Force, director of the Whitney Museum of American Art, suggesting that a meeting with Diller might illuminate Force's understanding of abstract art.[43]

The years 1930–33 were promising for Diller. Despite the comparatively few showcases available to American artists with modernist affiliations, he was singled out for inclusion in several significant group exhibitions and honored with a solo exhibition at Contemporary Arts—one of the most prominent galleries devoted to young artists of unusual promise.[44] In an introduction to a 1933 group exhibition, John Sloan identified Diller as one of a number of young, independent artists "ready to be known."[45] Professional advancement was matched by personal good fortune: in 1930 he had married Sarah (Sally) Conboy, a strikingly beautiful redhead who worked in the classified department of *The New York Times*. Exuberant and dynamic, Sally seemed a wonderful match for Diller; to friends, they were "a prince and princess in fairy land."[46] Sally's salary, combined with what Diller earned in his afternoon job at the Art Students League store, provided the couple with a modest but sufficient income; indeed, Diller had more money at the time than most artists at his level.[47]

Public Works of Art Project

In December 1933, the League was forced by the Depression to cut employee salaries and staff, and Diller had to search for another job. One month later, he was hired on the Public Works of Art Project. Established on December 3, 1933, the Public Works of Art Project (PWAP) was part of the general effort developed in the first few months of the New Deal

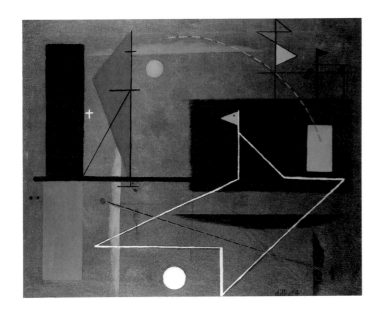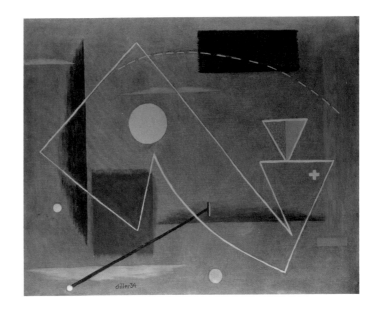

Fig. 36.
Abstraction, 1934
Oil on canvas
Made for the Public Works of
Art Project
Whereabouts unknown

Fig. 37.
Abstraction, 1934
Oil on canvas
Made for the Public Works of
Art Project
Whereabouts unknown

to employ out-of-work Americans. That artists had been included along with other unemployed Americans was due to the efforts of George Biddle and Edward Bruce, who administered the program under the auspices of the Treasury Department—the agency that controlled funds for the construction of federal buildings. In keeping with its status as an appendage of the Treasury Department's building program, the PWAP's mandate was to place artists' work in tax-supported buildings—schools, hospitals, libraries, and museums. For administrative purposes, the PWAP divided the country into sixteen geographic regions. Juliana Force served as regional chairman of New York City, with six hundred jobs to dispense.

On January 8, 1934, Diller was accepted into the PWAP program as an easel painter on the basis of four paintings, which the agency official described as "Braque-like" abstractions whose style might be suitable for decorative panels.[48] Based on their titles—*R.R. Crossing, 2 A.M., Knife and Fork*, and *Abstraction*—these works represented the range of Diller's recent aesthetic investigations. In the work he produced for the program, however, he dropped the titular allusion to subject matter in favor of untitled abstractions. While some of these works contain distinct figurative and landscape references (Figs. 36, 37), others begin to move into a non-objective realm in which even the nominally allusive vocabulary of Biomorphism gave way to circles, squares, and triangles floating against simple zones of color (Figs. 38–40). As with Diller's watercolors of 1933, the technique of suspending geometric shapes within a relatively indeterminate space recalled the work of Kandinsky, Klee, and Miró. But Diller passed up ideographic figures and pictographic signs for an abstract geometric vocabulary. With this work, he also left behind his earlier

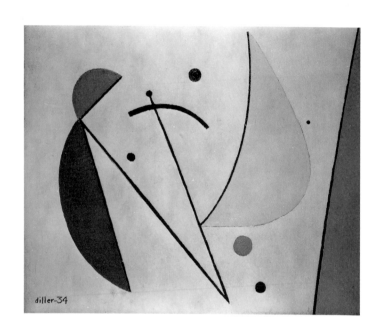

fascination with decoratively enlivened surfaces and began to apply paint in smooth, unmodulated areas.

The acceptance of this vocabulary by the PWAP, although not unique to Diller's case, was also not the norm; there were few abstract artists employed on the Project. Within the PWAP administration were those who felt that the program should create a permanent record of the aspirations and achievements of the American people; consequently, they urged a subject matter that interpreted the American scene.[49] That Diller's art was viewed with some suspicion is indicated by its exclusion from the exhibition that PWAP director Edward Bruce organized in April 1934 at The Corcoran Gallery in Washington, D.C., to showcase the quality of art produced under the program and thereby to generate enough enthusiasm to secure new federal patronage for the arts.[50]

The PWAP, along with its funding agency, the Civil Works Administration (CWA), had been conceived only as a short-term measure to last through the spring of 1934. Its termination on April 28 left many projects incomplete. To take up the slack, the reactivated Temporary Emergency Relief Administration (TERA) agreed to employ artists to finish the work they had begun if they could qualify for relief.[51] One of the unfinished PWAP projects transferred to TERA was the mural *Abstraction of the Machine Age*, designed by Eric Mose for Samuel Gompers High School in the Bronx. Diller, who had been employed in the PWAP as an easel painter, third class, was hired by TERA as one of Mose's mural assistants.[52] After nine months, his classification was switched to "artist." What Diller did as an artist under TERA is unclear. It is possible that he assumed some supervisory responsibility for the mural program.[53] What is more likely is that he remained as an assistant to Mose on a higher pay scale through May 1935, when Mose's mural was installed at Samuel Gompers High School.

The involvement of governmental agencies in the economic support of art had given artists a sense of equality within American culture. Artists had no money, but neither did anyone else. Diller even felt that the level of impoverishment to which artists were accustomed had prepared them for the Depression.[54] Despite the hardships, groups of artists intermingled as never before. It was one of those rare moments when nothing interfered with friendship—there were no sales, no exhibitions, no careers. As Diller later remarked, "So it was a question of most of us just pitching in together and sometimes we'd have one pot of soup for ten, sometimes hardly enough for one. It's crazy, but it was wonderful. I think, as a matter of fact, there's something unforgettable about that period. There was a wonderful sense of belonging to something, even if it was an underprivileged and down-hearted time. You just weren't a stranger."[55] Similar sentiments run through many reminiscences of the period—from David Smith's recollection that parties were never as wonderful as in the

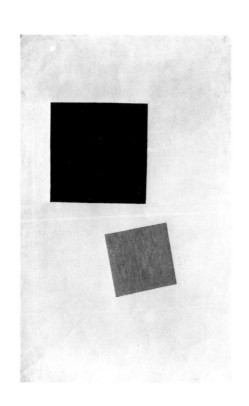

1930s when everyone chipped in to Ben Shahn's remark that "there was a strange harmony with the time. . . . I don't think I've ever felt that way before or since."[56]

By the spring of 1934, when the PWAP ended, Diller had become a leader within the emerging community of abstract artists—so much so that when Katherine Dreier, founder of the Société Anonyme, wanted to initiate discussions with a group of artists about the possibility of an exhibition or publication of the work of American abstract artists, she turned to Diller to organize a meeting in his house.[57] Among those who attended were Arshile Gorky, John Graham, Stuart Davis, and Josef Albers, along with less established artists—Werner Drewes, Paul Kelpe, and Harry Holtzman. Out of this and subsequent meetings came a commitment to produce a portfolio of eight original prints, in an edition of forty, to be distributed under the name "Group A."[58] Since one of the purposes of the portfolio was to disseminate information on abstract art to the public, half of the portfolios were to be sent to museums and collectors.[59] Of the remaining twenty, twelve were to be sold to cover production costs and eight were to be distributed among the group.

There was clearly a desire to form a nucleus of artists from which a larger organization could be built.[60] Nevertheless, given the small number of artists in America in 1934 whose work excluded representational elements, the non-objective ambitions of the artists in Group A were perhaps too restrictive to allow for a wide membership. Such was the critique leveled at Diller by Balcomb Greene. "One might even suspect," he admonished, "that you think the honors to be won from your fight are so precious as to merit distribution only to very few. . . . It seems to me that we need a group at least twenty strong. Such a group will not approximate the quality or oneness of ideas of German or French groups—yet at present we can have no other sort of beginning. . . . If you are giving birth to a new idea today, or to a new organ, why not let it be a big one."[61] Greene's more expansive vision would predominate two years later with the formation of the American Abstract Artists. Still, the activities which Diller initiated in 1934 represented the first attempt in America to form an official alliance of abstract artists.

The Philosophical Imperative of Neoplasticism

By 1934, a radical shift had taken place in Diller's work as he moved toward a personal interpretation of Constructivism and De Stijl abstraction. Louis Lozowick's book on contemporary Russian art, published in 1925 by the Société Anonyme, had introduced Diller to Constructivism and Suprematism, and *Cahiers d'Art* had augmented this influx of images with reproductions of works by Malevich, El Lissitsky, Theo Van Doesburg, and Piet Mon-

drian. Diller first incorporated the ideas of these artists in a series of canvases in which variously scaled, isolated shapes floated within a seemingly unbounded spatial continuum (Figs. 41, 42). The use of basic geometric forms of unmodulated color, organized in free, unstructured space, recalled Malevich's Suprematist compositions from the second half of the teens (Fig. 43). Diller's works emulated the compositional austerity of Malevich's paintings as well as the dynamic sensation of movement they conveyed through differently sized and diagonally positioned geometric shapes floating on fields devoid of materiality. Although Diller was virtually alone among the Americans in embracing a Suprematist vocabulary in 1934, the progression to it from his PWAP experiments with geometric shapes on transparent grounds seems natural.

Diller also executed several reliefs in 1934 in which he placed rectangular wooden shapes, painted in primary colors, on flat grounds (Figs. 44, 45). The austerity of these reliefs, in concert with their free-floating circles, rectangles, and ellipses, was fully in the spirit of his Suprematist-derived paintings. Yet the incorporation of "real" rather than illusionistically painted elements and the interplay between them and painted forms lent the reliefs a sense of materiality and complex spatial contradiction very different from the infinite space in his concurrent paintings.

Diller's subsequent canvases mirrored the growing influence of De Stijl on his art. De Stijl, founded in Holland in 1917 by Mondrian, Van Doesburg and Bart van der Leck, was the purest and most idealistic of the abstract movements that had emerged at the end of World War I. Imbued with a sense of ethical and spiritual mission, it postulated the existence of a universal harmony in which man could participate if freed from individuality and the particularities of the visible world. Until such perfection was achieved, art had to serve as a paradigm of the synthesis of opposing forces. All aspects of De Stijl's visual language—or Neoplasticism as Mondrian called it—derived from a conception of this harmonious new reality. Asymmetry, the opposition of vertical and horizontal lines, the use of primary colors and elemental forms—all these pictorial means abrogated specificity and discreteness for a harmony of non-equal but equivalent forces.

For Diller and a handful of other artists, the vocabulary and grammar of Neoplasticism exerted a psychological as well as an aesthetic appeal. Here was an art infused with moral authority because it claimed to have culminated the Western pictorial tradition of naturalistic representation. The evolution, begun with Cézanne's understanding of the two-dimensional surface, had been extended but not fully realized by the Cubists. It was left to De Stijl to carry the abolition of particular form and the creation of pure plastic art to its logical conclusion. To Americans, anxious to contribute as equals to the new aesthetic formulations, the fixed grammar of Neoplasticism provided a sense of certainty and security.

Moreover, there was something euphoric about associating with a style that self-consciously broke with the old, moribund order and epitomized the new age—its overthrow of established social systems and its breakthroughs in science and industrial technology. To some extent, all abstract art prided itself on its relationship to these new realities. As Rosalind Bengelsdorf Browne wrote, "It is the era of science and the machine. . . . So-called abstract painting is the expression in art of this age. The abstract painter coordinates his emotional temptations with his reason: the reason of this age."[62]

For Diller, art needed to be more than personal expression; it needed to have structure. His own reserve and proclivity for order and precision demanded it. He believed in absolutes, and this belief pervaded his actions and his personality: one student and later colleague remarked that people came to Diller asking for the truth.[63] Neoplasticism offered a vehicle for the universal expression of immutable certainties without resorting to sentimentalism or pretension; it avoided the illusion of realism and the self-indulgent outpourings of expressionism. By removing the irrational from the illusive and subjective experiences that divide people from one another, Neoplasticism implicitly promised a universal language. Because it eliminated allusions to external reality and thereby obliterated reminders of the social, political, and economic differences between people, it accorded with the egalitarian tenets of democracy. Finally, Neoplasticism carried with it a moral imperative: once Diller had accepted art as a finite self-sufficient system with its own inexorable evolution, Neoplasticism seemed the only possible pursuit.

Given that Neoplasticism took hold in Diller's consciousness in 1934, at the apex of the Depression, it is also not hard to see his choice of style as a response to a world in turmoil. Following the stock market crash of 1929 and the bleak economic years of the early thirties, Americans reached out for heroic images and optimistic visions. The Regionalists supplied these in the form of bucolic, idealized images of an uncluttered—if nostalgic—agrarian past. Neither rising Fascism nor the all-pervasive Depression marred the quiet and contentment of Regionalist vistas. The movie industry, for its part, accommodated the need for an alternative to pressing reality by picturing a world of prosperity and carefree pleasure. Diller's embrace of geometric abstraction likewise sprang from an envisioned utopia, an ideal realm of harmony, stability, and order in which "every form and spatial interval" could be "controlled and measured."[64]

An almost heady euphoria surrounded Diller's choice of Neoplasticism. The Depression had precipitated the need for a new national identity: the hegemony and authority of the old value system had collapsed; new visions of the future not only seemed possible but essential. With Neoplasticism, Diller was prepared to forge a new integration of art with society.

Fig. 44.
Construction, 1934
Painted wood and fiberboard, 24 × 24 × 1¾ (61 × 61 × 4.5)
Hirshhorn Museum and Sculpture Garden, Smithsonian Institution, Washington, D.C.; Gift of Joseph H. Hirshhorn

Fig. 45.
Construction, 1934
Painted wood and masonite, 24 × 24 × 1 (61 × 61 × 2.5)
Hirshhorn Museum and Sculpture Garden, Smithsonian Institution, Washington, D.C.; Gift of Joseph H. Hirshhorn

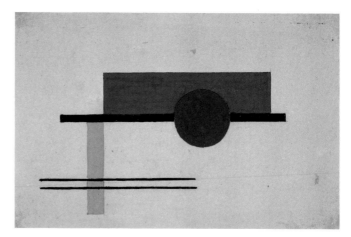

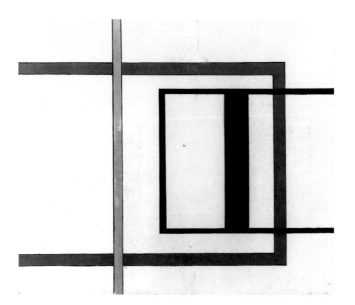

In 1934, inspired by examples of De Stijl work that he saw reproduced in contemporary art journals and by the Mondrian canvases that Gallatin installed at the Museum of Living Art early in 1934, Diller began to emulate De Stijl's elemental geometric forms of pure primary colors (along with white, black, and gray) in austere linear relationships. At first his paintings amalgamated both Constructivist and Neoplastic tendencies (Figs. 46–48). He eliminated all color save the three primaries and incorporated a linear armature, but generally continued to include circular forms.

Diller's decision to limit himself to primary colors owed to his belief that they possessed the greatest degree of clarity. But he maintained that all colors—even primaries—were relative, not absolute: "A primary color is a snare and a delusion. There isn't any such thing. No one primary is absolute; they are conceived only in relation to one another."[65] Diller's conception of the relativity of color derived from Hofmann, who had taught his students that pure color was a fiction, and that color defined itself only in relation to other colors. He had instilled in them the precept that light and dark modeling must be avoided in favor of color contrast. Diller in particular heeded Hofmann's admonitions that color, for greatest effectiveness, should be juxtaposed with white or black.[66] Such juxtapositions, Hofmann had argued, strengthened the freshness of the color sensations by providing rest areas or divisions between colors that allowed individual colors to speak more distinctly. Although by 1934, Diller had abandoned some of Hofmann's lessons—such as his claim that the basis of color is violet, green, and red rather than red, yellow, and blue—he had incorporated a significant amount of what he had learned from his German-born teacher.

With these works, Diller embarked on what would be a lifetime pursuit: perfecting the skin, or surface, of his paintings. He spent endless hours researching various recipes for egg tempera, the medium to which he now turned.[67] Intent on attaining certain color values, he bought pigments from different companies and mixed his own colors.

Diller soon began to rely exclusively on the right angle as the basic principle of composition, which brought his works into closer conformity with the strictures of Neoplasticism. Yet these efforts should not be seen as deriving exclusively from Mondrian's format, but as legitimate contributions to the diversity within the Neoplastic idiom. Indeed, Diller's early explorations of Neoplasticism are as much allied with the work of Theo Van Doesburg, who had been the conduit through which Diller had first been attracted to De Stijl; only later had Diller concluded that "Mondrian was much more of a painter."[68] The tendency to ignore Van Doesburg and other De Stijl artists in discussions of Diller owes to Mondrian's greater critical acclaim in America. Mondrian's arrival in this country in 1940 undoubtedly helped enshrine his position here, but even earlier his work occupied an important place in the collections of the Société Anonyme and the Museum of Living Art. To the American art

Clockwise:

Fig. 49.
Theo Van Doesburg
Composition Simultanée, 1929
Oil on canvas
31³/₈ × 27½ (79.7 × 69.9)
Yale University Art Gallery,
New Haven; Gift of Katherine
S. Dreier for the Collection
Société Anonyme

Fig. 50.
Piet Mondrian
*Composition with Blue
and Yellow*, 1932
Oil on canvas
16¼ × 13 (41.3 × 33)
Philadelphia Museum of Art;
A.E. Gallatin Collection

Fig. 51.
Georges Vantongerloo
*Composition II, Indigo Violet
Derived from Equilateral
Triangle*, 1921
Oil on canvas mounted on
cardboard
13 × 14¾ (33 × 37.5)
The Museum of Modern Art,
New York; The Riklis Collection
of McCrory Corporation
(fractional gift)

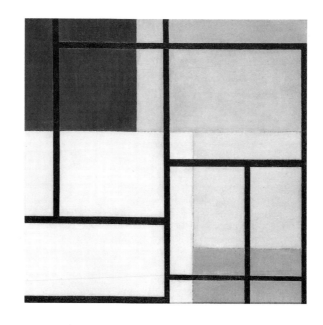

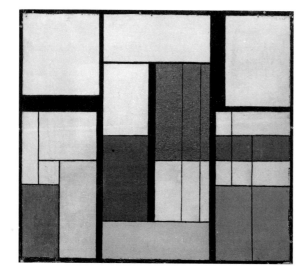

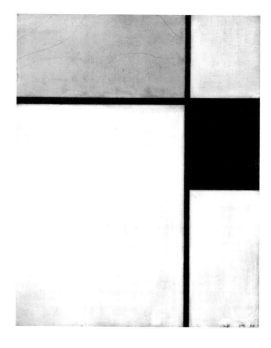

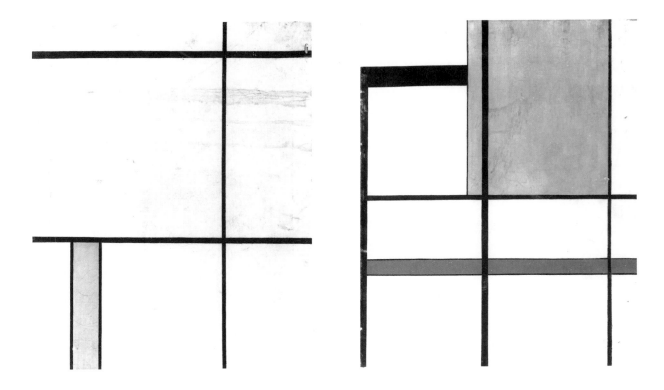

Fig. 52.
Early Geometric, c. 1934
Tempera on canvas
24 × 20 (61 × 50.8)
Meredith Long & Company,
Houston

Fig. 53.
Early Geometric, c. 1934
Tempera on canvas
24 × 20 (61 × 50.8)
Meredith Long & Company,
Houston

community, Mondrian *was* De Stijl. Even today, the relative obscurity of other De Stijl artists makes Mondrian's influence appear exclusive.

At first, Diller experimented with an asymmetric grid format (Figs. 52, 53), where the spatial dynamics between planes of color and black lines did closely ally with Mondrian's work (Fig. 50). In contrast to the intersecting network of colored lines in Diller's other work of the period, the organization here is planar. Lines primarily define the boundaries between zones of color and non-color. Stretching from one edge of the canvas to the other, they never suggest autonomous configurations and rarely vary in width or overlap. Even though these Diller paintings adhere more narrowly than others to Mondrian's stylistic doctrines, their residual overlapping can be seen as related to De Stijl artists such as Georges Vantongerloo and Van Doesburg, who likewise modified the Dutch master's vocabulary for their own expressive purposes (Figs. 49, 51).

Diller soon adopted a system of horizontal and vertical lines that defiantly intersected and crossed each other as they traversed the picture plane (Figs. 54, 56, 57). This use of crossed lines to evoke a simultaneous sense of flatness and spatial recession contrasted with the absence of overlapping in Mondrian's work and his insistence on strict two-dimensionality. Indeed, Diller's employment of these devices linked his efforts to those of Jean Hélion, whose residency in America and role as an adviser to Gallatin made him an influential presence in the early thirties (Fig. 55).[69] Like Hélion's work, Diller's rectangular

Clockwise, starting upper left:

Fig. 54.
Untitled, 1933
Linocut
6 × 4 (15.2 × 10.2)
Meredith Long & Company,
Houston

Fig. 55.
Jean Hélion
Composition, 1932
Oil on canvas
25½ × 19½ (64.8 × 49.5)
Philadelphia Museum of Art;
A.E. Gallatin Collection

Fig. 56.
Early Geometric, 1937–38
Tempera on masonite
21 × 24 (53.3 × 61)
Meredith Long & Company,
Houston

Fig. 57.
Second Theme, 1938
Oil on canvas
34 × 34 (86.4 × 86.4)
Collection of Fayez Sarofim

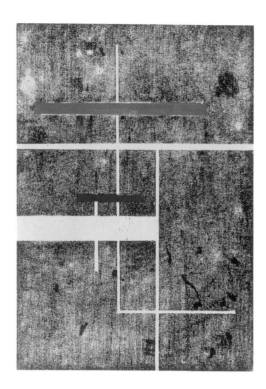

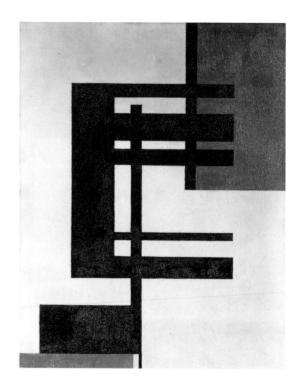

Fig. 58.
Second Theme, 1938
Pencil and crayon on paper, 12½ × 12¾ (31.8 × 32.4)
Whitney Museum of American Art, New York; Purchase, with funds from The List Purchase Fund 79.5

Fig. 59.
Second Theme, 1937-38
Oil on canvas, 30⅛ × 30 (76.5 × 76.2)
The Metropolitan Museum of Art, New York; George A. Hearn Fund

Fig. 60.
Second Theme, 1938-39
Oil on canvas, 24 × 24 (61 × 61)
Collection of Anne and William J. Hokin

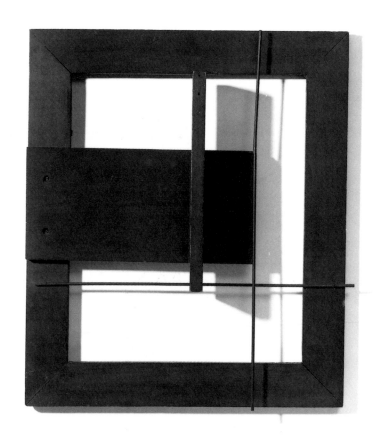

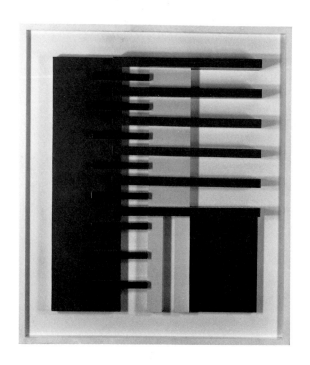

forms against white fields functioned as discrete subjects whose autonomy or "particularity" was reinforced by the widths and colors of their constituent lines. Their truncated configurations suggest partial figures whose remaining sections are to be found beyond the painting's perimeter—a practice that denies the sense of the artwork as a self-contained entity. Color, entirely contained within these linear armatures, radiates a freshness against the white background. Although some of the lines run top to bottom, they generally enter into a dialogue more with each other than with the framing edge. This is particularly true when they do not completely traverse the picture plane or end at an intersection but instead make a 90-degree turn. Diller's involvement with this overlapping linear scaffolding would gain even greater momentum in the 1940s; yet even by 1937, his use of wide bands of color, consuming most of the picture surface, gave his works an explosive and powerful presence (Figs. 58–60).

As a three-dimensional corollary to the overlapping and intersecting in these paintings, Diller, in 1938, turned with enthusiasm to relief (Figs. 61, 63–65). Some of these followed his earlier reliefs in combining flat grounds (on which forms were painted) with projecting elements in low relief. Most, however, employed an open-frame construction whose nonexistent background plane lent a greater ambiguity to the spatial interplay between elements. Unlike his concurrent paintings, these reliefs combined the linear with the planar. The physical reality of the three-dimensional elements gave them a greater presence as well as complexity. Overlapping elements no longer simply demarcated the boundaries of planes; they became planes themselves. Moreover, the relationship between painted forms and three-dimensional ones created complex spatial ambiguities, intensified by the shadows cast by the overlapping forms.

Diller's reliefs were part of a general move in the 1920s and 1930s to break out of the two-dimensional picture surface and shatter the tradition of three-dimensional illusionism. The Cubists had done it first. Picasso, in *Guitar* (1911–12), explored the dynamic relationship between solid and void by describing the interior volume of a guitar with curved sheets of metal attached to the pictorial ground. Influenced by this and similar Cubist experiments, the Constructivists created non-objective reliefs using a full range of materials, such as glass, metal, and plastic, which produced greater spatial complexities and linked more directly with the technology of the machine age. By the early 1920s, non-objective constructions were being produced across Europe. A decade later, Americans too began to respond. Vaclav Vytlacil and Paul Kelpe, who had become acquainted in Germany with the works of Kurt Schwitters and Friedrich Vordemberge-Gildewart, produced painted constructions that included an assortment of found objects. Other Americans allied the Biomorphism of Miró and Arp with Constructivist materialism. Calder's wall reliefs and kinetic

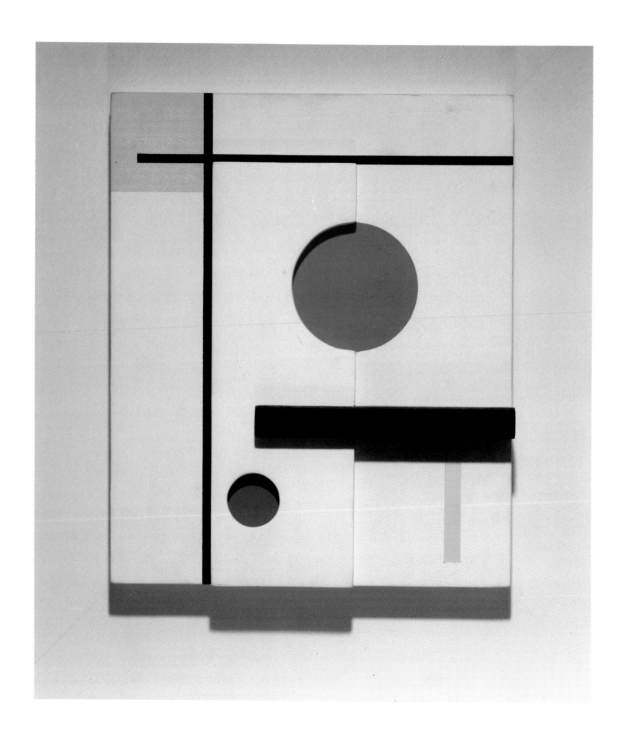

Fig. 63.
Construction, 1938
Painted wood, 11½ × 9½ × 2 (29.2 × 24 × 5.1)
Private collection

Fig. 64.
Construction, 1938
Painted wood, 14¾ × 12½ × 2½ (37.5 × 31.8 × 6.4)
Harriet Griffin Fine Arts, New York

Fig. 65.
Construction #16, 1938
Painted wood, 31⅞ × 27¾ × 5⅛ (81 × 70.5 × 13)
The Newark Museum, New Jersey; Purchase 1959 The Celeste and Armand Bartos Foundation Fund

Fig. 66.
First Theme, 1938
Oil on canvas, 30⅟₁₆ × 30⅟₁₆ (76.4 × 76.4)
Whitney Museum of American Art, New York; Purchase, with funds from Emily Fisher Landau 85.44

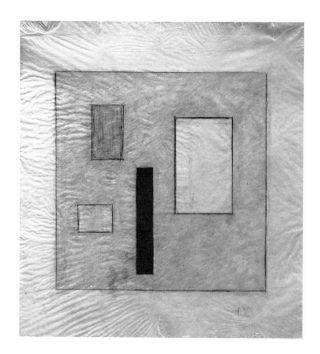

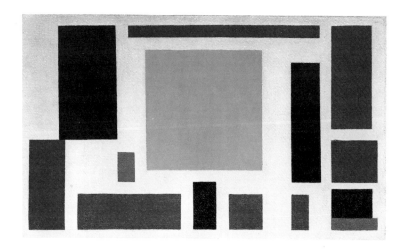

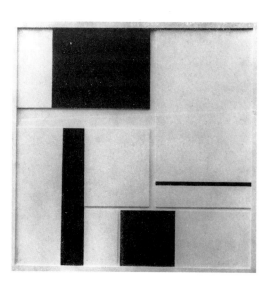

Opposite page
Clockwise, starting upper left:

Fig. 67.
Construction, 1938
Painted wood
11½ × 9¾ × ¾
(29.2 × 24 × 1.9)
Collection of Fayez Sarofim

Fig. 68.
Untitled, 1938
Pencil and crayon on paper
12½ × 12 (31.8 × 30.5)
Hirshhorn Museum and Sculpture
Garden, Smithsonian Institution,
Washington, D.C.; The Joseph
H. Hirshhorn Bequest

Fig. 69.
Jean Gorin
Composition, 1931
As reproduced in *Cahiers d'Art,*
vol. 7, no. 1–2, 1932, p. 79

Fig. 70.
Theo Van Doesburg
Composition (The Cow), c. 1917
Oil on canvas
14¾ × 25 (37.5 × 63.5)
The Museum of Modern Art,
New York; Purchase

constructions of the early 1930s paved the way for Gertrude Greene, Theodore Roszak, Ibram Lassaw, and Charles Shaw to mix Biomorphism with geometric abstraction. Among Americans, only Diller and Charles Biederman (Fig. 62) wedded the language of De Stijl to the relief format. Although Diller may have seen Biederman's reliefs in the "Concretionists" show that Gallatin organized at the Reinhardt Gallery in March 1936, Diller's experiments are far more reductive and lyrical.[70] Diller's choice of a planar organization may have derived from the constructions of Cesar Domela and Jean Gorin, which he could have seen at the Museum of Living Art or reproduced in *Cahiers d'Art.*

Contemporaneous with Diller's reliefs and linear paintings of 1938 was a third compositional format: free-floating, unbounded rectangles in primary colors deployed on unmodulated black fields (Fig. 66). On the basis of one label, affixed in 1961, this series has been dated 1933–34.[71] Yet the compositional sophistication of this series could only have followed Diller's mature experiments in Neoplasticism. This is borne out by the 1938 inscriptions on other works in the same mode, most notably a relief and a study drawing for a painting (Figs. 67, 68). Certain precedents for the use of unbounded rectangles of color can be found in the work of Van Doesburg and Jean Gorin (Figs. 69, 70), although even these artists generally followed Mondrian's injunction against color planes not attached to lines because they might be read as independent entities. Diller's dramatic reduction in the number of compositional elements and his stark deployment of them on black backgrounds mark his work as distinctly original.

Diller meticulously adjusted the size of the rectangles and the values of their constituent colors so as to avoid forfeiting the two-dimensionality of the picture plane: for example, he balanced an assertive color such as red with larger areas of a weaker color such as yellow. Thus, although his rectangles separate themselves from the ground as autonomous entities, they read neither as openings in the canvas nor as objects floating in an undefined space. Diller therefore created a dynamism among forms that generated surface tension and ensured pictorial interest and vitality. These paintings more than lived up to Hofmann's desire that movement and counter-movement of positive and negative spaces in a painting create a simultaneity of flatness and spatial recession and progression.

WPA/FAP

During the period between 1934 and 1938, when Diller was breaking aesthetic ground in his studio, he also embarked on a path of public service under the auspices of the Works Progress Administration's Federal Art Project. The WPA/FAP came into existence in August 1935 in order to give work to the unemployed.[72] Diller was hired immediately and given administrative responsibility in the mural division. His task was to find jobs quickly for a large number of artists. As he later wrote, "there had been a sum of money granted . . . [but] there were no jobs . . . it was a madhouse. You can imagine just overnight being set down in the middle of a big business without the business."[73] For Diller's mural division, the task was especially complicated. The mural division could potentially absorb more artists than the easel division because a single project might involve an established artist and several assistants. However, unlike the procedure in the easel division, murals had to be requested from tax-supported, public institutions. "When I was called in there it was an extraordinary situation because the thing had been just started in the past month or so; our job was to put people to work. But we had a double-fold responsibility. You can't put people to work at nothing."[74] Therefore, the most immediate problem was to find sponsors—a task to which Diller was assigned. Audrey McMahon's perception of Diller as "talented and indefatigable" soon led to his promotion to project supervisor.[75] In this capacity, Diller had to find space; convince the institution to support the project and underwrite all non-labor costs; develop a plan suitable for the space; enlist appropriate artists; determine and research a suitable subject; prepare preliminary sketches for approval by the WPA/FAP committee, the sponsor, and the Municipal Art Commission; assemble assistants and arrange working facilities; and gain the successive authorizations that were required before the mural's approval was final.[76] Until 1937, Diller divided responsibilities on the mural division with Lou Block. When Block left to head the Index of American Design, Diller became sole administrator in charge of public schools, colleges, libraries, public and municipal buildings, and hospitals.

Diller's decision to accept a supervisory position on the FAP was not undertaken lightly. Becoming a supervisor meant relinquishing time he would otherwise have spent in his studio; an eighteen-hour day on the Project was the rule not the exception. "[It] was not a full time job," Diller said; "it was two full-time jobs. You'd be at a committee meeting and things that could last till the middle of the night and you'd be expected to be some place at eight o'clock the next morning for another round."[77]

For Diller, the WPA/FAP was a heroic experiment. Here was an opportunity to transfer the utopian idealism of his Neoplastic principles to a democratic arena. He felt eu-

phoric not only about putting artists to work—and thereby granting them a modest income—but, more important, about assuring them a more useful and integrated relationship to society. "It was exciting," Diller later remarked, "we worked day and night and weekends and believe me, we were not paid well for it, but we thought it was the most wonderful thing that could be happening. We were enthusiastic and we were ready and willing to do anything."[78] The widespread government support turned the artist's position from one of social isolation to that of a full, contributing member of society. As Forbes Watson wrote, "[the artist] was almost forced to take root again in his own country. . . . Brought back by circumstances from a life which involved neither social nor political responsibilities . . . given opportunity . . . to ask himself quite seriously what on earth the whole thing was about . . . the better sort woke up."[79]

Diller's willingness to temporarily set aside self-interest stemmed from a belief that art was more than picture making: "you can't disassociate your art as something separate from life and living, and responsibility," he noted. "After all, what is art? Something that exists in you, a sense of awareness or something. . . ."[80] In the midst of the Depression, the argument against self-interest was persuasive. As Philip Evergood wrote about his and Diller's work on the Project, "We both did our best under the trying conditions of conversion from creative work to office regime. I think the reason we made this sacrifice is obvious to you. These were times of stress and we both felt that at the moment it was the most useful tool we could make of ourselves."[81]

Diller's self-determined mission was to secure a legitimacy for abstract art at a time when it was viewed with suspicion if not disfavor. Underlying Holger Cahill's directorship of the WPA/FAP was John Dewey's philosophy of art as a mode of interaction between man and his environment. Cahill envisioned the WPA/FAP, especially the mural division, as supporting the unity of art with common experience: "Mural painting is not a studio art; by its very nature it is social. In its great periods it has always been associated with the expression of social meanings, the experience, history, ideas, and beliefs of a community."[82] Within such a context, abstract art could easily be seen as isolated from society. Moreover, with the federal government as patron, there was a decided pressure within the program to give the public artwork with which it could understand and sympathize.[83]

Given such injunctions, Diller realized that abstract artists would have very little chance of being accepted into the mural division unless they served as assistants. But he was determined to change this by getting them jobs as practitioners of abstract art—"an impossible sort of task, but one you thought you had to do something about."[84] Diller's decision in this regard was courageous. By rejecting the arguments put forth by fellow supervisors and administrators that the WPA/FAP was more of a public service organization

than a creative one, he risked his own position on the Project. Yet however much his injections of abstract art may have been decried, they were tolerated. As he later remarked, "I survived."[85]

Diller's success at integrating abstract art into the mural division contributed significantly to the growth of non-representational styles in this country. Indeed, he became the central patron of abstract art during these years.[86] George McNeil later remarked that "[Burgoyne Diller's direction of the WPA/FAP mural project] exemplified the influence, following Carlyle's theory, of an individual on history. If, instead of the five years' day-by-day development especially needed by artists in their twenties, Bolotowsky, Browne, Davis, de Kooning, Greene, Gorky, Lassaw, McNeil, and Shanker had had to teach or otherwise divert their talent, it is probable that the sudden upsurge of abstract art after World War II would have occurred much later."[87] A similar sentiment was expressed by Ilya Bolotowsky: "I don't think people realize that at that time Diller was instrumental in something historical. . . . He played a most important role in the development of abstract art in this country as mural project administrator. . . . He was totally dedicated to promoting abstract style in murals before abstract art was accepted in the U.S. He deserves absolute full credit for his work in all the future art history books."[88]

In seeking commissions for non-representational work, Diller sometimes resorted to verbal semantics: "they didn't have to be called art—abstract or anything. So the name was a dangerous thing. I found in other places that we introduced abstract work just simply by calling it . . . 'the decoration'—if you avoided the word 'art' they were happy."[89] For the housing project at Williamsburg, Diller justified the use of abstraction by claiming that it offered a more relaxing environment for tenants who were surrounded, in their workplaces, by images of technology.[90] Likewise, in a project for radio station WNYC, Diller's voice can be heard behind the public statement that was made to justify the appropriateness of abstract murals: such murals best contributed, it was claimed, to the atmosphere of quiet and concentration required during a broadcast.[91]

A few mural sites were allocated to individual abstract artists. Among the most prominent were Gorky's ten-part *Aviation* series at Newark Airport (Figs. 72–74); Lucienne Bloch's *Evolution of Music* at George Washington High School, New York; Bolotowsky's mosaic at Theodore Roosevelt High School; Byron Browne's semi-abstract mosaic for the United States Passport Agency in Rockefeller Center; and Jean Xceron's design for the Jewish chapel at Riker's Island Penitentiary (Fig. 75). Most abstract murals, however, were clustered at a few sites: the Williamsburg Housing Project in Brooklyn; radio station WNYC in the Municipal Office Building in Lower Manhattan; the Chronic Disease Hospital and Central Nurses' Home on Welfare Island (now Roosevelt Island); and the Public Health Building and the WPA Community Building at the 1939 New York World's Fair (Figs. 76–91).[92]

Fig. 71.
Maquettes for two benches
designed by Diller
for the New York World's
Fair, 1939
Diller Estate, Orlando, Florida

Diller was not always successful. Even after a non-representational approach had been conceptually approved by a sponsor, the artist's design needed to pass through several levels of review. Among the projects rejected at this stage were Gorky's proposal for Brooklyn's Floyd Bennett Airport (in which he incorporated photographs of airplanes and airports taken by Stuart Davis' brother Wyatt); Fernand Léger's design for the French Line cruise ships (acceptable under WPA/FAP regulations because it would generate work for American assistants); and the abstract designs by Gorky, Balcomb Greene, Peter Busa, and John von Wicht for chapels at Riker's Island Penitentiary.[93]

Although, retrospectively, Diller's support of abstraction within the context of the WPA has superseded other considerations, abstractions represented a small fraction of the more than two hundred murals produced under his guidance. His benevolent encouragement of the individuals under his care and his skill at mediating between conflicting interest groups made him a magnet for artists of all persuasions as well as a respected administrator within the WPA/FAP hierarchy.[94] Beneficiaries of his bureaucratic acumen ranged from the well-known realist Edward Laning, for whom Diller procured a mural commission at the main branch of the New York Public Library,[95] to younger artists such as Philip Guston and Jackson Pollock, both of whom credited Diller with intervening at critical moments on their behalf.[96]

Eventually Diller's administrative skill led to his participation in other programs affiliated with the WPA: he designed and installed the first Federal Art Gallery, served as consultant to the museum extension and children's book program, taught at the Design Laboratory, and was WPA liaison to the 1939 World's Fair, a job that included the installation of the WPA exhibition in the Contemporary Arts Pavilion and the design of benches for the galleries (Fig. 71).

Yet it was Diller's involvement with murals, whether realistic or abstract, that provided a forum for his idea that art was a medium of democratic values which could bridge social and economic class distinctions and encourage solidarity among people. By their very nature (large scale and on permanent public display), murals offered the most direct bridge between the artist and the public. They belonged, in Philip Evergood's words, "to a people's audience."[97] The realization that murals could forge a bond between society and the arts lent a missionary zeal to the mural projects. Comparing the WPA/FAP murals at the World's Fair with those produced by commercial muralists, Anton Refregier noted: "They are making at least ten times more money than we are. But they can have it. Theirs will be the usual commercial crap. They are not moved as we are by our content—by our search for creative and contemporary design—by our concern for people. WE are the mural painters. We hope we are catching up with our great fellow artists of Mexico. We will show what mural painting can be!"[98]

Newark Airport

Clockwise, starting upper left:

Fig. 72.
Arshile Gorky
Mechanics of Flying, 1936-37
Oil on canvas
108 × 134 (274.3 × 340.4)
The Newark International Airport
Collection, The Port Authority of
New York and New Jersey; on
extended loan to The Newark
Museum, New Jersey

Fig. 73.
Arshile Gorky
Aerial Map, 1936-37
Oil on canvas
77 × 120 (195.6 × 304.8)
The Newark International Airport
Collection, The Port Authority of
New York and New Jersey; on
extended loan to The Newark
Museum, New Jersey

Fig. 74.
Arshile Gorky
*Aviation: Activities on the
Field*, 1936
Oil on canvas
Overpainted

Arshile Gorky's *Aviation: Evolution of Forms under Aerodynamic Limitations* was a ten-panel, 1500-square-foot mural painted for the foyer of the administration building of Newark Airport, New Jersey. The series of semi-abstract images was installed by July 1937. During World War II, the airport was under military control, and most of the panels were painted over. Two have been recovered and are on loan to The Newark Museum.

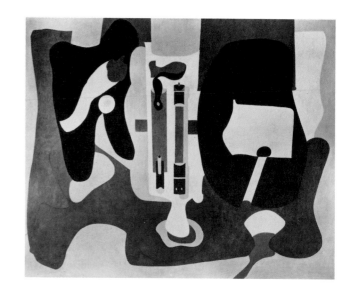

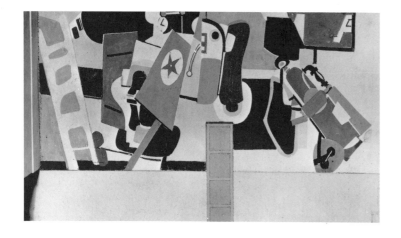

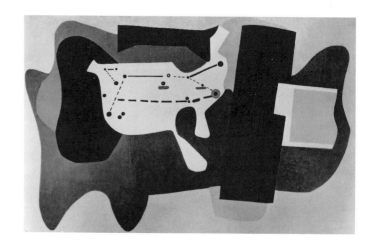

Riker's Island Penitentiary

Riker's Island Penitentiary commissioned abstract murals by Balcomb Greene and Jean Xceron and a stained-glass window by Arshile Gorky. Greene's mural, intended for the left panel of the Jewish chapel, was rejected by the rabbi because it included a symbol that resembled a swastika. Xceron ultimately executed both panels. Gorky's stained-glass window was given preliminary approval by the New York City Art Commission, but was later rejected because of its non-representational content.

Fig. 75.
Jean Xceron
Abstraction in Relation to
***Surrounding Architecture**, 1942*
Oil on canvas
Jewish Chapel, Rikers' Island
Penitentiary
Whereabouts unknown

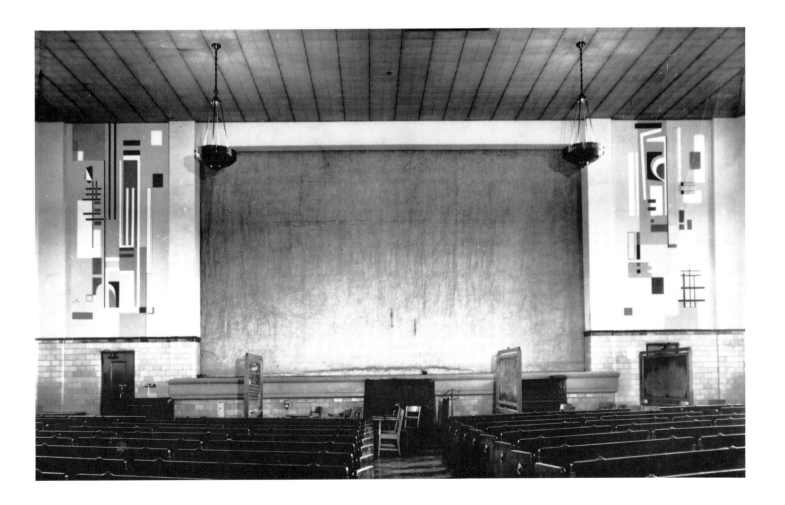

Williamsburg Housing Project

The Williamsburg Housing Project, Brooklyn, New York, was begun by the Public Works Administration and completed by the New York City Housing Authority in 1937. Designed by William Lescaze, it consisted of twenty buildings for low-income housing, with communal social rooms in some of the buildings. Diller commissioned twelve artists to execute murals for these rooms: Ilya Bolotowsky, Harry Bowden, Byron Browne, Francis Criss, Stuart Davis, William de Kooning, Balcomb Greene, Paul Kelpe, Jan Matulka, George McNeil, Eugene Morley, and Albert Swinden. Those by Bolotowsky, Greene, Kelpe, and Swinden have recently been restored and are on extended loan from the New York City Housing Authority to The Brooklyn Museum; Criss' semi-abstract *Sixth Avenue El* was never installed and is now in the National Museum of American Art, Smithsonian Institution, Washington, D.C.; Davis' *Swing Landscape* is in the Indiana University Art Museum, Bloomington. William de Kooning completed only preliminary sketches of a proposed mural before being taken off the project because he was not a US citizen. George McNeil joined the war effort before completing his mural. Uncertainty surrounds the remaining murals: some may never have been executed; others may be lost or destroyed.

Fig. 76.
Paul Kelpe
Abstraction, 1938
Oil on canvas: left panel,
98 × 89½ (248.9 × 227.3);
right panel, 91½ × 139¼
(232.4 × 353.7)
New York City Housing
Authority; on loan to The
Brooklyn Museum

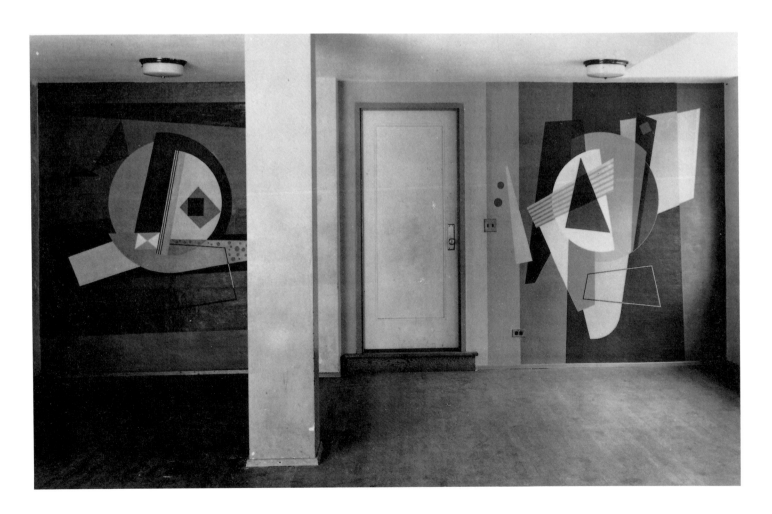

Fig. 77.
Byron Browne
Abstraction, 1936
Oil on canvas
114 × 180 (289.6 × 457.2)
Whereabouts unknown

Fig. 78.
Ilya Bolotowsky
Abstraction, 1937
Oil on canvas
84 × 210 (213.4 × 533.4)
New York City Housing
Authority; on loan to The
Brooklyn Museum

Fig. 79.
George McNeil
*Study for Williamsburg Housing
Project*, 1937
Whereabouts unknown

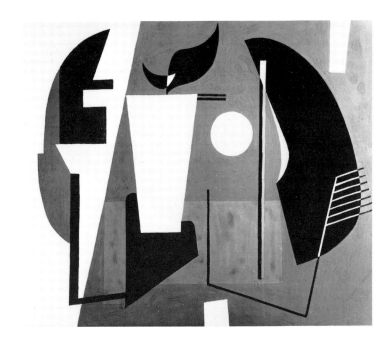

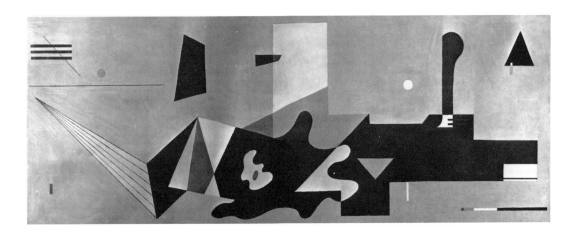

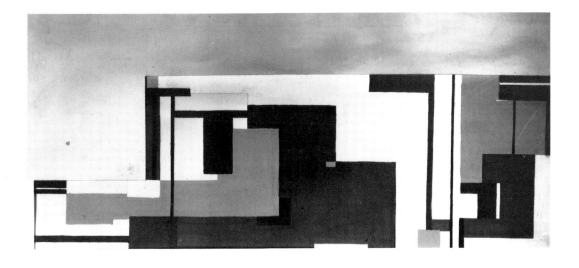

69

Fig. 80.
Stuart Davis
Swing Landscape, 1938
Oil on canvas
84 × 168 (213.4 × 426.7)
Indiana University Art Museum,
Bloomington

Fig. 81.
Albert Swinden
Abstraction, c. 1937
Oil on canvas
111½ × 168 (283.2 × 426.7)
irregular
New York City Housing
Authority; on loan to The
Brooklyn Museum

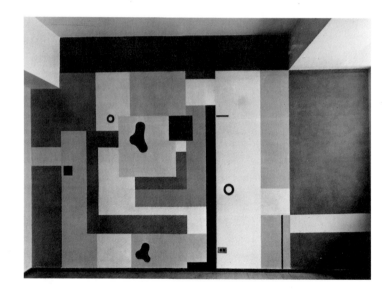

Radio Station WNYC

Radio station WNYC, on the twenty-fifth floor of the Municipal Office Building in lower Manhattan, was the site for abstract murals by Byron Browne, Stuart Davis, Louis Schanker (semi-abstract), and John von Wicht. The artists coordinated the architecture, interior decoration, furnishings, and murals in one modern, functional entity. Davis' panel, done for Studio Band and recently restored, is on loan to The Metropolitan Museum of Art, New York. The Browne and von Wicht murals have been restored and relocated within the building to the twelfth and seventeenth floors, respectively; the Schanker mural remains *in situ*. Of the additional murals commissioned, that by Louis Ferstadt was completed but never installed; those by Paul Kelpe and Lee Krasner never went beyond the study stage.

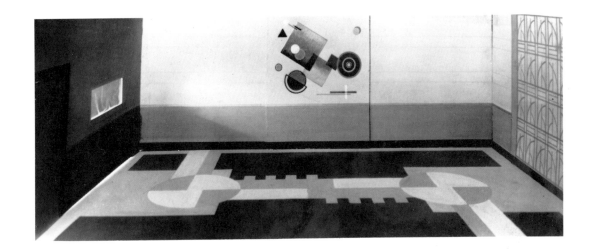

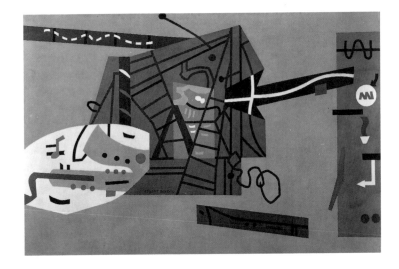

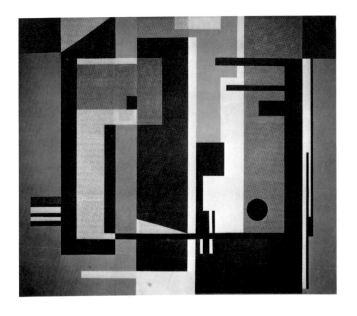

Chronic Disease Hospital, Welfare Island

The Chronic Disease Hospital, Welfare Island, commissioned abstract murals from Ilya Bolotowsky and Albert Swinden, semi-abstract murals from Joseph Rugolo and Dane Chanase, and a photomural from Byron Browne. The murals, painted on the concave walls of the communal rooms, received final approval from the New York City Art Commission in 1942, making them among the last murals completed by the WPA Art Program.

Fig. 85.
Ilya Bolotowsky
Abstraction, for dayroom 11, 1941
Oil on canvas
Whereabouts unknown

Fig. 86.
Dane Chanase
Modern Music, for ward
41-A, 1942
Oil on canvas
Whereabouts unknown

Fig. 87.
Joseph Rugolo
Abstraction, 1942
Oil on canvas
Whereabouts unknown

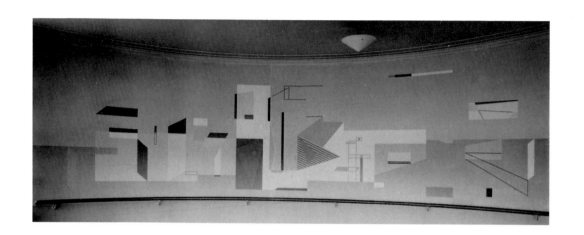

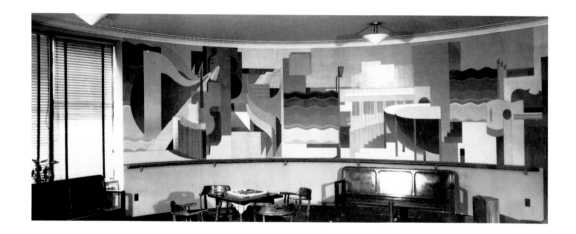

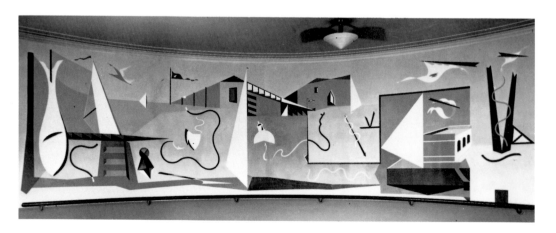

Central Nurses' Home, Welfare Island

Hananiah Harari and Rosalind Bengelsdorf (Browne) were given preliminary approval to paint abstract murals for the living rooms of the Central Nurses' Home on Welfare Island. Only Bengelsdorf's was executed, in 1938.

Fig. 88.
Hananiah Harari
Study for *Abstraction*, c. 1938
Oil on canvas
Whereabouts unknown

Fig. 89.
Rosalind Bengelsdorf (Browne)
Study for *Abstraction*, c. 1938
Casein and tempera on board
Whereabouts unknown

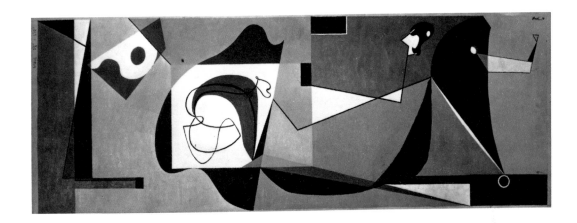

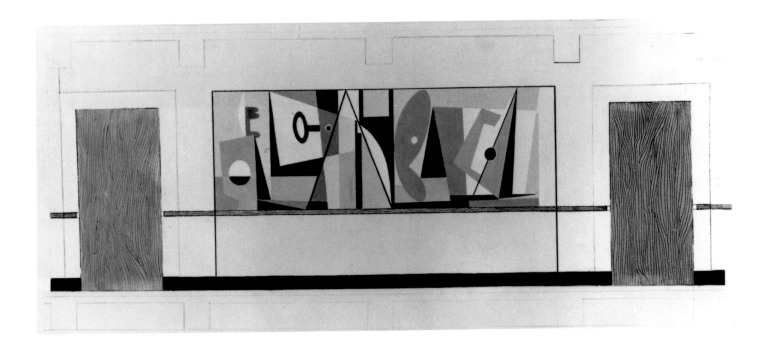

1939–40 World's Fair

For the 1939–40 World's Fair at Flushing Meadow in Queens, 102 murals by thirty-two artists were commissioned. The WPA/FAP commissioned twelve of these for the Public Health Building (designed by Fan Woodner) and the WPA Community Building. Those by Byron Browne, Ilya Bolotowsky, Louis Schanker, Balcomb Greene, and George McNeil (mosaic) were abstract. The murals were apparently destroyed at the close of the fair in 1940.

Fig. 90.
Ilya Bolotowsky
Abstraction, 1939
Oil on canvas
Whereabouts unknown

Fig. 91.
Byron Browne
Study for *Abstraction*, 1938
Whereabouts unknown

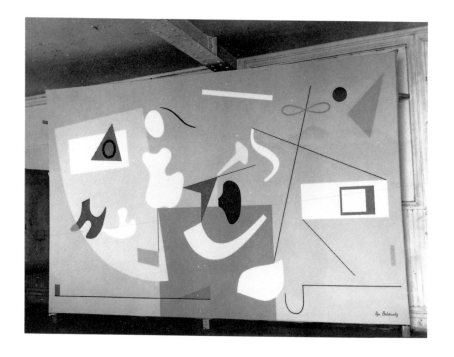

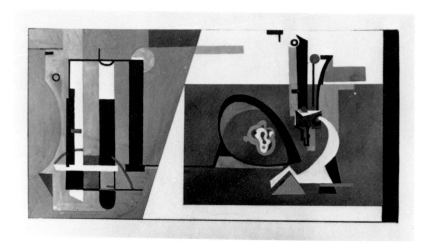

The American Abstract Art Community

Diller's participation in the WPA put him in better stead than most abstractionists of the 1930s to answer the call to enter the "arena of life's problems."[99] "The early 1930s were coldly sobering years," Louis Guglielmi wrote. "The artist, a highly sensitive person, found himself helplessly a part of a devastated world. Faced with the terror of the realities of the day, he could no longer justify the shaky theory of individualism and the role of spectator."[100] The decade's social and economic problems engendered a moral imperative among artists and intellectuals to create an art that was socially responsible. Abstraction, in this context, appeared morally bankrupt and escapist.[101] Artists who practiced it felt compelled to justify their art on the basis of its social utility.

For Diller, abstract art needed no specious justification. Not only was the aesthetic tradition in which he had chosen to work—Neoplasticism—predicated on effecting a more perfect, egalitarian world, but he believed that geometric abstraction was more appropriate than realism to express industrialized America. Growing up around engineers in the industrial towns of Battle Creek and Buffalo, he regarded science and industry—the results of rationality and modernization—as central components of the American landscape, a landscape best represented by the hard edges and smooth surfaces of geometric abstraction.

The notion that geometric abstraction—or any non-representational mode—was a singularly appropriate national expression was not, however, upheld in most circles. During the 1930s, realism was perceived as the authentic American expression. Some critics ascribed the country's attachment to realism as intrinsic to the Anglo-Saxon heritage of literalism.[102] Others, such as the staff of the Whitney Museum, saw realism as a means for the country to retain its native voice, distinct from that of Europe. Ironically, The Museum of Modern Art, which showcased European abstraction, also heralded realism as the paradigmatic American style and implicitly denied the legitimacy of American geometric abstraction. Its exhibition program duplicated that of the Whitney Museum in granting space to even pallid American Scene painters and older generation realists while shutting out the American vanguard community.[103] In 1936, Alfred H. Barr, Jr. cast an even more demoralizing pall on the chances for American geometric artists to be accepted at the museum by predicting that the geometric tradition of abstract art was on the decline and would soon be superseded by that of the expressionists.[104]

Given the marginalization of American abstract artists, it is natural that they felt the need to band together for protection and mutual encouragement. This they did through the formation of the American Abstract Artists. Diller's WPA mural division was the meeting ground for the nucleus of the group; as Rosalind Bengelsdorf Browne remarked, "the

networks meshed and all roads led to the formation of the American Abstract Artists and to Diller."[105]

The impetus for artists to join together to advance mutual needs was not new. Indeed, it was artists who had earlier established the Art Students League and the National Academy of Design and organized the ground-breaking Independents Show of 1910 and the Armory Show of 1913. By the 1930s, the sense that collective action was the most effective means for artists to solve problems had been fueled by the country's political unions. Alliances of artists abounded: the American Artists' Congress, the Artists' Union, and the National Society of Mural Painters. Even the Washington Square Outdoor Show had been initiated by artists.

Within the community of abstract artists, interconnecting alliances had begun to form in the mid-thirties. These had ranged from more formal efforts such as Diller's Group A in 1934 and The Ten in 1938 to the looser alliance of thirteen artists—Rosalind Bengelsdorf Browne, Harry Bowden, Byron Browne, Mercedes Carles, Giorgio Cavallon, Ivan Donovetsky, Balcomb Greene, Ray Kaiser, Marie Kennedy, Leo Lances, George McNeil, Albert Swinden, and Albert Wein—that had come together for the purpose of exhibiting at the Municipal Art Galleries in 1936.[106]

The possibility of a group exhibition had likewise precipitated discussions in the fall of 1935 between Rosalind Bengelsdorf Browne, Byron Browne, Albert Swinden, and Ibram Lassaw. But these discussions eventually led to a more permanent organization: the American Abstract Artists. Diller attended this group's second meeting, held in January 1936 in Lassaw's studio, along with four other artists—Balcomb and Gertrude Greene, George McNeil, and Harry Holtzman.[107] After another meeting and the refusal of John Baur to sponsor an exhibition of their work at The Brooklyn Museum, Holtzman took a more decisive step: in November 1936, he rented a studio, collected work from all the abstract artists he knew, and called a general meeting. Conflicting goals and volatility among strong personalities characterized this and a subsequent encounter at his studio.[108] Though Diller could not attend either meeting, he encouraged Holtzman, with whom he talked a good deal about the younger artist's planned organization of artists. He credited Holtzman's gatherings with "getting that thing together."[109] Indeed, out of the sessions arranged by Holtzman came a firm commitment to form an organization that would introduce abstract work to the public. On January 8, 1937, at Albert Swinden's studio, twenty-two artists voted to organize and to begin weekly meetings of what would be called the American Abstract Artists.

Diller's relationship to the AAA was both crucial and distant. To some extent, he occupied a fatherly role because of his patronage of abstract artists through the WPA/FAP. As Rosalind Bengelsdorf Browne stated, "at least half of the AAA membership was employed

by the Project—a very active half. It was impossible to separate their welfare on the Project from the welfare of the AAA."[110] Although Diller had been part of the original nucleus of nine artists that had met at Lassaw's studio, his duties as WPA/FAP supervisor had prevented his attending Holtzman's gatherings or the January 8, 1937, meeting.[111] Therefore, he was not one of the AAA's twenty-two founding members. Nor was he among the artists who were immediately invited to join, presumably on the basis of their earlier interest in the group.[112]

It was not until the March 12 meeting, when a decision was made to temporarily suspend the ruling that called for artists to submit work prior to being considered for membership, that Diller was asked to join. After that, he attended meetings and participated in exhibitions whenever possible. He served, at least nominally, on five committees in the first year, but was unable to prepare a lithograph for the portfolio that accompanied the group's first exhibition at the Squibb Gallery in April 1937. As he explained it, "there was a time when I was trying to get things ready for a show, the project work would be in a rush and I had to drop out."[113] Over the next four years, he participated in only one AAA exhibition, that in 1940. AAA rules were stringent about members paying annual dues and participating in exhibitions; failure to comply resulted in loss of membership. By 1941, the demands of Diller's job, coupled with the expense of AAA membership, led him to drop out of the organization; not until 1947 would he again be involved.[114]

Paradoxically, the aesthetic thrust of the AAA was perfectly suited to Diller. Although the group accommodated a wide variety of abstract styles, a geometric vocabulary came to predominate. This was due to the policies and polemics of the group's leadership as well as to the rigorous selection process to which work was subjected preceding each exhibition—a process that favored hard-edge, geometric work over semi-abstract, painterly, and expressionist submissions.[115] Already by 1939, the division between the expressionist work of those who abstracted from nature and the non-objective forms of those who favored an art of pure relationships had begun to splinter the group.[116] By 1946, a year before Diller reentered the group, the purists had prevailed.[117]

That the battle lines were drawn so fiercely between the factions of abstraction indicated the extent to which these styles embodied ethical positions; what was at stake was the function and meaning of art. This became apparent in the vitriol that surrounded Hilla Rebay, the German-born artist and adviser to Solomon Guggenheim.[118] A fervent supporter of Kandinsky and Rudolf Bauer, Rebay represented the third tributary within modern art, which posited art as a vehicle that could transport the artist and viewer from the world of concrete realities to a spiritual realm. To artists who abstracted their images from life, such attitudes were anathema. Seven such practitioners defended art's connection to visible reality in an open letter to Rebay that was published in the October 1937 issue of *Art Front*.[119]

Characteristically, Diller had little to say against Rebay's aesthetic preferences. What particularly enraged him—as it did other AAA members—was her arrogance and intolerance. Her exclusion of all art that bore any trace of representational imagery, her apparent haughtiness in telling artists what to paint and with whom to associate, and her alleged anti-Semitism inspired Diller and his friend Dan Johnson to "declare war" on her in an exchange of letters in the fall of 1940.[120] The vehemence of Diller's response revealed an aversion to ideological fanaticism. Essentially an American pluralist, he did not believe in exclusionary systems, but in an equal voice for everyone. This is what had guided him as a WPA administrator and would later account for his success as a teacher.

An Embattled WPA and the Early War Years

Congressional budget cuts—and responding agitation by the American Artists Union—had become a regular part of the WPA as early as 1936.[121] But in June of 1939, Diller's difficulty in securing commissions was compounded by a Congressional appropriations bill that struck a major blow at federal support of the arts. Accusations of financial inefficiency within the WPA/FAP, coupled with a newly elected coalition of Republicans and conservative Democrats, created an environment in which the cultural programs of the WPA/FAP came under easy attack. Henceforth, workers were furloughed after eighteen months and all employees were required to take a loyalty oath. Since most blue-collar workers remained with the WPA/FAP only slightly more than a year, the furlough clause was not critical for them; for muralists, whose tenure with the WPA/FAP tended to be longer, it signaled disaster. Even more significant for Diller was the requirement that states assume supervision of the projects and contribute twenty-five percent of the costs. Not only did this mean a subordination of creative production to community service and education, but, for New York City, which had received almost forty-five percent of the WPA/FAP national budget, it made continuing the programs at the earlier levels impossible.

State supervision meant that all WPA/FAP projects in New York City were under the jurisdiction of the local WPA/FAP official, Colonel Brehon Somervell, who felt that art was not legitimate work and that the art divisions were hotbeds of Communism.[122] Somervell's attitude had been given credence by the House Committee on Un-American Activities, headed by Martin Dies, which had marshaled innuendo and unchallenged evidence to create a picture of the WPA/FAP cultural programs as rife with Communists and illicit political activity.[123]

This climate of suspicion affected Diller's employment. In 1941, after Congress passed the Emergency Relief Appropriations Act, which specifically excluded Communists from the WPA/FAP rolls, Somervell issued a mandate against anything that smacked of social com-

ment or propaganda. With a fanaticist's eye, Somervell began seeing Communist symbols everywhere. Three murals, all of which had been installed under Diller's supervision, came under particular attack: August Henkel's mural at Brooklyn's Floyd Bennett Airport, Abraham Lishinsky's mural at Samuel Tilden High School, and Arshile Gorky's *Aviation* cycle at Newark Airport. Most of the allegedly Communist symbols proved bogus. The figure in Henkel's mural, which Somervell claimed resembled Stalin, was based on a photograph of Franz Feichelt, an American parachutist who had been killed in a test jump from the Eiffel Tower; the "Soviet" plane was an American-made Vultee; and the red star on white background was the mistake of an assistant who reversed the colors of the emblem of the US Naval Reserves.[124] Similarly, in Lishinsky's mural, the fist, which supposedly depicted the Communist salute, could be read as such only if the object it was holding were removed, while the red star was shown to be a customary trademark. In the case of the Newark Airport mural, the red star—which turned out to be blue—was based on the emblem of the Texaco Oil Company. Nevertheless, Diller was temporarily suspended for his purported complicity in having approved the murals, Lishinsky and Henkel were dismissed from the Project, and three of Henkel's panels were burned.

Although Diller was cleared of the specific charge of having willfully slipped Communist propaganda into the Project, his position as supervisor made him the target of other accusations. On April 9, 1940, nine months after the mural debacle, he and eight other supervisors were suspended, pending an investigation into their Communist affiliations. The atmosphere of intrigue and slander that had characterized the Dies Committee pervaded the inquiry against Diller. Some of the accusations were maliciously based on guilt by association. Others were more nefarious fabrications.[125] None had any substance and, one month later, Diller was cleared of the charges. But not before the federal government had spent countless hours interviewing fifty-nine present and former WPA/FAP employees.

In 1940, Diller was promoted to assistant technical director of New York City's WPA Art Program with responsibility for all of the visual arts divisions.[126] He assumed the position just as the WPA began to shift its direction toward the defense effort by producing training aids, decorating the interiors of service clubs, and designing posters for the armed forces.[127] With the intensification of hostilities in Europe during the spring and summer of 1941, the tempo of defense activity accelerated. Fine arts gave way entirely to practical arts and the production of training aids. Following America's entry into the war on December 7, 1941, the WPA was subsumed under the WPA War Services Division. Within the year, Roosevelt would call for the transfer of all able-bodied men to training facilities to assist in the war effort.[128] On January 30, 1943, Diller obliged by becoming, at thirty-seven years of age, one of the oldest enlisted men in the US Navy.

Fig. 92.
Morse code blinker designed by
Diller for the Naval Training Aids
Center
Cardboard
2½ × 2½ (6.4 × 6.4)
Diller Estate, Orlando, Florida

Diller's decision to enlist in the Navy revealed a deep-rooted sense of the artist's responsibility toward society. The dilemma facing American artists about how to reconcile their political and aesthetic beliefs had become acute following America's entry into World War II. Suddenly, the position that progressive art was inherently revolutionary and would naturally lead to the radical reconstruction of society no longer seemed adequate. Political action seemed mandatory; to do less was to abdicate one's responsibility as a citizen. Diller demanded more of himself than the defensive justification that discoveries in painting were of positive social value and that abstract art is "a direct progressive social force."[129]

Diller had enlisted in the Navy without any assurance of his ultimate assignment. Only the persistent lobbying efforts of Holger Cahill and Audrey McMahon during his three months of basic training secured him a position at the Navy Training Aids Center in New York.[130] Even so, he entered Navy service as an enlisted man. The decision to refuse him a commission apparently stemmed from the earlier accusations of Communist affiliations. Robert Wolff, who served with Diller in the Training Aids Center, wrote that of the five artists chosen to work at the Center, "[Diller] alone was refused a commission. Not because he was less qualified than the others but for political reasons. Although Diller was not a political person and was in no way connected with the large and active radical movement among the artists of the New York Federal Art Project, his prominent position on the Project . . . left him suspect of radical sympathies and connections which caused the Navy bureaucracy to refuse to bring him into the service as an officer, although by some strange reasoning they found him quite fit for the same service as an enlisted man."[131] Not for three years, on the eve of his release to inactive duty, would the Navy promote him to lieutenant junior grade.

The Training Aids Division of the Bureau of Naval Personnel, located in New York, had been established in October 1942 with essentially the same mission as that of the WPA War Services Division: to produce models, graphics, and three-dimensional devices to be used in training Naval personnel.[132] Several months after Diller arrived, he invented a hand-held blinker for training people in Morse code. It consisted of two small squares of cardboard, one with black and the other with white stripes, which were cut and slotted so that the resulting flat object could be held in the palm of the hand and manipulated from a black-and-white to an all-black surface by pressure of the fingers (Fig. 92). Eventually, over 3.3 million blinkers were produced.[133]

According to Robert Wolff, Diller's tenure with the Center was far from blissful. Having the lowest rank of anyone in the company put Diller in a position of inferiority. Moreover, he reported to what Wolff described as a mean-spirited superior officer who treated him as a flunky out of jealousy for the praise and notoriety Diller had received for his train-

ing device. Yet Diller bore this "daily humiliation" with characteristic dignity, reserve, and self-discipline.[134]

Diller's Art, 1939–1950

Diller's artistic output in the late 1930s and early 1940s had been severely curtailed by his responsibilities on the WPA and, later, in the Training Aids Center. He had, however, managed to "sweat out a few hours of [his] own."[135] In these few hours, he had continued to explore—in reliefs, watercolors, and paintings—his preoccupation with overlapping and intersecting elements (Figs. 93, 94, 97–103). Some of these works recall his earlier conjunction of planes with lines that traverse the entire picture surface. In others, however, what few rectangles he included were penetrated by lines or planes of contrasting color that destroyed the rectangles' integrity. Although these latter pieces retained the overlapping of colored lines on a white or off-white background, they differed from their antecedents in having more open compositions and more lyrical color. Rarely did the linear elements of these works traverse the picture from edge to edge; instead they generally floated or stopped midway across the picture plane. Occasionally, Diller marked the juncture of two lines with a contrasting rectangle of color; at other times, he inserted a colored rectangle along a linear expanse as if to imply intersection with an otherwise invisible line. In this way, he bestowed an overall syncopated rhythm on the surface of his paintings. The influence of Van Doesburg's and Hélion's overlapping lines remained, but was augmented by the example of Diller's good friend during this period, Jean Xceron, who highlighted the intersection of lines with contrasting color bars (Figs. 95, 96).

In a few isolated instances in 1942 and 1943, Diller returned to the theme of unbounded rectangles on a flat field. In contrast to his earlier articulation, he now dramatically increased the scale of his rectangles and floated them on white rather than black fields (Figs. 104–108). He also vertically elongated differently sized rectangles of color and often abutted them against one another or against the perimeter of the canvas thereby creating hybrid configurations.

This involvement with planes proved temporary; in 1943, Diller turned the overlapping linear forms that had engaged him since 1934 into an overall linear network. He announced this new style in a painting whose vertical black lines ran from top to bottom of the canvas and functioned almost as ladders connected by sparsely placed colored horizontal bars of varying widths (Fig. 109). Soon he increased the number of horizontal and vertical lines and began coloring the horizontal interstices (Figs. 110–113). As in earlier works, colored rectangles accentuated the junction of lines, and cubes of contrasting color disintegrated colored planes. But in these post-1942 paintings Diller replaced free-floating linear elements

Fig. 93.
Second Theme, c. 1939
Pencil and colored pencil on
tracing paper
6½ × 6¾ (16.5 × 17.2)
Private collection; courtesy
Harcourts Modern and
Contemporary Art, San Francisco

Fig. 94.
Untitled, c. 1942
Tempera, pencil, and
crayon on paper
11 × 10 (27.9 × 25.4)
The Skye Wood Collection

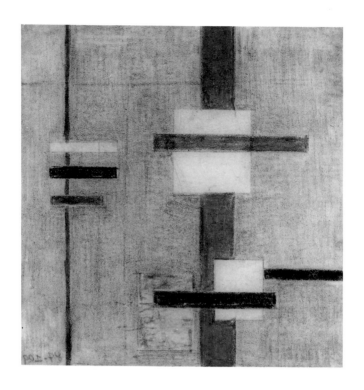

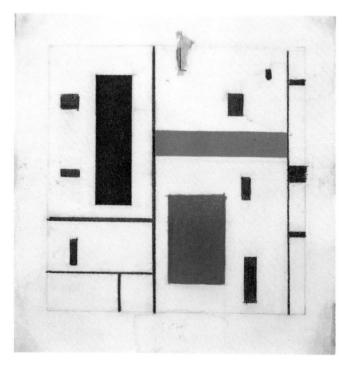

82

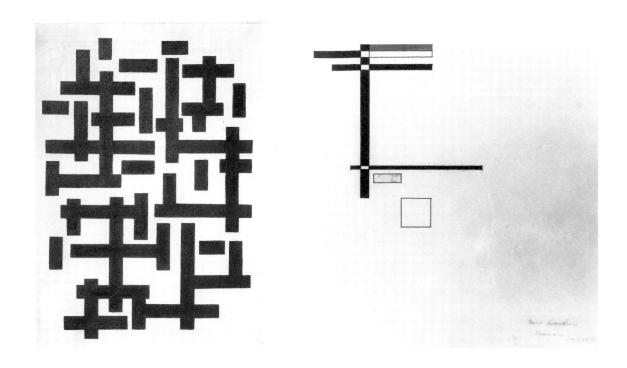

with an overall organization of vertical and horizontal lines, often composed of blocks of color, but all firmly echoing the shape of the canvas and connected to its edges. Varying the dimensions and colors of the horizontal rectangles and the colors and widths of the vertical strips added to the painting's spatial ambiguity and the overall rhythmic effect. So too did the sense of a wickerlike construction, which obliterated the distinction between figure and ground. The result of these staccato rhythms and back-and-forth spatial effects was a surface that rippled with agitation and repressed energy.

Diller had used overlapped lines and intersections marked by blocks of contrasting color before 1942. But his decision to extend linear elements across the entire surface of the canvas and thereby exploit an all-over compositional structure owed to the example of Mondrian, whose own work underwent a stylistic change after his arrival in New York in October 1940. Diller's personal contact with Mondrian was minimal. They participated in one exhibition in 1942 and had perfunctory exchanges at several subsequent openings, but Diller only talked with Mondrian once. This was due to the protective shield thrown around Mondrian by Harry Holtzman, who had supplied him with money to come to America and, after his arrival, took responsibility for many of the practical aspects of his life. Possessive of Mondrian and perhaps jealous of potential rivals for his affection, Holtzman arranged only one meeting between his former friend and the Dutch artist.[136] Yet whatever disappointments Diller may have felt at being excluded from Mondrian's New York orbit, they did not dissuade him from drawing on aspects of Mondrian's new work for his own art.

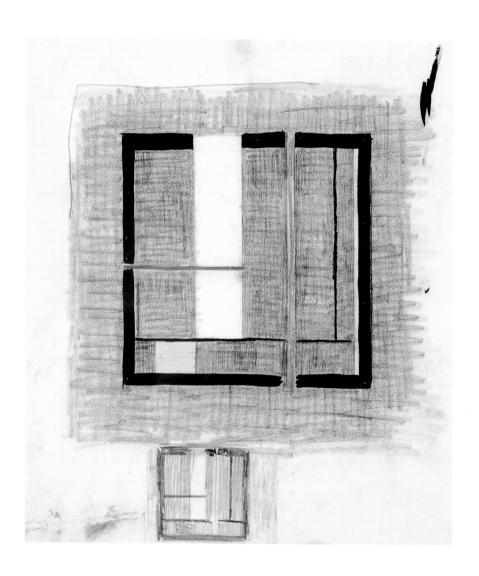

Fig. 97.
Collage for Wall Sculpture, 1948
Watercolor, pencil, and crayon on paper, 16⅞ × 13 ⅞ (42.9 × 35.2)
Meredith Long & Company, Houston

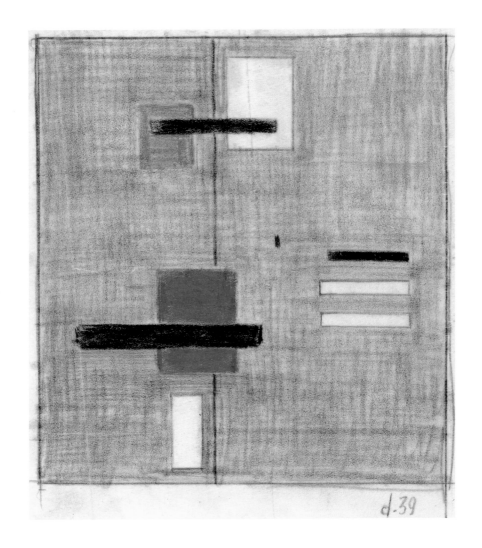

Fig. 98.
Untitled (Composition with One Vertical), 1939
Pencil and crayon on tracing paper, 8⅜ × 7³⁄₁₆ (21.3 × 18.3)
Yale University Art Gallery, New Haven;
Gift of Katherine S. Dreier for the Collection Société Anonyme

Fig. 99.
Untitled (Composition with Red Rectangle), 1941
Pencil and crayon on tracing paper, 16⅛ × 13¾ (41 × 35)
Yale University Art Gallery, New Haven;
Gift of Katherine S. Dreier for the Collection Société Anonyme

Fig. 100.
Construction, 1940
Oil on wood and masonite, 24 × 24 × 3¹⁄₁₆ (61 × 61 × 7.8)
Yale University Art Gallery, New Haven;
Gift of Katherine S. Dreier for the Collection Société Anonyme

Fig. 101.
Early Geometric, c. 1942
Oil on canvas, 36 × 42 (91.4 × 106.7)
Meredith Long & Company, Houston

Fig. 102.
Second Theme, 1942
Oil on canvas, 34 × 34 (86.4 × 86.4)
Collection of Cornelia and Meredith J. Long

Fig. 103.
Construction, 1948-60
Painted wood, 23⁵⁄₁₆ × 23¼ × 2⁵⁄₈ (59.2 × 59 × 6.7)
The Baltimore Museum of Art; Given in Memory of Marion Priest Joslin, by exchange,
and Edward Joseph Gallagher III Memorial Fund

Fig. 104.
First Theme, 1942
Oil on canvas, 42 × 42 (106.7 × 106.7)
The Museum of Modern Art, New York; Gift of Silvia Pizitz

Fig. 105.
Untitled, c. 1943
Pencil and crayon on paper, 11¾ × 11¾ (29.8 × 29.8)
Collection of Fayez Sarofim

Fig. 106.
Interplay (Number 3, Second Theme), c. 1943
Oil on canvas, 42¼ × 42⅛ (107.3 × 107)
Hirshhorn Museum and Sculpture Garden, Smithsonian Institution, Washington, D.C.;
Gift of the Joseph H. Hirshhorn Foundation

Fig. 107.
First Theme, 1943
Oil on canvas, 33 × 34 (83.8 × 86.4)
Collection of Fayez Sarofim

Fig. 108.
First Theme, 1942-43
Oil on canvas, 42 × 42 (106.7 × 106.7)
Private collection

Fig. 109.
Third Theme, 1942-44
Oil on canvas, 48 × 48 (121.9 × 121.9)
Collection of Fayez Sarofim

Fig. 110.
Third Theme, 1945
Oil on canvas, 36 × 42 (91.4 × 106.7)
Collection of Sue and David Workman

Fig. 111.
Third Theme, 1943-44
Oil on canvas, 26 × 26 (66 × 66)
New Jersey State Museum, Trenton; Purchase

Fig. 112.
Third Theme, 1946-48
Oil on canvas, 42 × 42 (106.7 × 106.7)
Whitney Museum of American Art, New York; Gift of May Walter 58.58

Fig. 113.
Third Theme, 1950-53
Oil on canvas, 55½ × 55½ (141 × 141)
Private collection

Diller would have seen Mondrian's new work in several group exhibitions and in the two larger exhibitions of his paintings that were held in New York between Mondrian's arrival and his death in 1944. The first, in 1942, included several paintings, begun in Europe, which abandoned the relational format he had earlier employed in favor of a gridlike structure of black lines that extended across the entire surface of the canvas. His second exhibition, in 1943, included only six paintings, but among them were *New York City I* and *Broadway Boogie Woogie,* the last canvas he completed before his death (Fig. 114). In these paintings, Mondrian retained an all-over structure but now introduced colored lines whose overlapping and intersecting produced flickering optical effects and spatial ambiguity. These paintings, along with *Victory Boogie Woogie,* which was displayed in Mondrian's studio after his death, became the springboards for the syncopated arrangements of contrapuntal blocks of color that mark Diller's post-1942 work.

The complexity of Diller's post-1942 paintings required a new, more painstaking manner of execution. He now typically began a painting by dividing the canvas with charcoal lines into large rectangular areas, which he subsequently broke up into small planes. His method was intuitive; although he normally used a T-square or triangle, his lines were not entirely geometric. "There are situations," he remarked, "when you have to come off the vertical or the horizontal slightly to retain the sense of them."[137] To determine the initial position of his blocks of color, he cut colored paper to size and pinned it to the canvas. Next, he painted pieces of paper with his own color mixes and attached these to the canvas in order

Opposite page:

Fig. 115.
Untitled, 1944
Pencil and crayon on paper
8¼ × 8¼ (21 × 21)
Private collection

Fig. 116.
Untitled (Diagonal), c. 1944
Collage on canvas
24 × 24 (61 × 61)
Meredith Long & Company,
Houston

to approximate more closely the spatial impact made by even slight alterations in the tone and density of color. Only then did he commence painting. This, too, involved more than a simple transcription onto the canvas; only after hundreds of corrections and revisions, often taking a period of years, would the painting be complete.[138]

To offset this regimen, Diller turned to drawing, which allowed him the freedom to work spontaneously and to experiment freely with compositional ideas (Figs. 115–119). Drawings sometimes led directly into paintings; most often, however, they represented the final formulation of a pictorial idea. This was particularly true in the 1940s, when many drawings offered variations on the syncopated blocks of color in concurrent paintings. But in some drawings from the period Diller articulated radically different ways of creating an all-over composition. Drawings that include several images on the same sheet reveal the range of solutions he considered to a particular problem (Figs. 120–122). Everything seemed at his disposal: diagonals; irregular shapes; abutted rectangles defined by cross-hatching and parallel lines; fields of floating horizontal and vertical lines. Even non-primary colors were tolerated. Working rapidly, Diller dispensed with the precision that characterized his paintings. In its stead were pencil markings, sometimes rough, sometimes delicately grained, that would often leap beyond the ruled lines of a limiting edge. In contrast to the uniform, matte surfaces in his paintings, the textures in his drawings ranged from tight and crisp to velvet and loose. Often he would border a composition with scribbled or cross-hatched lines so that it seemed to give off a gray, lambent radiance.

At the end of the decade, Diller introduced a sparser, more subdued format: open frame, vertical constructions (Figs. 123, 124) and extremely simplified paintings containing, at times, only a single horizontal band bounded by pencil-thin verticals (Figs. 125, 126). These latter paintings, described by Dore Ashton as having a "lyrical lightness," exude an otherworldly refinement and calm, as if they were removed from the cacophony and conflicts of life.[139] Using a restricted palette of one or two primary colors on an unmodulated white ground, Diller evoked an order that was neither mechanical nor impersonal.

Critical Reception in the 1940s

Diller's critical fortunes rose in the forties as he gave up administrative duties and returned full-time to the making of art.[140] Between 1935 and 1942 Diller had participated in only four shows—three of them group events with the AAA. Suddenly, in 1942, this sparse exhibition record began to improve. In that year, he was included in the show "Masters of Abstract Art" at Helena Rubinstein's gallery, and Sidney Janis asked to see his work along with that of other interesting Project artists.[141] Three years later, an exhibition of Diller's

Fig. 117.
Third Theme, c. 1944
Pencil and crayon on paper, 14½ × 13⅞ (36.8 × 35.2)
The Skye Wood Collection

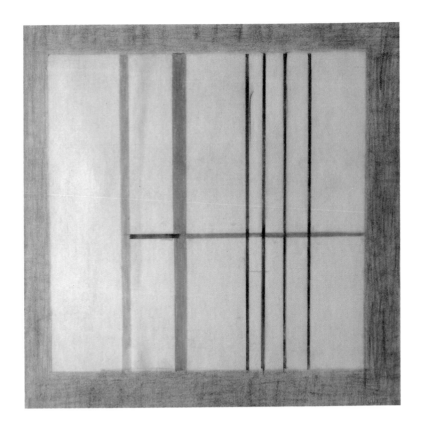

Fig. 118.
Untitled, c. 1944
Pencil and crayon on paper,
7 × 7 (17.8 × 17.8)
Collection of Istvan and
Nicole Schlégl

Fig. 119.
*Untitled (Composition with Cross,
with Blue-Gray Band)*, 1945
Pencil and crayon on paper,
17 × 13⅞ (43.2 × 35.2)
Yale University Art Gallery,
New Haven; Gift of Katherine S.
Dreier for the Collection
Société Anonyme

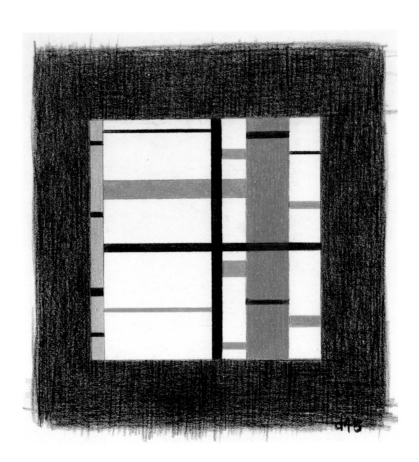

Fig. 120.
Diagonal Variation, c. 1944
Pencil and crayon on paper
14 × 17 (35.6 × 43.2)
André Emmerich Gallery,
New York

Fig. 121.
Untitled, c. 1942
Pencil and crayon on paper
16½ × 12¼ (41.9 × 31.1)
Meredith Long & Company,
Houston

Fig. 122.
Untitled, 1942-43
Pencil and crayon on paper, 17½ × 17⅞ (44.5 × 45.4)
Meredith Long & Company, Houston

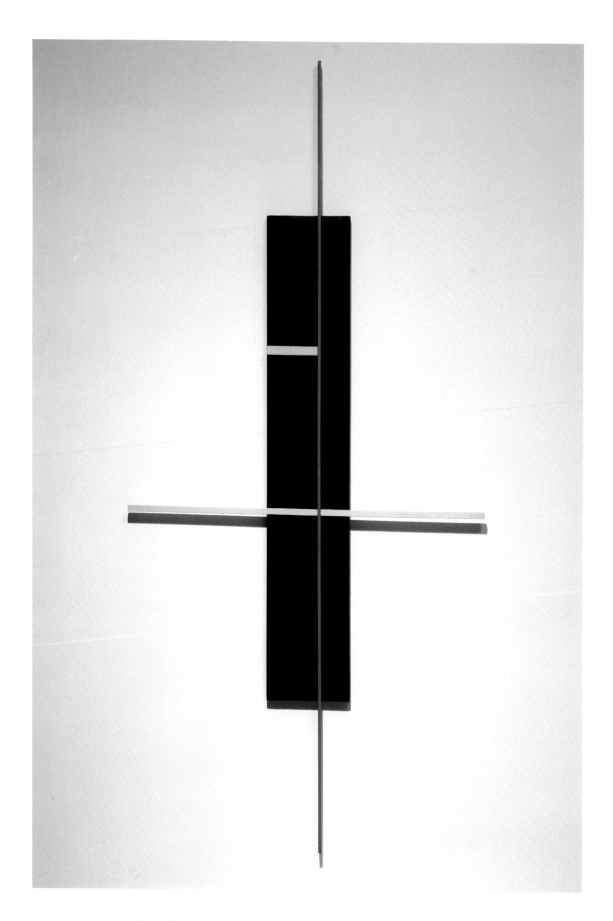

Fig. 123.
Untitled, 1949-50
Painted wood, 62 × 29 × 2 (157.5 × 73.7 × 5.1)
Collection of Mr. and Mrs. Louis Gardner

Fig. 124.
Study for Wall Construction, 1950
Pencil and crayon on paper, 14 × 6¾ (35.6 × 17.2)
Collection of Jenny and Edwin Murphy

Fig. 125.
Second Theme (Composition), 1944-46
Oil on canvas, 42 × 42 (106.7 × 106.7)
Private collection

Fig. 126.
Second Theme, 1948
Oil on canvas, 20 × 20 (50.8 × 50.8)
Collection of Natalie and Irving Forman

and José de Rivera's work was held at Harvard University, and in February 1946 he was honored with a retrospective at the Munson-Williams-Proctor Institute in Utica, New York. By 1946, Katherine Dreier, with whom Diller had maintained friendly relations, had purchased one painting and fourteen drawings for the Société Anonyme collection as exemplars of the "new philosophy of painting."[142]

The rise of Diller's star seemed limitless. In 1946, he began an affiliation with Rose Fried's Pinacotheca gallery, which assured him a respected and highly visible forum for his work. His association with one of the few dealers who steadfastly championed geometric abstraction ranked him among the select Americans—along with Ilya Bolotowsky, Josef Albers, Byron Browne, and Fritz Glarner—to be placed in the company of European masters of De Stijl and Constructivism.

Since Diller did not have enough recent work to fill The Pinacotheca, his first exhibition with Fried, in December 1946, surveyed his entire career—a pattern he would duplicate whenever he had insufficient work. Two subsequent shows followed—one in 1949 at The Pinacotheca and the next, in 1951, after the gallery became known under Fried's own name. Critical response to these shows was divided: on the one hand were those who saw in Diller's work too great a resemblance to Mondrian; on the other were critics who perceived in it a subtle and original adaptation of Neoplastic principles.[143] However, by the 1940s, critics were accustomed to abstract art and Diller's work fared better than Mondrian's, which had earlier been interpreted as "so many simple commonplace patterns for bathroom tiles," or Picasso's, which had been deemed "ridiculous and uncouth."[144]

Diller seemed particularly unmoved by either praise or criticism. His quest was for truth and self-discovery, not for accolades.[145] His defiant attitude toward external appraisals had remained essentially the same since 1933 when Balcomb Greene wrote to him: "Sometimes a man takes up this matter of art; and gives himself to it so thoroughly, that he asks no favors, makes an ass of himself for no one, can tell that polite and treacherous world of sponsors and promoters at the proper moments—to go to hell. Your attitude seemed substantially that. . . . Given a reasonably long life, lots of energy, AND THIS PECULIARLY RARE DEFIANCE—[your] work will speak for itself."[146]

Although Diller's art was beginning to do just that, few artists in the mid-1940s could expect to support themselves from sales of their art, and Diller had to find another source of income. This came in June 1946 with his permanent appointment to the faculty of Brooklyn College.[147] Teaching made summer exits from New York possible, a situation Diller took advantage of by building a studio adjacent to his mother-in-law's house in a rural section of Atlantic Highlands, New Jersey. Here, on a tree-covered slope, Diller and his wife, Sally,

spent the summer months. Consisting of one room, 35×22 feet, the studio had large windows facing north, south, and west. For Diller, it offered the dream of a big studio in the quiet of a country setting. For Sally, it offered a respite from housekeeping and cooking, both of which were supplied by her mother, to whose house they would go every evening for meals. The arrangement worked to everyone's satisfaction: Diller and his mother-in-law were unusually close; before his death in 1965, he reserved a burial plot for her next to his in the Red Bank cemetery.

Every September Diller and Sally would return to their apartment in New York and Diller would resume his job at Brooklyn College. The department of design, as the art department was called, had adopted Bauhaus teaching methods after the appointment of Serge Chermayeff as chairman in 1942.[148] Chermayeff had introduced a program of design courses complemented by studio workshops. In basic design, students were taught abstract elements of design and were encouraged to experiment with different materials; in the workshops, they applied these basic principles to each of the various art disciplines. The goal was to break down the distinction between applied and fine arts and to stress the conjunction of art, design, and fabrication. Although Chermayeff had left Brooklyn in 1946 to assume the directorship of the Chicago Institute of Design after Moholy-Nagy's death, his mark on the department was indelible. Not only had he established a curriculum based on the Bauhaus model, but he had hired a contingent of artists—Harry Holtzman, Robert Wolff, Carl Holty, Ad Reinhardt, and Ilya Bolotowsky, among them—who had assured the school's reputation as a stronghold of abstraction.

Diller's experience made him singularly well suited for Chermayeff's department. Already in 1939, through his affiliation with the Design Laboratory in New York, Diller had taught a "design synthesis" course that correlated the general principles of design and fine arts with shop practice.[149] At Brooklyn College, Diller instituted a Sculpture I class that became legendary. He instructed his students to describe a shape—first in clay and then in plaster—that was self-contained, unified, rounded, and perfectly discrete: a "oneness."[150] He then directed them to make two or three cuts in the shape to modify its mass without denying its basic unity. After being cast in plaster, the shape was further refined by being coated with gesso, sanded, and polished. Sometimes Diller would direct the students to interlock two self-contained shapes to create a "twoness." Consuming the entire semester, these processes were designed to inculcate an understanding of the benefits of patience, deliberation, and the wide spectrum of choices that existed within a seemingly circumscribed set of parameters. Beloved by his students, Diller passed on to them the notion that art was about form and relationships and principles—not about emotions.

Diller's critical success during the 1940s mirrored the changes that had occurred in the art world. With America's entry into World War II, the isolationist position underlying the Regionalist and American Scene movement lost its credibility as the nation prepared to take its place in the international political order. That art could, and must, transcend geography was reinforced by the arrival of European refugee artists whose presence shifted the art capital of the world from Paris to New York. What was needed was an independent American art with the power to live up to this new calling. In 1941, Samuel Kootz had already called for a new, strong, original art to replace the bankruptcy of "subject," exhausted by ten years of nationalist propaganda.[151]

At first, geometric abstraction had seemed a perfect prescription of internationalism tinged with American qualities of individualism, strength, and inventiveness. Even the abstractionists' once disparaged focus on formal issues began to be seen as apt following the disillusionment with Soviet policies in the years before and during World War II, and the attendant waning of the demand that art be allied with politics. Clement Greenberg, who heralded the growing supremacy of formal concerns, became a major champion of abstract American art—in particular of purism, of which Diller's Neoplasticism was a central part. In 1940, Greenberg applauded purism as "the terminus of a salutory reaction against the mistakes of painting and sculpture in the past several centuries."[152] Two years later he acclaimed the AAA's annual exhibition for being able to "tell us most about the probable future of abstract art in this country."[153]

The critical success of geometric abstraction proved temporary. A new generation of artists had begun to emerge in the early 1940s with a deep-seated sense of man's vulnerability and tragic condition and a shattered faith in rationality. With this had come a profound dissatisfaction with the underlying philosophy of Neoplasticism. One of the first indicators of the new sensibility was Motherwell's 1942 article on Mondrian. Identifying Mondrian's work as "scientific," Motherwell asserted that it had failed because Mondrian's means were too restricted to "express the felt quality of reality." The proposition that "$2 + 2 = 4$" was unsatisfying, Motherwell argued, in a time "when men were ravenous for the *human*. . . ."[154]

This desire for the "human" turned the concentration of younger artists away from formal innovations with which Neoplasticism was identified. As Gottlieb said: "It is generally felt today that this emphasis on the mechanics of picture-making has been carried far enough."[155] The momentum was sufficiently strong by 1943 that Rothko and Gottlieb, in collaboration with Barnett Newman, could confidently write that "there is no such thing as good painting about nothing."[156]

Within the canons of this new vanguard, Neoplasticism was viewed as decadent, decorative, and even totalitarian since it was based on a set of pictorial "rules." It was not just that it ignored the human and subjective side of life; even its use of hard edges and unambiguous forms was considered anachronistic because it was based on a conception of a world guided by rational principles. Writing of Mondrian's 1945 exhibition at The Museum of Modern Art, Barnett Newman noted: "There has been a great to-do lately over Mondrian's genius. In his fantastic purism, his point of view is the matrix of the abstract aesthetic. His concept, like that of his colleagues, is however founded on bad philosophy and on a faulty logic."[157]

As a new national pride began to assert itself in America following the Allied victory, the distinction between artists whose styles were indebted to European modernism and the new "American" vanguard gradually became fundamental. By the end of the 1940s, painters who were once considered advanced were swept aside because their work was considered too closely related to the School of Paris.[158]

Even Clement Greenberg turned against the geometric abstractionists. Writing of the AAA's 1947 annual he noted: "Here the hand of the past descends more heavily because none of the thirty-seven artists represented can quite boast a temperament . . . nowhere does [vitality] break through the canonical modes of the School of Paris to assert a new independent personality—or an idea."[159] Within this critical climate, Diller's work was increasingly discredited. Although he continued to have partisans who praised his "almost hypnotic expressions," these accolades were drowned out by the voices of dissent.[160] Still "too embarrassingly close to Mondrian," he was viewed as having chosen "a field too rarified to admit emotional qualities."[161]

Eclipse and Reemergence, 1950–1961

Once considered seminal to the New York art world, Diller found himself relegated in the fifties to its edges, his art and ideals considered relics of the past. One night at the Cedar Bar, someone even accused him of swallowing a sliver of the Snow Queen's looking-glass—to which he responded by slamming his fist down on the table and shouting, "Christ! I've got passion."[162]

Always a heavy drinker, Diller turned now to alcohol as a release from a world in which he felt devalued. So did Sally—with even more disastrous results. Whereas Diller never lost his composure or assurance, Sally was more externally affected by liquor, sometimes getting hopelessly drunk and having to be physically assisted by Diller.[163] Sally had

Fig. 127.
Second Theme, 1954
Pencil and collage on paper, 11½ × 11½ (29.2 × 29.2)
André Emmerich Gallery, New York

long disapproved of the direction Diller's work had taken and resented the material sacrifices which an artist's life entailed.[164] Despite the strains, they had remained devoted to one another.[165] With Sally's deepening alcoholism, however, their relationship began to deteriorate and Diller turned to other women.[166] Even Sally's job at *The New York Times* became loathsome to her. According to Robert Wolff, "as time went on she grew to hate the work she did and began to blame Diller more and more for what she considered a lifetime trap brought about by Diller's inability throughout their marriage to provide the good things of life that she so greatly missed."[167] Dynamic and forthright, Sally had never been shy about arguing with Diller. After 1948, with her heavy drinking and general depression, these bouts took on more physical overtones.[168] Friends described how they would throw plates at one another, and Diller recounted how Sally would shout curses at him and scream with fury when he tried to withhold liquor from her.[169] Not wanting to forfeit her pension fund—which came due only after twenty-five years of service—she worked at *The New York Times* until November 1953, despite a terminal case of cirrhosis of the liver. Three months after her retirement, at forty-five years of age, she died in her mother's home in New Jersey.

Diller's artistic production had fallen precipitously in the years between 1950 and 1954. The sorrow and burden of Sally's illness, added to his own sense of professional estrangement, had enveloped him in a cloud of sadness and resignation. After Sally's death, he began to try to pull his life together. Visiting his mother and stepfather in St. Mary's Lake, Michigan, in the summer of 1954, he met Grace Kelso LaCrone, recently separated from her husband and living with her three children in her father's home—the site of frequent social encounters with Diller's family. Attractive and accustomed to taking care of others, Grace offered Diller an unquestioning security and consuming affection. Falling in love with her gave him a renewed enthusiasm for life and unleashed a passion that he had rarely allowed himself to express. It was a love affair conducted at a distance—through letters, telephone calls, and the few visits Diller could accommodate within his teaching schedule.

Diller's letters to Grace oscillate between desperate longing and elation.[170] He writes that meeting her is "like coming alive—being reborn," that she has given him a better understanding and more creative relationship to life, that he feels something has "happened in him—a will to do—a response to things—feelings—that have been dormant too long suddenly emerge." Consumed by the feeling that he loves her "more than [he] has ever loved" with "every fabric of [his] being," he confesses that he has "never come so close to another human being—where the we is really one. . . ."

Diller became convinced that Grace offered him salvation, and with this conviction grew his desperation to be with her and his fear that she would stop loving him. He became

like a schoolboy: her telephone calls made his heart palpitate and her letters set him at peace. By December, five months after they met, he was writing to Grace about hastening her divorce so that they could be married. On July 22, 1955, they traveled to Angola, Indiana, where they could quickly procure a marriage license, and exchanged vows before a justice of the peace.

After several months of makeshift living in Diller's one-room studio in Atlantic Highlands, he and Grace moved into a low-frame suburban house nearby with Grace's adolescent daughter, Suzanne. Two years later, her middle child, William, joined them.

Grace gave Diller loving attention, but apparently little intellectual companionship. Though sweet and subservient, she was not his equal. To Diller's friends and colleagues, she seemed limited and foolish in comparison to Sally.[171] Whatever the legitimacy of their assessments, her parochial background had not prepared her for a more urban life-style, and she was definitely out of place in Diller's world. Nor does she seem to have had much success in comprehending the subtleties of her husband's work. As she herself acknowledged in a Valentine card to him in 1957: "I didn't say I didn't like your paintings—I just don't understand them—."[172]

Notwithstanding the domestic security and comfort Grace provided, Diller reached a nadir in these years. With no shows of his work in New York since 1951, he felt justifiably neglected and abandoned.[173] He turned increasingly to alcohol—a pleasure he reputedly shared with Grace. Although her family disputes this allegation, even Diller occasionally remarked about her ability to match his heavy liquor consumption.[174]

Living full time in New Jersey exacerbated Diller's estrangement from the New York art world, although, conversely, the disregard shown his work might also have fueled his desire for isolation. Whatever the reasons, the impression was that he had "disappeared from the earth."[175] Alcohol offered only a temporary abatement of his distress. Those who visited Diller in the late fifties invariably describe him as despondent—at the "lowest state of his life," as one critic noted.[176] To visitors, his studio seemed desolate, as if it had not been used for years. In the early part of 1959, the basement where he stored his work flooded; by summer, it was still damp and dirty and neither the paintings nor drawings in it had been salvaged. When a critic admonished him for this, he countered by saying that his work from the 1930s "wasn't very good anyway."[177]

By this time, it had been six years since Diller had completed any substantial amount of work. Acquisitions in 1958 of his earlier paintings and constructions by the Whitney Museum of American Art and The Museum of Modern Art only reinforced his lack of contemporary relevance—a fact he bitterly realized.[178]

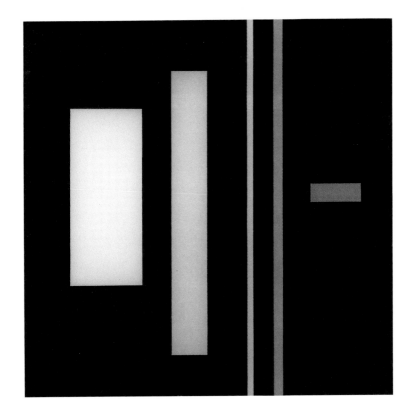

Several factors converged to break this cycle of despondency and encourage Diller to resume painting. In 1959, a group of eight female artists from Atlantic Highlands convinced him to hold weekly, afternoon classes in his studio. By forcing him to explain his compositional principles to a group of grateful acolytes, these classes rekindled his enthusiasm for the practice of art.[179]

Even more compelling was the offer made in 1958 by Madeleine Lejwa of the Galerie Chalette to handle his work. For Diller the validation was cathartic. He requested a reduced work load from Brooklyn College that fall and began to prepare for an exhibition. The works he produced over the next five years took up the theme of free-floating rectangles that he had initiated in 1955 and 1956 but had been unable to complete (Figs. 128–137). Like their 1938 antecedents, these paintings contained colored rectangles and squares that touched infrequently; when they did, it was at the corners alone. Most often, they were isolated in the field with, at most, only one of the blocks of color connected to a framing edge. In some works, Diller stabilized the composition with an intense blue band that ran top to bottom. Since each composition consisted of only a few elements, subtle changes in shape, position, or color significantly altered the effect. Diller's choice of predominantly black backgrounds endowed these works with a great quiet and restfulness. Imposing and self-contained, their unattached shapes can be read as abstract equivalents

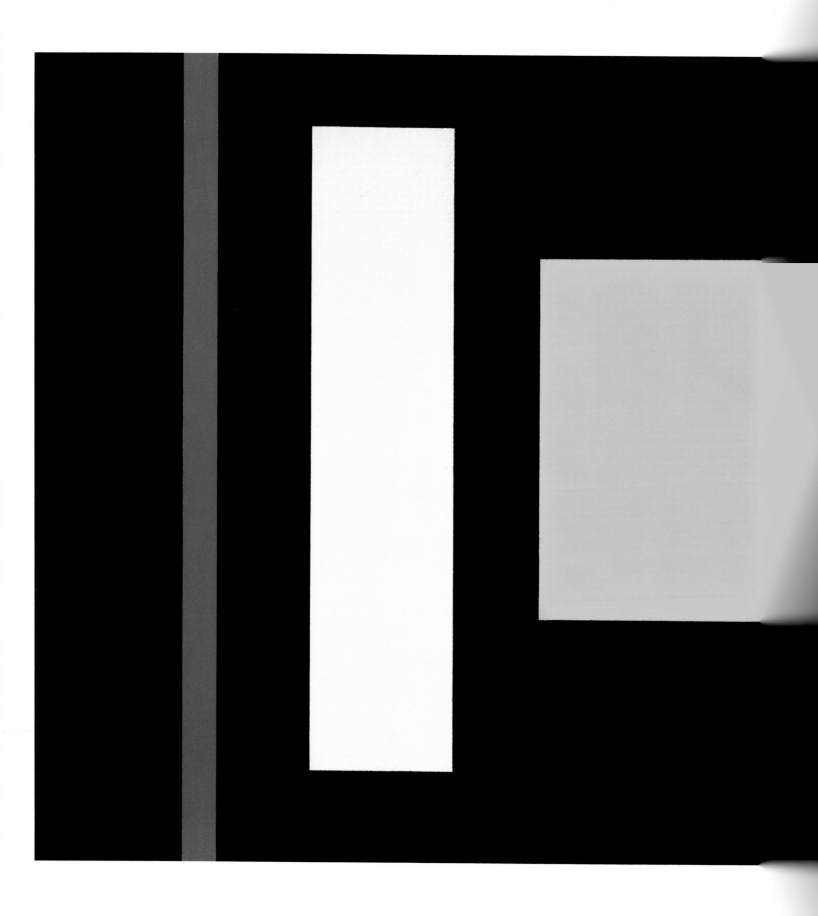

Fig. 129.
First Theme, 1955-60
Oil on canvas, 42 × 42 (106.7 × 106.7)
Collection of Natalie and Irving Forman

Fig. 130.
First Theme, 1959-60
Oil on canvas, 42 × 42 (106.7 × 106.7)
Collection of Anne and William J. Hokin

Fig. 131.
First Theme, 1956-60
Oil on canvas, 54 × 38 (137.2 × 96.5)
Collection of Edward and Betty Harris

Fig. 132.
First Theme, 1961
Oil on canvas, 42 × 42 (106.7 × 106.7)
Collection of Mrs. Donald A. Petrie

Fig. 133.
First Theme, 1961-62
Collage, pencil, and crayon on paper, 10 × 7¾ (25.4 × 19.7)
Collection of Mrs. Paul M. Hirschland

Fig. 134.
Number 47, 1962
Oil on canvas, 48⅛ × 48¼ (122.2 × 122.6)
The Newark Museum, New Jersey; Purchase 1970 Newark Museum Purchase Fund

Fig. 135.
First Theme, 1962
Oil on canvas, 72 × 72 (182.9 × 182.9)
The Art Institute of Chicago; Wilson Mead Fund

Fig. 136.
First Theme, 1963
Oil on canvas, 90 × 38 (228.6 × 96.5)
The Cleveland Museum of Art; Andrew R. and Martha Holden Jennings Fund

Fig. 137.
First Theme, 1962
Oil on canvas, 42 × 42 (106.7 × 106.7)
Collection of Erling Neby

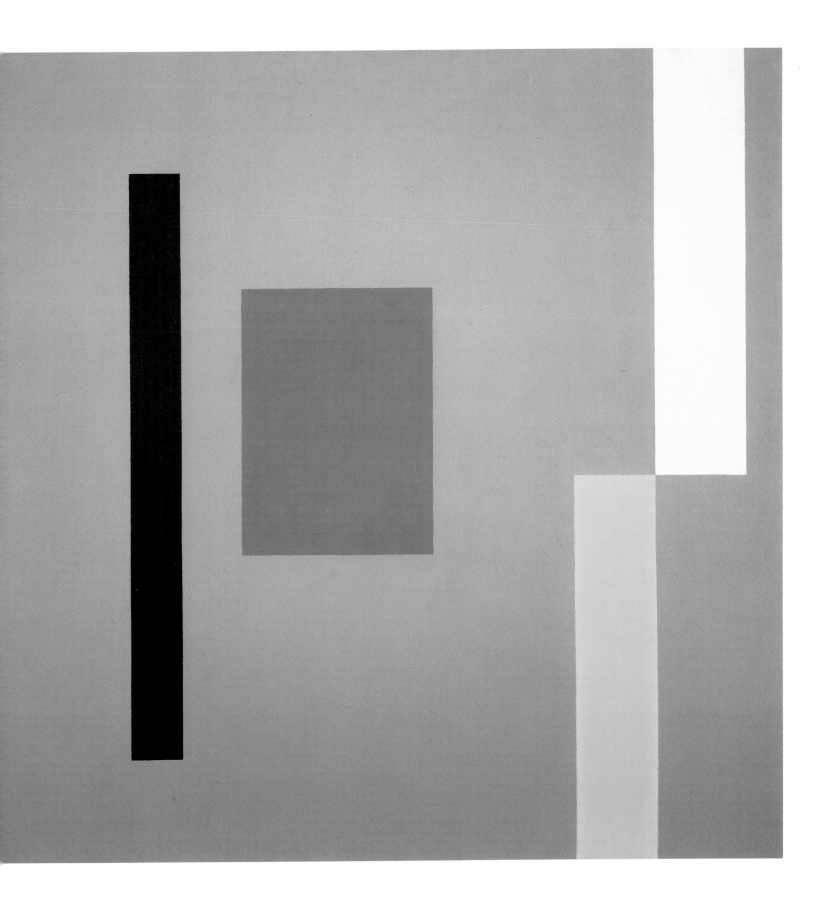

Fig. 138.
First Theme, 1962
Oil on canvas, 48 × 48 (121.9 × 121.9)
Collection of Erling Neby

Fig. 139.
First Theme, 1962
Crayon on paper, 14 × 17 (35.6 × 43.2)
Meredith Long & Company, Houston

Fig. 140.
Untitled, 1962
Pencil, colored pencil, and collage on paper, 10¼ × 7¾ (26 × 19.7)
André Emmerich Gallery, New York

of psychological states. Diller had always claimed that "one approaches reality by creating symbols for it."[180] In these new paintings, it was as if he had transferred to his work the peace and assurance that was eluding him in his life. Large in scale, they vindicated the proposition made by Rothko, Newman, and Gottlieb that large shapes have the impact of the unequivocal,[181] and that, as Rothko said, "eight feet of red is redder than two feet of red."[182]

Diller had always striven for pictorial clarity; it accounted for his sharp-cut edges, smooth surface, and clear colors. His decision now to concentrate on black backgrounds owed to his desire for more unambiguous color differentiation as well as for greater chromatic luminosity. From the beginning of his career, Diller had been a gifted colorist and had prided himself on mixing his own colors. He viewed color as a form of light energy—as the absorption and diffusion of light rays or wavelengths.[183] So intent was he on marshaling this energy that he even determined the direction of his strokes according to the desired diffusion of light: some areas he brushed vertically, others horizontally. Anxious to eliminate anything that might detract from the painting's overall effect, he removed any accidents or blemishes generated by uneven drying of colors or oil settling on the painting's surface. To keep oil from rising to the top and marring the evenness of the surface he mixed his paints only with turpentine. If he changed the position of a rectangle during execution, he would scrape it clean so as not to leave ridges that would disturb the otherwise immaculate surface. Shiny surfaces he almost always sanded or pumiced down.

Diller's exhibition at the Galerie Chalette, originally intended to open in January of 1959, was postponed until May 1961 to give him time to complete new work. The opening marked a turnabout in his critical fortunes. After a ten-year absence from the exhibition scene, his return seemed "tantamount to rediscovery," as Sidney Tillim noted.[184] "He is both old and new at the same time." Suddenly his impersonal facture, geometric forms, simplified arrangements, and commitment to what one critic identified as "the austere and almost inhuman beauty of intellectual order" no longer were disparaged. Indeed, they were central to the era's dominant aesthetic.[185] The rise of Minimalism gave legitimacy to Diller's past and present endeavors.

Diller included in the exhibition a chart that established his two central concerns: the "basic" plane and the "movement—and constant opposition" which occur in that plane (Fig. 141). Within this framework, he then identified his ongoing concern with three visual themes, which he had announced but not enumerated in the brochure to his 1951 exhibition at the Rose Fried Gallery. The chart attempted to explicate these themes as intertwining involvements rather than as sequential evolutions. The themes gave critics a convenient means to identify paintings without resorting to lengthy descriptions. Yet they also became

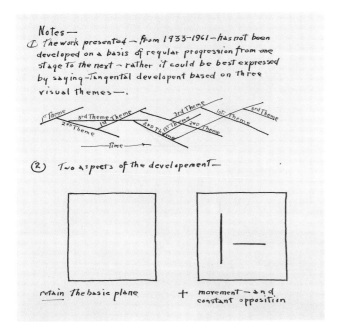

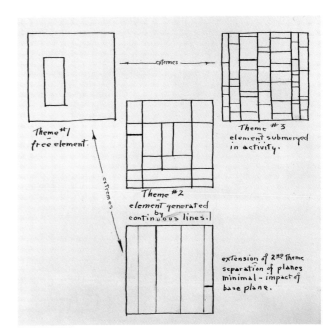

Fig. 141.
*Notes on Theme #1, Theme #2,
Theme #3*, 1961
Ink on paper
19⅞ × 14 (50.5 × 35.6)
The Metropolitan Museum of
Art, New York; Gift of the Arthur
and Madeleine Lejwa Collection

something of a trap since they suggested fixed categories which were, in fact, antithetical to Diller's notion of interdependent influences. Also, although helpful in identifying images, they inadvertently caused later errors in titling, since most of Diller's work was executed without reference to specific themes. The extremes were not difficult to identify: *First Theme* work was composed of free-floating rectangles and *Third Theme* work exulted in linear interplay. More ambiguous was *Second Theme* work, whose elements were "generated by continuous lines." As Diller had attempted to establish in his chart, the differences between the *Second* and *Third* themes—or even the *First*, with which the *Second* is sometimes confused—was one of degree rather than fundamental vocabulary. This accounted for Diller's simultaneous exploration of several formats, as in the 1960s, when his predominant involvement with *First Themes* did not preclude experimentation with new approaches to the *Second Theme* (Figs. 142–144).

Final Years

Unfortunately, Diller's alcoholic past intervened just at his moment of triumph. In the fall of 1954, before his marriage to Grace, he had been hospitalized for pulmonary edema and had been advised to limit his alcohol consumption—which he did, but only for a short time. Once he began painting again in the late 1950s, he again greatly curtailed his intake.

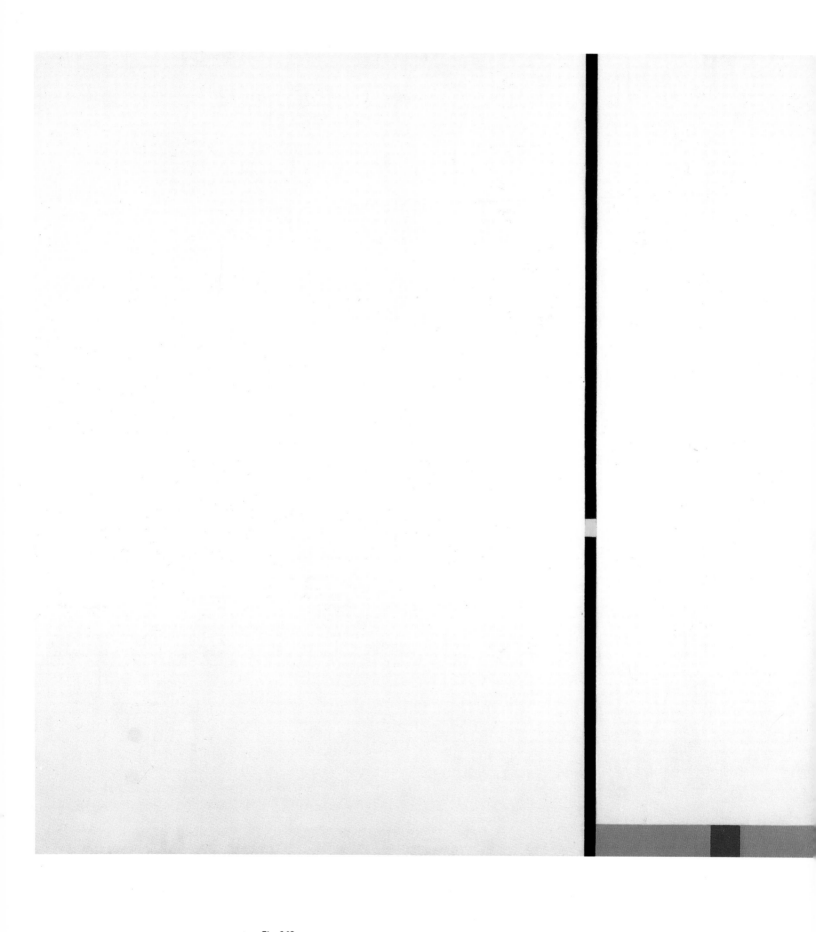

Fig. 142.
Second Theme, 1961-62
Oil on canvas, 42 × 42 (106.7 × 106.7)
Collection of Dr. and Mrs. John R. Lane

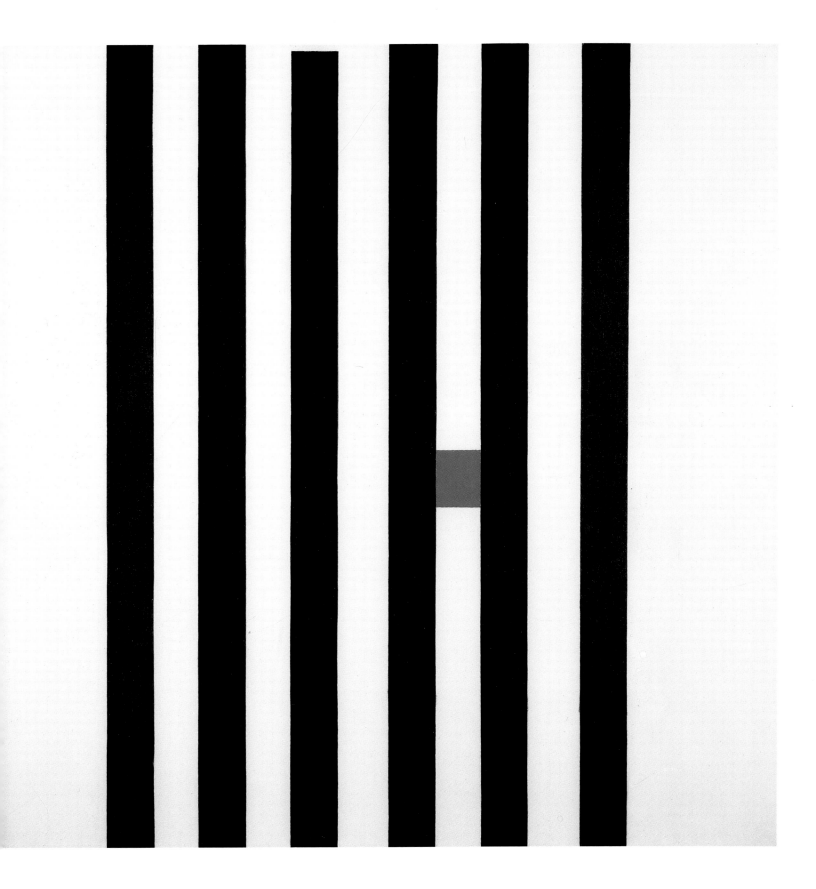

Fig. 143.
Number 5—Second Theme, 1963
Oil on canvas, 42 × 42 (106.7 × 106.7)
Museum of Fine Arts, Springfield, Massachusetts; The James Philip Gray Collection

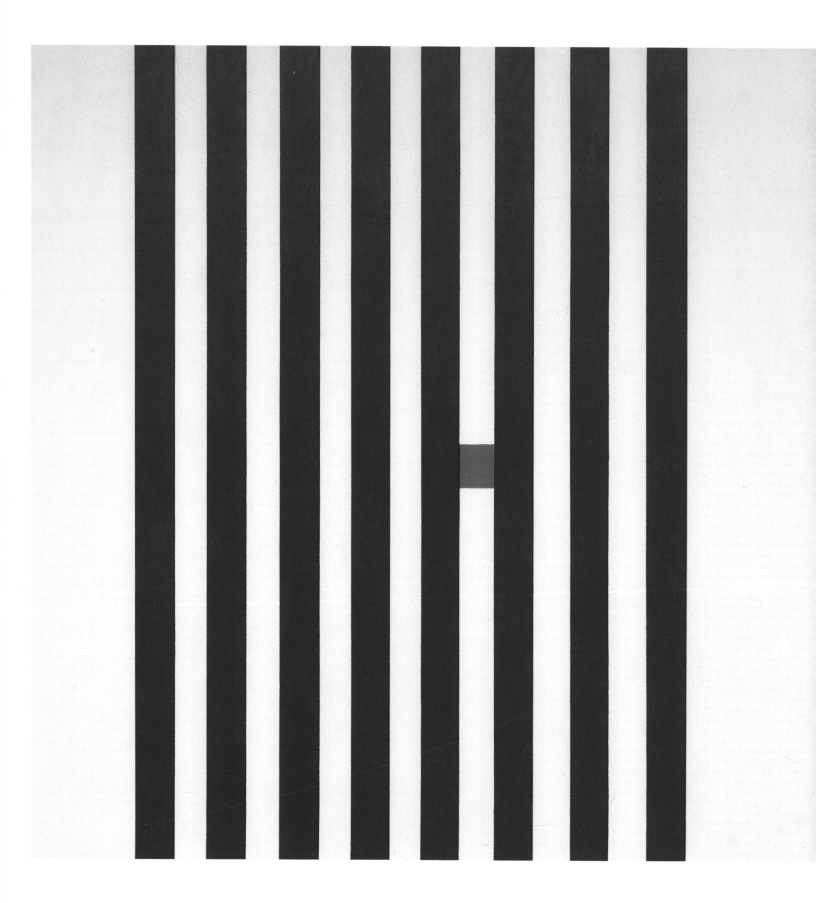

Fig. 144.
Second Theme, 1963
Oil on canvas, 42 × 42 (106.7 × 106.7)
Collection of Jane and Ron Lerner

However, years of alcoholism had irreversibly damaged his liver, heart, and lungs. By January 1960, his condition had so deteriorated that he was forced to take a sabbatical from Brooklyn College. A weakened heart and pulmonary edema made breathing difficult. Although he stopped drinking and began taking medication for his liver and heart, he continued to have trouble breathing and periodically had to have fluid drained from his lungs. Eventually, the condition prevented him from lying down for anything but a few hours at a time and he developed the habit of working long into the night in his studio and sleeping only intermittently—often in a chair.[186] The four-hour commute to and from Brooklyn became an enormous strain. Too ill to teach, he was also too financially pressed to resign. Over the next four years, he exhausted his accumulated sick leave and taught only in the fall semesters of 1962 and 1963. Even then, other faculty members would often have to cover for him on days when he was too incapacitated to travel to Brooklyn. Frail and easily tired, he could walk only short distances without having to stop and catch his breath. Occasionally, he would suffer an angina attack on campus and have to take nitroglycerin tablets. By 1963, he had become so thin and sallow that he grew a beard to hide his changed appearance. Yet even though he seemed "the picture of a dying man," he also radiated a magnificent and ethereal dignity—a "chastened divinity," as Richard Bellamy described it.[187]

The "divinity" which Diller radiated reflected a deep-seated, spiritual approach to reality. The Catholicism he had practiced as a boy may have laid the groundwork for a world-view in which unassailable and ineluctable truths obtained. It was in theological terms that Diller couched the harnessing of unity and opposition within individual paintings. He described the first line drawn upon the canvas as establishing a "trinity" of relationships: the line, whatever existed around the line, and the relationship between the canvas and the line.[188] The final unity, the object, was analogous to the "Holy Ghost"; it was a manifestation of "the Father—Son—Holy Ghost . . . Father—Mother—Child."[189]

Diller had long believed in the indissoluble unity of all things. His goal had been to create images whose component parts could not be separated from the totality without irreparable damage to the parts. "I am attempting to feel the oneness of all," he wrote, "to wipe out the heritage of isolation—it is a *lie*—man can no more isolate himself than can he isolate a molecule of matter.—Not until I can achieve this knowledge of unity in its entirety—Do I feel that I can truly express the forces I feel myself in and a part of—."[190] Diller characterized this unity by means of a parable: "Let us call the artistic or creative impulse a sea—in this are many forms of living things—the oyster—hard shelled, inflexible—is born—clings to some sunken rock—and grows—hoarding within its shell a pearl—The moods of the sea are many—but the oyster feels them not—smug—

Fig. 145.
First Theme, c. 1962
Oil on canvas
50¼ × 50⅛ (127.6 × 127.3)
Collection of Emily Fisher Landau

complacent—within its fortress—neither hearing—nor speaking—nor moved by the movement of the sea—and then it dies—perhaps the pearl is found. . . . Another organism is cast adrift in this sea—it is constantly moving—activated by every caprice of the sea."[191]

Convinced that his paintings "were the instrument for [his] own development," he prophesied that they "will mark out the progress of my understanding of myself and my relation to life—That the truest manner to reflect this growth will come from instruments that I will create in the process of this coming to understanding—By painting hard & sincerely—These instruments will fashion themselves—I will find that I have them. . . . By my need for expression—I must hang on to that simplicity and breathe truth with every brush stroke."[192]

The imminence of death seemed to intensify Diller's resolve to materialize his pictorial ideas. In the year following his 1961 exhibition, he introduced a new format: black, white, yellow, and blue shapes, predominantly square, on gray fields (Figs. 138, 145, 146). As before, each element was precisely and logically related to the others and to the canvas shape. Final color, shape, and position came only after endless adjustments during the

Fig. 146.
First Theme, 1962
Oil on canvas, 42 × 42 (106.7 × 106.7)
Collection of Mrs. Robert M. Benjamin

painting process. These adjustments were not the result of intellectual but of intuitive decisions. As Diller said: "after all, you can't eliminate this feeling you have for the total thing because you're thinking on one hand of the intellectual resolving of a problem you see. After all, the visual thing is quite something else. That's certainly not an intellectual process; it only relates to it. . . . there are certain kinds of relationships between your elements of line, plane, color, movement . . . but this doesn't make a painting."[193]

Diller had always varied the hue and value of his primary colors from one painting to another. With gray as a background he was able to achieve the highest purity of color and, simultaneously, soft and muted effects. Dore Ashton described these works as "suffused with calm. Gentle luminescent greys . . . squares hang suspended. . . . Everything is intended to have the illusory, aerated quality of pure vision."[194] Diller's ongoing commitment to creating expressive art from a limited number of variables harked back to Hofmann, one of whose assignments at the Art Students League had been to "take three compositions exactly alike—try different color arrangements, with object in mind of keeping color through value and intensity in its proper place."[195]

Nineteen sixty-two also saw Diller extend his long-term interest in relief into more fully freestanding sculpture, or what he called "Color Structures." In 1949, predicting the supremacy of sculpture over what he viewed to be the decorative impasse of geometric abstraction, Clement Greenberg had identified Diller as one of a handful of "young sculptor-constructors who have a chance, as things look, to contribute something ambitious, serious and original [to the history of art]."[196] By 1962, Diller was doing just that. The Color Structures, initially vertical and composed of wooden "boxes" painted yellow, blue, and white and suspended at intervals by rods, dramatized the effect of color on the perception of volume. "The color structures," Donald Judd observed, "suggest the idea that different colors, given the same volume, appear to have different volumes in space. Or that different volumes, painted the right colors, can be equal or otherwise related."[197] Some of these constructions were totemic; others made intentional reference to human figures by reducing body parts to geometric equivalents.

By 1963, Diller had switched his material from painted wood to formica (Figs. 147–150). The smooth surface of formica, coupled with its ability to reflect as well as modulate light, lent a more elemental and foreboding quality to Diller's sculpture. The structure of these works also contributed to this sphinxlike aloofness. In place of vertically stacked cubes, separated by rods, the new series consisted of elemental, oblong forms in whose open centers rested another oblong, often of a contrasting color and set at right angles to the central monolith so that it projected in front of and behind it. Limited to black, white, blue, and yellow, these structures drew their power from references to archaic ritual and

Fig. 147.
Colored Formica Construction, 1963
Formica on wood, 104 × 23 × 7 (264.2 × 58.4 × 17.8)
Meredith Long & Company, Houston

Fig. 148.
Project for Granite, Number 5, 1963
Formica on wood, 85½ × 28¼ × 18 (217.2 × 71.8 × 45.7)
New Jersey State Museum, Trenton; Gift of the Grad Foundation and Purchase

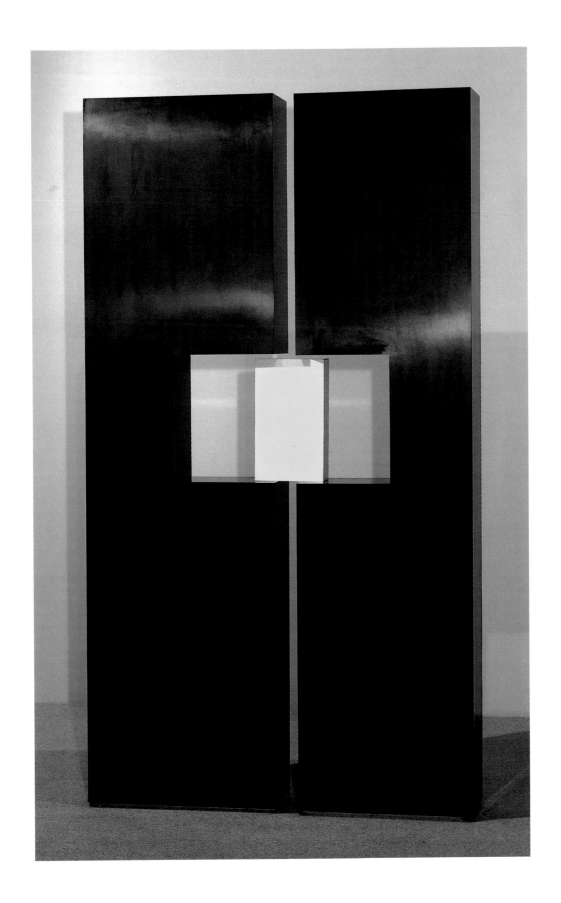

Fig. 149.
Colored Formica Construction, 1963
Formica on wood, 84 × 45 × 9 (213.4 × 114.3 × 22.9)
Meredith Long & Company, Houston

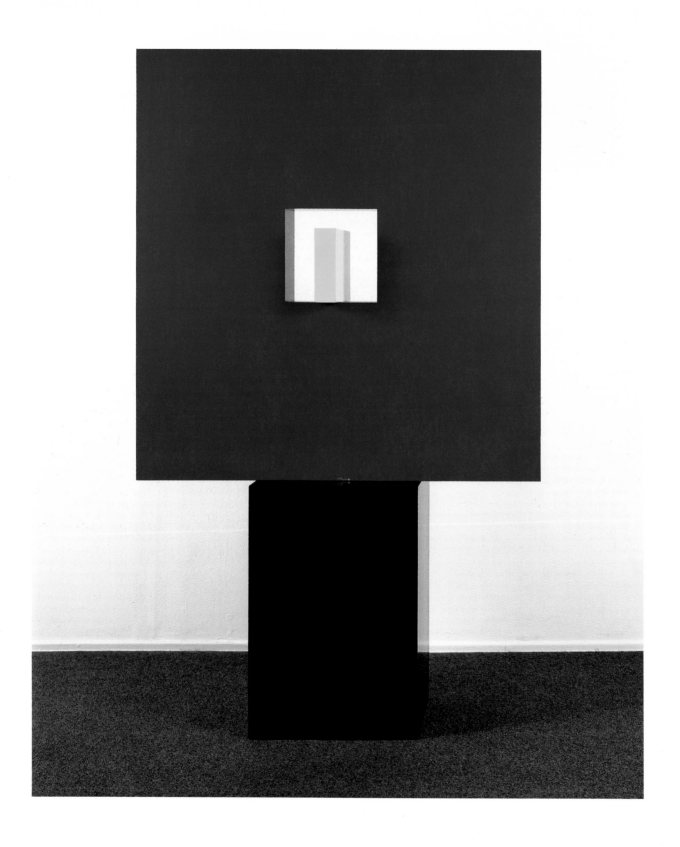

Fig. 150.
Colored Structure, 1963
Formica on wood, 71 × 44 × 15 (180.3 × 111.8 × 38.1)
André Emmerich Gallery, New York

primitive architecture. Such associations mirrored Diller's aspirations—as witnessed by drawings in which his forms loom over vast expanses of landscape like modern-day equivalents of Stonehenge (Fig. 151). But time began to run out for Diller; the number of drawings for sculptures found at his death attests to his sense of urgency combined with renewed self-confidence. Most of these sketches remained unrealized, as did his dream of transforming them into granite.

Related to the contained forms of his sculptures was a series of concurrent paintings composed of black fields in the middle of which were radiant, central shafts of white. Inside or bordering the white shaft were bands of red and yellow (Figs. 155–157). The white shaft generally originated at the top edge of the picture and terminated just short of the bottom; the red and yellow bands either followed suit or reversed the points of origin and termination. Among the last paintings in this series are two in which Diller bisected the vertical elements horizontally so as to suggest a cruciform (Figs. 158, 159). "There is nothing bleak" about these works, as Campbell remarked, "they shine like lamps."[198] Balanced and still, they glow with a profound tranquility. Their luminosity fulfilled Hofmann's directive that a painting "must light up from the inside through the intrinsic qualities which color relations offer. It must not be illuminated from the outside by superficial effects. When it lights up from the inside, the painted surface breathes, because the interval relations which dominate the whole cause it to oscillate and to vibrate."[199] The ambient glow and spiritual asceticism evoked by these works also call to mind the black cruciform paintings of Ad Reinhardt, a close friend and colleague of Diller at Brooklyn College.

Symmetrical and elemental, these works compositionally accorded with the canons of the new geometric aesthetic that dominated contemporary art in the sixties. In the early years of the decade, Diller's use of asymmetrical balance had caused the more fierce Minimalist champions to view his work as "regressive."[200] Donald Judd, for example, categorically dismissed Diller's 1962 exhibition at the Galerie Chalette: "this is a mediocre show. . . . squares [in relation] suggest a purposeful relationship, which is not present. . . . two differently colored, vertical rectangles touch. The context is too meager for this; there is Mondrian's use of the structure for comparison."[201]

Such negative assessments faded after 1963. Even Judd had agreed that the "somber color and the direct, uncompositional placement [in Diller's late work] are certainly not Purist."[202] Nevertheless, notwithstanding the truth of Lawrence Campbell's assertion that "Diller was, in the last years before his death . . . a hero for a generation of abstract painters who began to emerge about the same time,"[203] his work was never fully compatible with the Minimalist elimination of content and subjective decision making.

145

Clockwise, starting upper left:

Fig. 151.
Drawing for Sculpture, 1964
Pencil and crayon on paper
16¾ × 13¾ (42.6 × 34.9)
Meredith Long & Company,
Houston

Fig. 152.
Collage Study for Sculpture, 1963
Pencil, crayon, and collage
on paper
11 × 8½ (27.9 × 21.6)
Harcourts Modern and
Contemporary Art, San Francisco

Fig. 153.
Untitled, 1963
Pencil and colored pencil
on paper
14 × 19⅞ (35.6 × 50.5)
André Emmerich Gallery,
New York

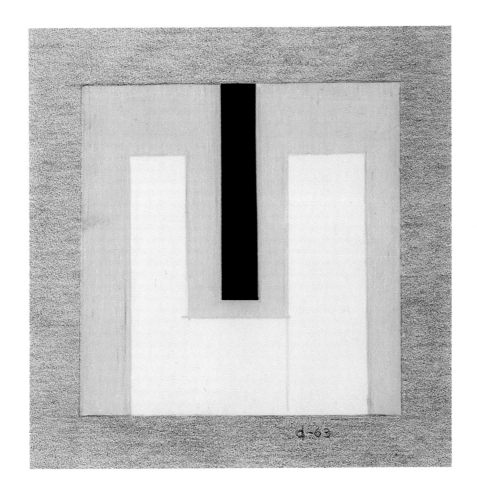

Fig. 154.
First Theme, 1963
Pencil and crayon on paper, 7 × 7 (17.8 × 17.8)
Collection of Anne and William J. Hokin

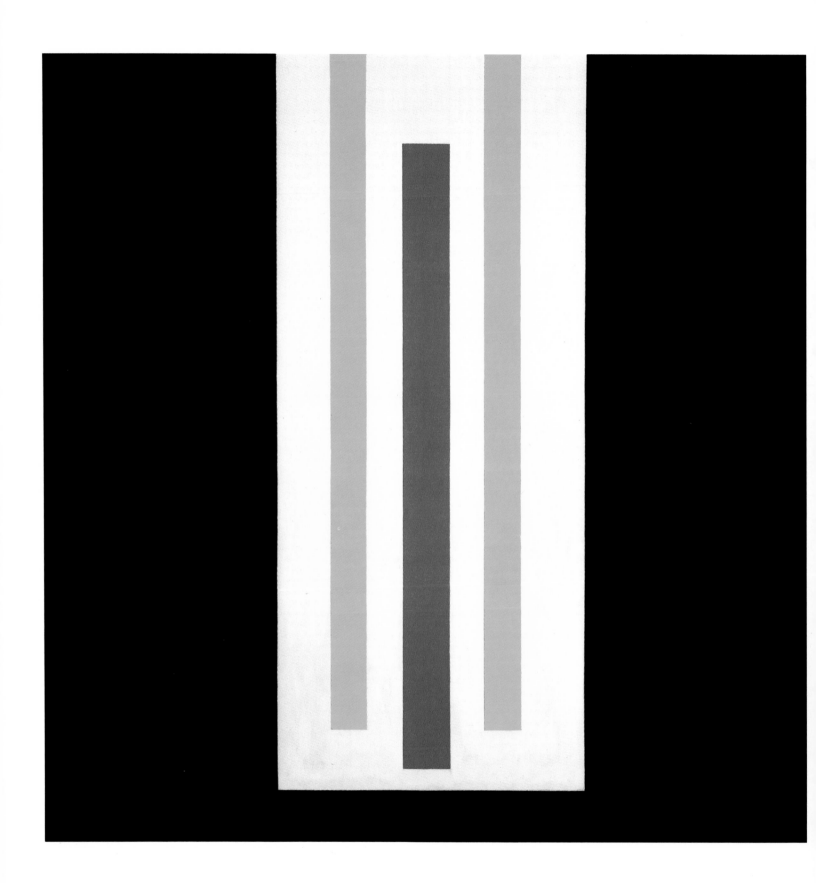

Fig. 155.
First Theme, 1963–64
Oil on canvas, 71¾ × 71½ (182.3 × 181.6)
Albright-Knox Art Gallery, Buffalo, New York; Gift of Seymour Knox

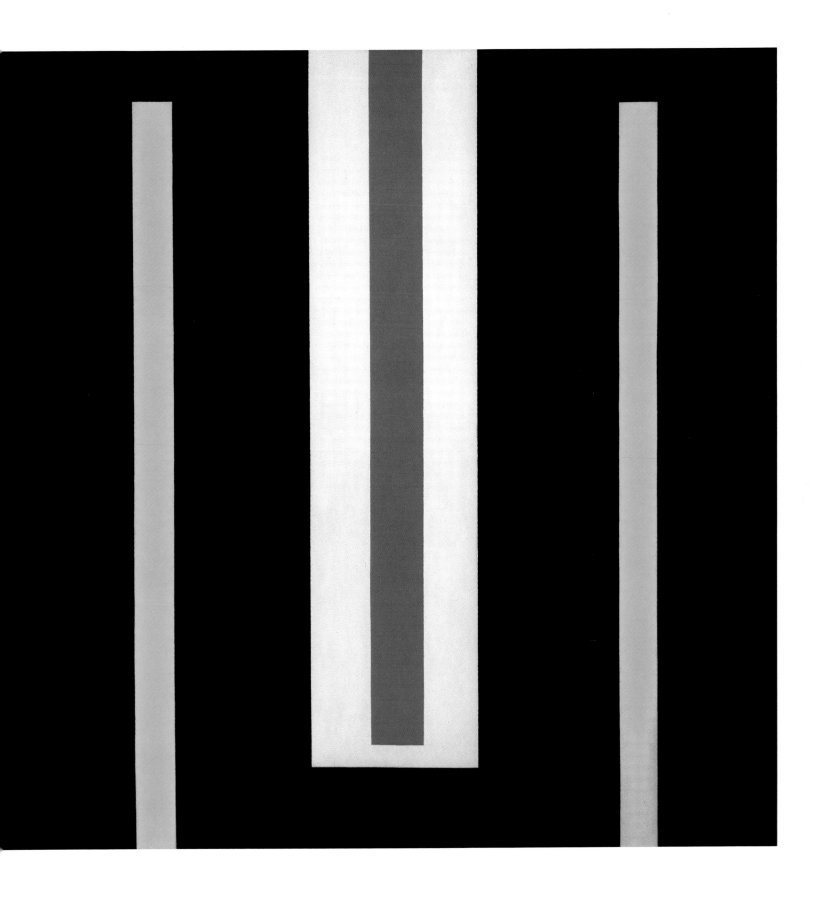

Fig. 156.
First Theme: Number 10, 1963
Oil on canvas, 72 × 72 (182.9 × 182.9)
Whitney Museum of American Art, New York; Purchase,
with funds from the Friends of the Whitney Museum of American Art 64.26

Fig. 157.
First Theme, 1963
Oil on canvas, 78⅞ × 68 (200.3 × 172.7)
Yale University Art Gallery, New Haven; Gift of Richard Brown Baker, B.A. 1935

Fig. 158.
First Theme, 1963
Oil on canvas, 72 × 71¾ (182.9 × 182.3)
The Museum of Fine Arts, Houston;
Museum purchase with funds provided by the Brown Foundation Challenge Grant Endowment Fund

Fig. 159.
First Theme, 1963-64
Oil on canvas, 72 × 72 (182.9 × 182.9)
Walker Art Center, Minneapolis; Gift of the Grandchildren of Archie D. and Bertha H. Walker

Fig. 160.
First Theme, 1963
Collage and crayon on paper, 6¾ × 6¾ (17.2 × 17.2)
Collection of Mrs. Robert M. Benjamin

Fig. 161.
First Theme, 1964
Oil on masonite
24 × 24 (61 × 61)
Collection of Mrs. Robert
M. Benjamin

Fig. 162.
First Theme Construction, 1964
Oil on masonite
22 × 22 (55.9 × 55.9)
Meredith Long & Company,
Houston

Despite deteriorating health, Diller worked through 1964 in an effort to complete as much as possible. In a series of small oils, a single white or yellow bar of color rested in the center of a black field (Figs. 161–163). These works gave proof to his thesis that "simplicity in itself is a verity—there is enough distraction." They manifested his desire to express "the truth that unites all things rather than . . . to make many things out of one truth."[204] Though physically weak during the last few months of 1964, his hopes for the future were high: he had already begun to make preliminary charcoal lines on a group of canvases far larger in size than any he had ever attempted. These remained unfinished when he entered the French Hospital in New York in critical condition in early January 1965. Diller was taken out of intensive care after several days and discharged, but the respite was temporary. Three weeks later, on January 30, 1965, he died.

Diller's tenacious commitment to abstraction and his patronage of it on the WPA/FAP had ensured the flowering of abstraction in America. He had persevered in his own work, despite personal hardship and public disapprobation, out of a belief in modernity and the potential of art to transform attitudes toward the world. He had consciously limited himself to a prescribed vocabulary in order to transcend the distractions associated with subjective excesses and thereby to more closely approximate elemental and universal truths. Diller's legacy, as one critic wrote, was a body of work whose "invention. . . . [and] breathtaking virtuosity. . . . uphold a standard that very few Americans of [his] generation have equaled."[205]

Fig. 163.
Untitled, 1964
Oil on canvas, 22 × 22 (55.9 × 55.9)
Collection of Rebecca J. LaCrone

NOTES

1. After Diller's death in 1965, his second wife, Grace, was unable to cope with the management of his paintings. Scholars who wanted to research his work were met with a barrier of silence; see, for example, Anita Ellis, "Burgoyne Diller: A Neo-Plasticist," M.A. thesis, University of Cincinnati, 1975, p. 3, and David Hoyt Johnson, "The Early Career of Burgoyne Diller: 1925-45," M.A. thesis, University of Arizona, Tucson, 1978, p. iv. Even the dealers who had handled Diller's work often refused to cooperate with scholars. In 1978, Kenneth Prescott was appointed estate representative. His effort to mount a retrospective at the National Museum of American Art failed, but his unflagging commitment to finding another venue deterred others from pursuing Diller research.

2. See, for example, Barbara Rose, *American Painting: The Twentieth Century* (New York: Skira/Rizzoli, 1977), p. 109: "Of the group [of Neoplasticists], only Burgoyne Diller, apparently through sheer intensity of spirit, created paintings of great distinction."

3. In an unpublished FBI interview, April 1941, p. 8, Diller recounted that he started painting as a child—a fact borne out by the painting lessons he took as an adolescent and by his recognized artistic achievements in junior high and high school. (Unless otherwise indicated, originals or photocopies of documentary and archival material cited are in the Diller files, Whitney Museum of American Art.)

4. Diller's father, Andrew, is described as a musical conductor and violinist by Diller's niece, Helen Oliver, and stepson, William La-Crone, in interviews with the author, February 15, 1990, and December 1, 1989, respectively, yet no records on him exist in the musical archives of Lincoln Center or in those of the Musician's Union, Local 802. The census of 1900 lists his occupation as "real estate." No death certificate for Diller's father has been found in New York City or Buffalo records; however, census records suggest that he died between 1908 and 1912. From his marriage certificate we know that he was born in March 1869 in New York, the son of Francis Diller and Mary Shields, both also born in New York. He married Mary Burgoyne at Holy Angels Church, Buffalo, New York, on September 13, 1899. The couple resided at 305 St. Ann's Avenue, the Bronx, in 1900.

5. Diller's mother, Mary Burgoyne, was born in Buffalo in 1875, the daughter of Robert L. Burgoyne (1841-1915), the superintendent of a distilling company, and Catherine Maller, who died before Diller was born. From census records, directory listings, society registers, church records, and an interview with Diller's niece, Helen Oliver, we know the following: The Burgoynes had three children: Mary, called May (Diller's mother), Genevieve (b. 1878), and Letitia (b. 1883). In 1900, Letitia was an art student. Genevieve lived on Grand Island, north of Buffalo, with her husband, Frank J. Smith; she took care of Burgoyne Diller on his summer visits to Buffalo during the 1920s.

6. Adrian Adney was reputed to be an Englishman, although his marriage certificate gives his birthplace as Bemile, Indiana. Adney worked for American Steam Pump Co. in Battle Creek; he was granted seven patents for his designs for steam pump parts (United States Department of Commerce, Patent and Trademark Office, Washington, D.C., report to the author, March 15, 1990).

7. Diller's baptism in St. Anselm's Church, Tinton Avenue, the Bronx, was attested to by John P. Cohalan, official referee of the Supreme Court of the State of New York, whose wife, Margaret, was the godmother; see letter submitted to the Navy, verifying Diller's birth, Diller Estate Archives, courtesy of Kenneth Prescott, Austin, Texas (hereafter cited as Diller Estate Archives/Prescott). No baptismal records have been retained by St. Anselm's. In Buffalo, the Burgoyne family belonged to the Holy Angels Church. Diller attended its school and that of Immaculate Conception Church.

8. In a resumé Diller compiled for the Naval Reserve, he noted that he had attended Lane Technical High School in Chicago; Diller Estate Archives, Orlando, Florida, Collection of William LaCrone (hereafter cited as Diller Estate Archives/LaCrone). Although Diller's brother, Robert, was living in Chicago during Diller's high school years, the school has no record of attendance.

9. Diller kept a number of notebooks, only one of which is dated—that from 1924-25. All are unpaginated. They contain thoughts about painting and paint technique as well as more practical jottings such as lists of books or slides for lectures. Five of them are deposited in the Archives of American Art, Smithsonian Institution, Washington, D.C., box 080583 (hereafter cited as Diller notebook, AAA).

10. Diller took only two classes in the spring of 1921, for which he received a B and a D. He did not attend school in the fall of 1921. He made up classes by going to summer school in 1922. Diller's final grade point average at Battle Creek High School was a 3.1.

11. In his notebook, Diller flirted briefly with the idea of attending the University of Pennsylvania, whose location in Philadelphia would allow him to take classes at the Pennsylvania Academy of the Fine Arts; Diller notebook, 1924-25, AAA. In a Battle Creek newspaper article on Diller from the 1930s and in chronologies prepared during his tenure with the Naval Reserve, Diller noted that he had entered Michigan State on an athletic scholarship, but no records of this exist; Diller Estate Archives/LaCrone. In the FBI interview, p. 9, Diller said that he had "a sort of job scholarship" at college.

12. Michigan State, East Lansing, is a Land Grant college, which had compulsory military training of all male students.

13. During school recesses, Diller worked in Battle Creek at Kellogg & Co. doing machine work and taking inventory, and at Rich Steel Products, drilling Chrysler valves; Diller notebook, undated, AAA.

14. Ibid.

15. For a list of the jobs Diller had in Buffalo, see Chronology; information compiled from Harlan Phillips, "Interview: Burgoyne Diller Talks with Harlan Phillips," *Archives of American Art Journal*, 16, no. 2 (1976), pp. 16-17, FBI interview, p. 9, Ruth Gurin, "Interview of Burgoyne Diller, March 21, 1964," unpublished manuscript, p. 8, Archives of American Art, roll 3418, and resumé prepared for Naval Reserve, Diller Estate Archives/LaCrone.

16. Diller attributed his decision to go to New York in part to the lack of employment opportunities in Buffalo; FBI interview, p. 9.

17. Lawrence Campbell, "The Rule That Measures Emotion," *Art News*, 60 (May 1961), pp. 34-35, described Diller's exposure to Seurat and Cézanne based on an entry he had seen in one of Diller's notebooks. Campbell submitted the article to Diller for his approval before publication. Although the location of the notebook is now unknown, others apparently read it; see William Agee, "Burgoyne Diller: Drawing and the Abstract Tradition in America," *Arts Magazine*, 59 (October 1984), p. 81.

18. Diller notebook, 1924-25, AAA.

19. Campbell, "The Rule That Measures Emotion," p. 35.

20. Gurin, "Interview of Burgoyne Diller," p. 7: "[I was] getting into Cézanne enough to begin to get why it works, but in 1928 I still had

a lot of unresolved questions about what exactly I would paint, why I would paint it, what sort of thing I'd paint and would I paint about something else or become more involved in painting itself, you know these are questions that you don't go any place and ask for an answer because you know these are things you have to find out."

21. For the controversy at the Art Students League, see "Threaten New Row at the Art League," *The New York Times*, April 29, 1932, and Helen Appleton Read, "Liberalism Put to Test," *Brooklyn N.Y. Eagle*, April 21, 1932, p. 12.

22. Diller notebook, 1924-25, AAA. That Diller's two previous art teachers, A.G. Scheele and Calogero Scibetta, had studied with Bridgman at the League may also have influenced his decision.

23. Susan C. Larsen, "The American Abstract Artists Group: A History and Evaluation of Its Impact upon American Art," Ph.D. dissertation, Northwestern University, Evanston, Illinois, 1975, p. 540.

24. See Diller's Art Students League transcript; Diller files, Whitney Museum of American Art.

25. In describing the reception of his work at the Art Students League, Diller recalled that his instructors "initialed most of the things I did to be hung in the lunchroom . . . as good examples of the student work"; Gurin, "Interview of Burgoyne Diller," p. 8.

26. Minutes of the Board of Control, Art Students League, May 2, 1930, Art Students League archives, New York.

27. Diller recounted the entire transaction with Nicolaides to illustrate their varying philosophies: "in the class I tried to do exactly what he [Nicolaides] specified as a problem. . . . I really tried to see what he was doing. . . . But they just were meaningless to me because

they were just like tricks. And so I asked him one time if I could bring in some of my own paintings and show them to him and would he criticize them. He said he would be only too happy to. So one day. . . . I brought half a dozen paintings or so and showed them to him. Well, he looked at them, and he said. . . . 'But these paintings they're really very interesting *but* you know a person of your age should not be interested in problems; they should be interested in learning how to feel.' And I said, 'Feel?' He said, 'Well, you love a woman. Taste the fruit. You know this is life, this is living and a young person like you should be experiencing *these* things, not getting involved with problems. Obviously you're involved with problems in these paintings'. . . . my only answer to him when he finished was, 'Well, if you want me to practice mental masturbation I'm very sorry. I'm not addicted to it' "; Gurin, "Interview of Burgoyne Diller," pp. 7-8.

28. Quoted in Patterson Sims, "Jan Matulka: A Life in Art," in *Jan Matulka: 1890-1972*, exhibition catalogue (New York: Whitney Museum of American Art; Washington, D.C.: National Collection of Fine Arts, 1980), p. 26.

29. Quoted in Jean Lipman, *Calder's Universe*, exhibition catalogue (New York: Whitney Museum of American Art, 1976), p. 111.

30. Dorothy Dehner, "Memories of Jan Matulka," in *Jan Matulka: 1890-1972*, p. 79.

31. Ibid.

32. Diller, FBI interview, p. 9, stated that he remained connected to the League during 1932 and 1933 only because of his job in the bookstore.

33. For Hofmann's denigration of Neoplasticism, see Harry Holtzman, unpublished recollections of

Diller, December 21, 1976, p. 4, collection of David Hoyt Johnson. Hofmann's rejection of Neoplastic principles is further attested by Carl Holty: "There was a time when Hofmann was so pedantic and emphasized one sort of structure [Cubism] to the neglect of anything else . . . he was rigid in all matter of method and dismissed the work of such artists as Mondrian and Miró out of hand"; Carl Holty, unpublished journals, January 7, 1967, n.p., collection of Milton Brown.

34. In a letter to Diller, November 4, 1933, Diller Estate Archives/Prescott, Hofmann outlined his fees for private criticism. He added a note at the bottom which read, "I would enjoy having you work with me without financial obligation."

35. Excerpted from Hofmann's 1935 recommendation of Diller, The Solomon R. Guggenheim Foundation, New York.

36. Hofmann, "Plastic Creation," *The League*, 5 (Winter 1932-33), pp. 11-15, 21-23. Hofmann's perception that reality is three-dimensional but that visual, sensory appearance is two-dimensional is often erroneously over-simplified to the view that Hofmann saw reality as being two-dimensional. See, for example, William C. Agee, "Burgoyne Diller: Drawing and the Abstract Tradition in America," *Arts Magazine*, 59 (October 1984), p. 81: "From Hofmann . . . Diller learned the two-dimensional, planar reality underlying three dimensions of appearance. . . . "

37. Hofmann, "Plastic Creation," p. 13.

38. Diller was sufficiently involved in the controversy over the hiring of Grosz and Hofmann to have been selected as one of the four student representatives to the Board of Control on this issue; see Minutes of the Board of Control, Art Students League, April 28, 1932, Art Students League archives. However, the League's constitution stipulated

that no member of the Board of Control could also be an employee of the League—a stipulation that forced Diller to turn down the offer in order to retain his job at the League store. Diller's part in organizing the 1933 Art Students League exhibition was confirmed by Harry Holtzman, letter to David Hoyt Johnson, January 26, 1977, collection of David Hoyt Johnson. Press reviews at the time noted Charles Trumbo Henry as the official organizer; see Margaret Breuning, *New York City Sun*, January 19, 1933, and [Henry McBride], "More Group Art Displays," *New York City Sun*, January 20, 1933, p. 16.

39. Harry Holtzman to David Hoyt Johnson, December 21, 1976, collection of David Hoyt Johnson.

40. Rosalind Bengelsdorf Browne, "The American Abstract Artists and the WPA Federal Art Project," in *The New Deal Art Projects: An Anthology of Memoirs*, ed. Francis V. O'Connor (Washington, D.C.: Smithsonian Institution Press, 1972), p. 228.

41. Quoted in Virginia Pitts Rembert, "Mondrian in America," manuscript, pending publication (revision of Ph.D. dissertation, "Mondrian, America and American Painting," Columbia University, New York, 1970).

42. Holtzman to David Hoyt Johnson, December 21, 1976, collection of David Hoyt Johnson. A.E. Gallatin's Museum of Living Art and *Cahiers d'Art* were among the few sources from which Americans could obtain information about modern European art. Gallatin's museum had been housed in the South Study Hall of New York University since 1927. It offered a well-chronicled survey of American and European modernism, but emphasized geometric art—from Cézanne and Cubism to the nonobjective works of De Stijl and Constructivism. *Cahiers d'Art* was

equally influential, as suggested by Arshile Gorky's comment to Byron Browne: "Don't tell me where modern art comes from . . . we all steal. You steal from *Cahiers d'Art*, I steal from *Cahiers d'Art*. The only difference is I steal better than you because I know French and you don't"; quoted in Larsen, "The American Abstract Artists Group," p. 521.

43. Tucker to Force, March 1933, Diller Estate Archives/Prescott.

44. Emily A. Francis founded Contemporary Arts in January 1930. In April 1931, a small group drew up a charter designating it a non-profit, membership association with a policy of presenting first one-artist shows. Repeatedly, it offered the public its initial glimpse of little-known but gifted young artists, and its membership came to include an array of notable names. In addition to showing their art, Francis enlisted artists to run the gallery as well. Balcomb Greene was managing the gallery in 1933, the year of Diller's first one-artist gallery exhibition; Lawrence Campbell, letter to the author, January 17, 1990; *Art Students League News*, 4 (August 15, 1951); pamphlet prepared by Contemporary Arts; Greene to Diller, 1933, Diller Estate Archives/ Prescott.

45. Sloan, introduction to *Exhibition by Ten Younger Artists from New York*, exhibition catalogue (Providence, Rhode Island: Nathaniel M. Vose Gallery, 1933).

46. Dorothy Dehner, interview with the author, May 1989.

47. In Phillips, "Interview," p. 17, Diller remarked: "It was only an afternoon job but it was money. It wasn't much, but believe me it was a lot compared to most of the artists that I was friendly with at the time."

48. Records of the PWAP, Correspondence of Region 2 office with artists, Archives of American Art, roll DC 112.

49. The prescription of proper subject matter for government art was particularly stressed by Edward Rowan, assistant director of the PWAP. In one directive, Rowan announced that any artist who found only foreign subjects sufficiently picturesque and worthy of painting "had better be dropped and an opportunity given to the man or woman with enough imagination and vision to use the beauty and possibility for aesthetic expression in the subject matter of his own country"; Richard D. McKinzie, *The New Deal for Artists* (Princeton: Princeton University Press, 1975), p. 23.

50. A.S. Baylinson, Francis Criss, and Jan Matulka were represented by abstract pictures in the Corcoran show, along with Byron Browne, Martin Craig, Stuart Davis, José de Rivera, Werner Drewes, Arshile Gorky, John Graham, Harry Holtzman, Ibram Lassaw, Pietro B. Lazzari, Louis Schanker, and Max Spivak, all of whom were working more or less abstractly; see Public Works of Art Project, *National Exhibition of Art*, exhibition catalogue (Washington, D.C.: The Corcoran Gallery of Art, 1934).

51. In New York City, the program was administered by Audrey McMahon, Frances Pollack, and Harry Knight, who had been involved with work projects for artists since late 1932 through the College Art Association.

52. Diller took no aesthetic responsibility for Mose's mural. Edward Alden Jewell, "Diverse Mural Projects: A Survey of Some Enterprises Directed by the College Art Association," *The New York Times*, May 19, 1935, p. 9, credited both Mose and Diller with the mural. Diller wrote a letter of protest asking Jewell to correct the information in one of his next columns; Diller to Jewell, undated, Diller Estate Archives/Prescott.

53. Audrey McMahon, who directed TERA, later recollected that Diller was the earliest mural supervisor for the program; McMahon, "A General View of the WPA Federal Art Project in New York City and State," in O'Connor, *The New Deal Art Projects*, p. 53. Yet she may have confused TERA with its successor, WPA/FAP, for which Diller *was* the first supervisor for murals. Harry Knight, whose testimony on the matter was more specific, claimed that Diller's first job for the WPA was to locate space in which murals might be placed; only after he demonstrated his skill at meeting the challenges of the bureaucracy was he promoted to a supervisory role; interviews conducted by the FBI in conjunction with its investigation of Diller; Diller files, Whitney Museum of American Art, pp. 18-19.

54. Diller noted that "the artist was probably the most self-reliant, self-sufficient individual in the city of New York"; Phillips, "Interview," p. 16. "We're trained for it; artists were trained for the depression"; Gurin, "Interview of Burgoyne Diller," p. 14.

55. Phillips, "Interview," p. 17.

56. David Smith recalled the 1930s in conversation with Dore Ashton; Ashton, conversation with the author, May 25, 1990. Ben Shahn's remark is quoted in Garnett McCoy, "The Artist Speaks, Part Five: Poverty, Politics and Artists 1930-1945," *Art in America*, 53 (August-September 1965), p. 96.

57. In Gurin, "Interview of Burgoyne Diller," p. 2, Diller credited Dreier with initiating the meeting and gave a lively account of the evening's events: "Because Katherine Dreier was going to be there they [Stuart Davis, Gorky, and Calder] showed up, but [by] then Calder was receiving a good deal of attention in Paris at the time and he was not too interested obviously. . . . Gorky and Davis who never got along too well took the

opportunity to insult each other. . . . Oh, boy, what a night! The comments back and forth between them. So the rest of us, the younger ones, just sat with them and listened. . . . As a matter of fact, we had a very funny sort of evening. She [Dreier] seemed to be quite interested in my work and so on. As I said, she asked me if I'd organize, get this group together. And her first comment after coming into the room was to let them know that she was in no position to finance a thing of this sort. . . . Well, she brought this up about three or four times. Finally I checked her by saying, 'Well, Miss Dreier, if you are really so poverty-stricken I'd be *very* happy to contribute to your share.' At that point I think she got along a little better." In a subsequent letter, Dreier applauded Diller and Werner Drewes for the "success" of their plan to produce the portfolio of abstract art; Dreier to Diller, undated, Diller Estate Archives/Prescott.

58. The eight artists who ultimately took part in the portfolio project (which was never realized) were: Albers, Diller, Dreier, Drewes, Gorky, Graham, Holtzman, and Outerbridge; see flier on the portfolio, Diller Estate Archives/ Prescott.

59. Ibid.

60. Gurin, "Interview of Burgoyne Diller," p. 2: "the intention was to get a few together and then try to see from that nucleus if we could get together more people."

61. Greene to Diller, July 4, 1934, Diller Estate Archives/Prescott.

62. Rosalind Bengelsdorf, "The New Realism," in *American Abstract Artists 1938* (New York: Privately printed, 1938), n.p.

63. Murray Israel, interview with the author, August 3, 1989.

64. The words are those of George L.K. Morris: "And it may come about that, in a period of chaos like the present, there will be many who can recover emotional stability and repose in the presence of such works as these, where every form and spatial interval has been controlled and measured"; quoted in *American Abstract Art*, exhibition catalogue (New York: Galerie St. Etienne, 1940).

65. Quoted in Elaine de Kooning, "Diller Paints a Picture," *Art News*, 51 (January 1953), p. 55.

66. For Hofmann's theories of color as understood by Diller, see Diller notebook, undated (c. 1931-33), AAA.

67. One of Diller's notebooks, AAA, is filled with hand-written recipes for egg tempera and with pamphlets of technical information on the medium.

68. "First I was interested in Van Doesburg rather than Mondrian. Then later on I became more sophisticated and I realized Mondrian was much more of a painter"; Gurin, "Interview of Burgoyne Diller," p. 5.

69. A native of France, Jean Hélion made frequent and extended trips to New York in the 1930s, where he met and established friendships with many renowned New York artists and collectors. By 1932, when A.E. Gallatin acquired two of his paintings for the Museum of Living Art, his work was already familiar to American artists through the pages of *Abstraction-Création*, of which he was a co-founder, and *Cahiers d'Art*. As Rosalind Bengelsdorf Browne said: "Hélion at that time was very exciting to us. The picture that Gallatin had of his was a very good one. He was important to us. There was so little going on at that time"; quoted in Larsen, "The American Abstract Artists Group," p. 541. Hélion had his first one-artist show in New York at the John Becker Gallery in 1934.

70. The "Concretionists" exhibition included Biederman, Charles Shaw, George L.K. Morris, John Ferren, and Alexander Calder. Following its New York showing, it traveled to the Galerie Pierre in Paris and the Mayor Gallery in London.

71. Diller's 1961 exhibition at the Galerie Chalette, New York, included an early painting, now owned by the Whitney Museum of American Art, which was erroneously dated 1933-34 (Fig. 66). The work has since been given this date. The Galerie Chalette was not always reliable in its dating and sometimes misdated works that Diller had actually signed and dated on the back. For example, a painting entitled *Third Theme* (Fig. 113) was listed as 1950-55 in the catalogue, while 1950-53 was inscribed on the back.

72. For a general history of the program, see Francis V. O'Connor, ed., *Art for the Millions: Essays from the 1930s by Artists and Administrators of the WPA Federal Art Project* (Greenwich, Connecticut: New York Graphic Society, 1973).

73. Gurin, "Interview of Burgoyne Diller," p. 6.

74. Phillips, "Interview," p. 17.

75. McMahon, "A General View of the WPA Federal Art Project," p. 59.

76. Phillips, "Interview," p. 18.

77. Ibid., p. 20.

78. Quoted in McCoy, "The Artist Speaks, Part Five," p. 96.

79. Quoted in Marlene Park and Gerald E. Markowitz, *New Deal for Art: The Government Art Projects of the 1930s with Examples from New York City & State*, exhibition catalogue (Hamilton, New York: Gallery Association of New York State [organizer], 1977), p. 8.

80. Phillips, "Interview," p. 20.

81. Philip Evergood, letter read at the memorial service for Diller held at the Art Students League on February 9, 1965, Art Students League archives.

82. Holger Cahill, *New Horizons in American Art* (New York: The Museum of Modern Art, 1936), p. 32.

83. Other government agencies were even more inhospitable to abstract art. As Olin Dows, director of the Treasury Relief Art Project (TRAP), another government agency that supported artists during the Depression, wrote to an artist in 1936: "Abstractions are impossible for us to use under this Project. I would suggest that you do no more abstractions like the one you sent in. Won't you, instead, do some more landscapes?"; quoted in Park and Markowitz, *New Deal for Art*, p. 31.

84. Phillips, "Interview," p. 18.

85. Ibid.

86. Diller's patronage of abstract art was particularly significant because of the concentration of abstract artists in New York City, which employed 44.5 percent of all FAP artists.

87. George McNeil, "American Abstractionists Venerable at Twenty," *Art News*, 55 (May 1956), p. 64.

88. Quoted in *Ilya Bolotowsky*, exhibition catalogue (New York: The Solomon R. Guggenheim Museum, 1974), p. 17. Rosalind Bengelsdorf Browne, "The American Abstract Artists," p. 227, repeated a similar sentiment: "Credit . . . should really go to one man who, almost single-handedly, achieved the first concrete public recognition and dissemination of abstract art in New York City—Burgoyne Diller. . . . He encouraged and expedited transfers of abstract artists to the mural division, gathering them, so to speak, 'under his wing.'"

89. Diller recalled another such incident in which the tactic was nearly thwarted: "We made a rather elaborate model of the work to be done for the Gorky mural in the Newark Airport. We did a rather good one for Gorky's presentation to the Art Commission of the City of Newark. The commission was made up of rather elderly gentlemen. I'm sure they were of some prestige socially and economically. I'm sure they fit into the upper echelons of Newark society—rather cool, forbidding characters. They were the sort of people you could see sitting in the windows of the Princeton Club, or the Yale Club. When we presented the mural I deliberately presented it as decoration so they wouldn't quibble about art. But one of them, probably brighter than the rest, said, 'Well, that's abstract art, isn't it?' That unleashed the devil. They started, of course, a tirade of questions and cross-questions and accusations and statements about modern art. Beatrice Windsor, who is socially and economically their equal, shamed them into accepting it"; quoted in Larsen, "The American Abstract Artists Group," pp. 200-01.

90. "The decision to place abstract murals in these rooms was made because these areas were intended to provide a place of relaxation and entertainment for the tenants. The more arbitrary color, possible when not determined by the description of objects, enables the artist to place an emphasis on its psychological potential to stimulate relaxation. The arbitrary use of shapes provides an opportunity to create colorful patterns clearly related to the interior architecture and complementing the architect's intentions"; Diller, "Abstract Murals," in O'Connor, *Art for the Millions*, p. 69.

91. See the unpublished WPA pamphlet, "Murals by Louis Schanker, Byron Browne, Stuart Davis, Hans Wicht for Radio Station WNYC," archives of the New York City Art Commission, City Hall: "This is the

first time that abstract murals have been painted for a radio station, although they are particularly suited for use in a modern broadcasting studio, where everything must contribute to quiet and the uninterrupted function of the broadcast. The studio itself is a sound-proofed, air-conditioned room, which must permit concentration during the performance of a program. The abstract mural is the best answer to these requirements, since it does not serve to distract the observer, but rather exercises a soothing influence through the proper use of form and color."

92. Perhaps encouraged by Diller's success, several other abstract murals were commissioned in New York outside the auspices of the WPA: Gorky was commissioned by William Lescaze, the architect of the Williamsburg Housing Project, to design an abstract mural for the Aviation Building at the 1939–40 World's Fair; and Willem de Kooning, Michael Loew, and Stuyvesant van Veen collaborated on a mural for the Hall of Pharmacy Building at the same fair. Across the country, the situation was bleaker. Stanton Macdonald-Wright, who became regional West Coast head of the WPA/FAP, might have performed a similarly encouraging function. But because there were relatively few non-representational artists in his region, there were almost no abstract murals produced under his jurisdiction.

93. In Phillips, "Interview," p. 21, Diller described Mayor La Guardia's rejection of Gorky's mural proposal. After seeing the design at the opening of the Federal Art Gallery, La Guardia apparently said, "Well, this is Tammany Hall politicians." The experience with the French Line is recounted in the same article, p. 19. Léger's design was rejected out of hand by the company president when he realized that it was being executed by Léger, whom he regarded as a Communist. Very little information exists on the Riker's Island rejections except in the case of Balcomb Greene, whose

design for the Jewish chapel contained a symbol which Diller advised Greene to exclude due to its similarity to a swastika; on the same basis, the design was rejected by the sponsoring rabbinical group.

94. See Gurin, "Interview of Burgoyne Diller," p. 14, for Diller's perception of the vying factions in the WPA: "you had the extreme position of extreme left and extreme right. . . . all striving for positions . . . places to put murals and whatever. Then you had an administration that was very anxious to curry favor because it was . . . in a sense a people's program. So you had so many forces at work . . . the WPA itself was a political football. . . . But caught in the middle of all these forces it was the sort of a thing where you sort of lived the program seven days a week. . . . it was like being involved in some form of an insane world. . . ."

95. Edward Laning, "The New Deal Mural Projects," in O'Connor, *The New Deal Art Projects*, p. 100, described how Diller secured the mural commission: "Diller had approached Mr. Isaac Newton Phelps Stokes, a member of the Board of Trustees of the Library and Chairman of the Art Commission of the City of New York, and had told him bluntly that it appeared that Mr. Stokes was hostile to young artists and indifferent to their fate. Mr. Stokes had been shocked by the charge and had denied it. Diller said that Mr. Stokes should prove his good faith by agreeing at least to look at sketches for those big empty spaces in the library's third-floor hall. . . . Stokes agreed."

96. Dore Ashton, *A Critical Study of Philip Guston* (New York: Viking Press, 1976), p. 39, notes that "Diller was a magnetic force for Guston," that "Guston had endless discussions about modern art with the gentlemanly Diller. . . . his knowledgeable discourse on recent

trends in Paris aroused Guston's doubts [about his commitment to the Renaissance vision]." Diller salvaged Jackson Pollock's job on the Project by pleading the validity of Pollock's work before the supervisor of the easel division, Lloyd Rollins, and the assistant technical director, Harry Knight; Gurin, "Interview of Burgoyne Diller," p. 5. Dorothy Miller remembered the same incident: "Pollock tried to leave the Easel Division because his work was not acceptable . . . Diller went after him and made him come back"; quoted in Stephen Naifeh and Gregory White Smith, *Jackson Pollock: An American Saga* (New York: Clarkson N. Potter, 1989), p. 845.

97. Philip Evergood, "Concerning Mural Painting," in O'Connor, *Art for the Millions*, p. 48.

98. Ibid., pp. 22-23.

99. Stuart Davis, quoted in John R. Lane, introduction to *Abstract Painting and Sculpture in America 1927-1944*, eds. John R. Lane and Susan C. Larsen, exhibition catalogue (Pittsburgh: Museum of Art, Carnegie Institute, 1983), p. 12.

100. Louis Guglielmi, "After the Locusts," in O'Connor, *Art for the Millions*, p. 113.

101. Meyer Schapiro, addressing the first American Artists' Congress in 1936, likened abstractionists to a woman who "constantly rearrange[s] herself as an aesthetic object"; he identified their art as "private instruments of idle sensation"; Schapiro, "The Social Bases of Art," *First American Artists' Congress*, 1936, quoted in Lane and Larsen, *Abstract Painting and Sculpture in America*, p. 12. Alfred Barr, director of The Museum of Modern Art, went so far as to suggest that the involvement of abstractionists "with the world of art instead of the world of life . . . may consequently be taken as a symbol of the modern artist's social maladjustment"; Barr, *Cubism and Abstract Art* (New York: The Museum of Modern Art, 1936), p. 15 n. 1.

102. See Peyton Boswell, Jr., quoted in American Abstract Artists, *The Art Critics—! How Do They Serve the Public? What Do They Say? How Much Do They Know? Let's Look at the Record!* (New York: Privately printed, 1940), p. 12.

103. One of the specific contentions against The Museum of Modern Art was that it exhibited Eugene Speicher and George Luks in 1940 while ignoring American abstract artists and that, when it came to mounting an exhibition of modern American masters, "Art in Our Time," in 1939, it chose marginal realist American artists such as Henry McFee, Alexander Brook, Eugene Speicher, Louis Eilshemius, Ernest Blumenschein, Alexandre Hogue, Fletcher Martin, and Ernest Fiene, and excluded American abstractionists (with the exception of Alexander Calder and Stuart Davis); see *Art in Our Time*, exhibition catalogue (New York: The Museum of Modern Art, 1939). In 1940, the museum's exhibition of cartoons created for the magazine *P.M.*, mounted at the same time that it was ignoring American abstractionists, so enraged members of the American Abstract Artists group that they picketed the museum, distributing a caustic but witty leaflet designed by Ad Reinhardt.

104. Barr, *Cubism and Abstract Art*, p. 20. Similarly, Stuart Davis, *Abstract Painting in America*, exhibition catalogue (New York: Whitney Museum of American Art, 1935), announced that "the period of greatest activity in abstract art in America was probably from about 1915 to 1927." The Whitney Museum staff apparently concurred, for it failed to include all but a handful of contemporary abstract artists in the exhibition.

105. Browne, "The American Abstract Artists," p. 229. Balcomb Greene, quoted in Larsen, "The American Abstract Artists Group," p. 525, reiterated the importance of the mural division as a meeting place for the future members of the

AAA: "The nucleus of the basic group got to know each other through the Project." Thomas Tritschler, *American Abstract Artists*, exhibition catalogue (Albuquerque: Art Museum, University of New Mexico, 1977), p. 3, noted Diller's importance to the formation of the AAA even more emphatically: "in his role as administrator of the Mural Division [Diller] could be described as partly responsible for [the American Abstract Artists'] creation."

106. The Ten, which included Rothko and Gottlieb, were independent artists, the majority of whom painted representational images in a loose, flat manner. In 1938 the group organized an exhibition, "The Ten: Whitney Dissenters," to protest the Whitney Museum's exhibition policies.

107. The group's first meeting, in the fall of 1935, was at Rosalind Bengelsdorf Browne's studio, 230 Wooster Street. Two subsequent meetings were held at Lassaw's studio, the second to initiate plans to exhibit at the Municipal Art Galleries, which required a minimum of twenty-five exhibitors. Information about these early meetings exists only in the form of reminiscences; see Rosalind Bengelsdorf Browne's corrected copy of Tritschler, *American Abstract Artists*, pp. 3-4, Library, Whitney Museum of American Art; McNeil, "American Abstractionists Venerable at Twenty," p. 64; Larsen, "The American Abstract Artists Group," pp. 539-40; Browne, "The American Abstract Artists," pp. 227-30. Rosalind Bengelsdorf Browne and McNeil both remember Diller attending meetings in Lassaw's house.

108. Holtzman proposed an abstract artists' cooperative workshop and school, which would be a center for intellectual discussions. Many people opposed this idea because they thought Holtzman perceived himself as the instructor. Gorky, acting immediately on Holtzman's proposal, suggested an assignment so that everyone would be able to compare work. Each artist would bring a painting of an electric light bulb, a piece of string, and one other item, executed in a red, black, and white palette, to the next meeting. At this subsequent meeting, artists resented Gorky's efforts to preside and challenged his assumption of leadership; after a heated debate with Werner Drewes, Gorky walked out and de Kooning left shortly after; see Larsen, "The American Abstract Artists Group," pp. 223-28.

109. Gurin, "Interview of Burgoyne Diller," pp. 9-10.

110. Browne, "The American Abstract Artists," p. 232.

111. Although some historians have assumed Diller attended the meetings in Holtzman's studio, he probably did not. See Gurin, "Interview of Burgoyne Diller," p. 9: "I was not at the first few meetings. I went to one of them . . . but after they'd been really started . . . because then I was in the thick of this Project business, I was absolutely unable to get there."

112. Invited to join at this first AAA meeting but not present were de Kooning, Gorky, Drewes, Arthur Carles, Ralph Ward, Barbara Bigelow, Marie Kennedy, Martin Craig; Larsen, "The American Abstract Artists Group," p. 231.

113. FBI interview, p. 7.

114. When Diller failed to participate in several successive exhibitions, the then treasurer, Alice Trumbull Mason, wrote to notify him that he was dropped from membership. Because of his supervisory authority over most of the AAA members, many believed that his lack of active participation in the organization was motivated by political factors; see Larsen, "The American Abstract Artists Group," p. 567, quoting George McNeil: "because so many of the people worked with him, it would not have been wise [for Diller] to be too involved." Balcomb Greene made a similar observation: "it seemed to be Diller's policy to be less intimate with those working under him than he would be otherwise"; FBI interviews (as in n. 53), p. 18. Diller himself agreed with this assessment, and told Irving Sandler that he had thought it inadvisable to take sides; notes from a 1959 interview with Diller, collection of Irving Sandler.

115. The AAA's presidency alternated between Balcomb Greene and Carl Holty. George L.K. Morris served as an equally important force through his articles in the group's annual catalogues and his column, "Art Chronicle," in the *Partisan Review*. Larsen, "The American Abstract Artists Group," p. 229, identified Morris as "the major spokesman for the American Abstract Artists."

116. See Vaclav Vytlacil, ibid., p. 581: "We came to the geometric form, we came from different backgrounds. Not everyone was willing to settle for geometric painting forever. This was a crusade out of those who took it to be the religion of the future. . . . some of us dropped away from it because we wanted to paint in other ways. . . . "

117. Ibid., p. 397.

118. Rebay is characterized as a "wench" in the official minutes of the American Abstract Artists, December 22, 1940, Archives of American Art, roll N69-72.

119. The co-signing artists were Rosalind Bengelsdorf Browne, Hananiah Harari, Jan Matulka, Herzl Emanuel, Byron Browne, Leo Lances, and George McNeil. The letter is quoted by Browne, "The American Abstract Artists," pp. 230-32.

120. In a letter written to Rebay by Johnson, he accused her of telling artists what to paint, denying them jobs if they didn't comply with her aesthetic viewpoint, and not allowing scholarship students to visit Hofmann for fear he would "contaminate" their viewpoint; see Johnson to Rebay, November 20, 1940, Diller Estate Archives/ Prescott. Diller kept a copy of Johnson's letter, along with a newspaper clipping noting that Rebay was held as a suspect by the New York City police during the war for hoarding rationed food items. In claiming that she had Nazi sympathies, Johnson cited her statement— which she denied—that now that the Jews are gone from Germany, Germans feel free to leave their doors unlocked.

121. For discussion of Congressional action and the political climate in the last years of the WPA/FAP, see McKinzie, *The New Deal for Artists*, pp. 155-58.

122. McMahon, "A General View of the WPA Federal Art Project in New York City and State," p. 56.

123. McKinzie, *The New Deal for Artists*, p. 156.

124. Audrey McMahon, unpublished report, July 30, 1940, National Archives, Washington, D.C., WPA records, reported on the outcome of the investigations of all three murals in question.

125. Diller's alleged Communist affiliation was based on the following: the people he associated with were thought to be Communists; he voted with members of a society thought to be Communist; members of the Shop Committee of the Workers Alliance were often in his office; he had been seen talking to Audrey McMahon across the street from a sit-in strike; he read and allowed *Red Paint*, a Communist publication, on the Project; he permitted class-conscious work to be done in the mural division; in 1934, he advocated forming an artists union; during the Spanish Civil War he allowed collections for the Abraham Lincoln Brigade to be taken in his office; he was high in

the councils of the Communist party under another name; he attended weekly meetings of the WPA Supervisors' Union and was friendly with a group of Communist organizers who attended those meetings; he carried copies of the *Daily Worker* and *New Masses*; he used Communist terminology; he voiced objections to the current US government, avowing that changes would be made when the revolution came; his work had been exhibited with the Society of Abstract Painters, a Communist front organization. See FBI interviews (as in n. 53) with Diller's colleagues and associates on the WPA.

126. In 1939, the WPA/FAP had been merged with the Work Projects Administration of the Federal Works Agency. Diller's duties as assistant technical director of the WPA Art Program included responsibility for the following divisions: mural, easel, stone carving, metal and woodworking, photography, design and drafting, and silkscreen printing. Diller resumé, Diller Estate Archives/Prescott; resumé prepared for US Naval Reserve, Diller Estate Archives/LaCrone.

127. Holger Cahill administrative papers, National Archives, Washington, D.C., RG69.

128. McKinzie, *The New Deal for Artists*, p. 171.

129. The words are those of Stuart Davis, "Abstract Painting Today," in O'Connor, *Art for the Millions*, p. 126. Diller's own views were recounted by Murray Israel, interview with the author, August 3, 1989.

130. The letters between Diller and his wife, Sally, during his three months in basic training are filled with concern over his ultimate assignment with the Navy; Diller Estate Archives/LaCrone.

131. Robert Jay Wolff, "Recollections of Burgoyne Diller," unpublished essay, July 1977, p. 2, collection of David Hoyt Johnson.

132. For the US Navy Training Aids Development Center, see "Administrative History, Bureau of Naval Personnel: Part IV—Training Activity, Volume Three—Training Aids Division," March 1942, Navy Department Library, Washington, D.C.

133. In May 1945, Diller was paid $1,000 for the "commercial and foreign rights" to the patent for his blinker device by the Einson-Freeman Company, Long Island City, New York; contract with Einson-Freeman, Diller Estate Archives/Prescott.

134. Wolff, "Recollections of Burgoyne Diller," p. 4: "it was an embarrassing and infuriating situation, although Diller took it philosophically." Wolff also vividly described Diller's superior officer as "a rather tight-lipped little man by the name of Beckwith who disliked Diller and seemed to go out of his way to be unkind to him."

135. Phillips, "Interview," p. 20.

136. According to Holtzman, he had arranged a dinner party for Diller and his wife to meet Mondrian. "We waited for almost an hour before the Dillers came . . . and when they arrived they announced that they couldn't stay for dinner as they had theater tickets"; Holtzman to David Hoyt Johnson, December 21, 1976, collection of David Hoyt Johnson. This account rings untrue. Diller was known, above all, for his perfect manners and gentlemanly behavior. That he would have insulted any host by knowingly forgoing a dinner would have been out of character.

137. Quoted in de Kooning, "Diller Paints a Picture," p. 55.

138. Ibid., for Diller's working method.

139. Dore Ashton, "Art Review," *Arts and Architecture*, 78 (July 1961), p. 5.

140. Diller's notoriety with the WPA had led certain artists to assume he had given up his art during that period; see Bolotowsky, in

Larsen, "The American Abstract Artists Group," p. 491.

141. Janis to Diller, 1942, Diller Estate Archives/Prescott.

142. Dreier to Diller, March 7, 1946, Dreier Archives, Collection of American Literature, Beinecke Rare Book and Manuscript Library, Yale University, New Haven.

143. For Diller's critics, see Edward Alden Jewell, "Two One-Man Shows," *The New York Times*, December 22, 1946, p. X12. For those who endorsed his work, see "Reviews and Previews," *Art News*, 45 (December 1946), pp. 52-53, and D[ore] A[shton], "Fifty-Seventh Street in Review: Burgoyne Diller," *The Art Digest*, 26 (November 15, 1951), p. 20.

144. Emily Genauer, *New York World-Telegram*, March 7, 1936; Edward Alden Jewell, *The New York Times*, November 1, 1936; both quoted in American Abstract Artists, *The Art Critics—!*, pp. 10 and 6.

145. Diller's notebook entries, AAA, are filled with such comments. See, for example, "The quest for truth is soul creating—but heart breaking."

146. Greene to Diller, 1933, Diller Estate Archives/Prescott.

147. Diller had held an adjunct professorship at the college in the spring of 1946.

148. For the Brooklyn College department of design, see *Brooklyn College Art Department, Past and Present: 1942-1977*, exhibition catalogue (New York: Davis & Long Company/Robert Schoelkopf Gallery, 1977), and faculty records on file in the Brooklyn art department.

149. The Design Laboratory was founded in 1935 through the initiative of the WPA/FAP administration. Its intent was to train students to apply the principles of fine arts to

industrial production. Originally affiliated with the WPA, it had become independent in 1937 after the first wave of WPA cutbacks; Belisario R. Contreras, *Tradition and Innovation in New Deal Art* (Lewisburg, Pennsylvania: Bucknell University Press; London and Toronto: Associated University Presses, 1983), p. 166, and McKinzie, *The New Deal for Artists*, pp. 131-32.

150. Milton Brown and Robert Henry gave accounts of Diller's sculpture course in interviews with the author, May 1989 and November 15, 1989, respectively, See also *Brooklyn Art Department*, p. 13.

151. Letter from Kootz to *The New York Times*, 1941, quoted in Serge Guilbaut, *How New York Stole the Idea of Modern Art* (Chicago: University of Chicago Press, 1983), p. 65.

152. Clement Greenberg, "Toward a Newer Laocoön," *Partisan Review*, 7 (July–August 1940), p. 24.

153. Clement Greenberg, "Art," *The Nation*, May 2, 1942, p. 526.

154. Robert Motherwell, "Notes on Mondrian and Chirico," *VVV*, 1 (June 1942), p. 59.

155. Ibid., p. 31.

156. Mark Rothko and Adolph Gottlieb (in collaboration with Barnett Newman), "Letter to the Editor," *The New York Times*, June 13, 1943, ibid., p. 62.

157. Quoted in Michael Auping, *Abstraction, Geometry, Painting: Selected Geometric Abstract Painting in America since 1945*, exhibition catalogue (Buffalo: Albright-Knox Art Gallery, 1989), p. 40. For Newman, Mondrian would remain the "matrix of the abstract aesthetic"; among the last of his paintings is a series of four works entitled *Who's Afraid of Red, Yellow, and Blue?*

158. Samuel Kootz, for example, dropped Carl Holty and Byron Browne from his gallery roster in

1949 and sold their work at Gimbel's department store; see Guilbaut, *How New York Stole the Idea of Modern Art*, pp. 178-79.

159. Clement Greenberg, "Art," *The Nation*, May 3, 1947, p. 525.

160. Marynell Sharp described Diller's "almost hypnotic expressions" in "Fifty-Seventh Street in Review: Dynamic Counterpart," *Art Digest*, 24 (December 1, 1949), p. 13.

161. Edward Alden Jewell, "Two One-Man Shows," *The New York Times*, December 22, 1946, p. X12, and Alonzo Lansford, "In Harmony with Mondrian," *Art Digest*, 21 (January 1, 1947), p. 14.

162. Lawrence Campbell, "Diller: The Ruling Passion," *Art News*, 67 (October 1968), p. 36.

163. Lillian Kiesler, interview with the author, May 24, 1989.

164. Sally apparently told Rose Fried that her advice to anyone would be never to marry an artist; Silvia Pizitz, interview with the author, April 1989; Holtzman verified that Sally disapproved of the direction of his and Diller's work; Holtzman to David Hoyt Johnson, December 21, 1976, p. 4, collection of David Hoyt Johnson.

165. Holtzman to Johnson, ibid.

166. According to Murray Israel, interview with the author, August 3, 1989, Diller fell in love with one of his students at Brooklyn College during this period.

167. Wolff, "Recollections of Burgoyne Diller," p. 9.

168. According to several of Diller's friends, Sally became "hopelessly psychotic" and was committed for treatment; Harry Holtzman to David Hoyt Johnson, December 21, 1976, p. 7, collection of David Hoyt Johnson; Murray Israel, interview with the author, August 3, 1989.

169. Wolff, "Recollections of Burgoyne Diller," p. 9.

170. The letters from Diller to Grace are undated but cover the period from the summer of 1954 until their marriage in July 1955; Diller Estate Archives/LaCrone.

171. Grace was generally described by Diller's friends as a simpleton; interviews with the author: Milton Brown, June 1989; Sidney Tillim, September 25, 1989; Lawrence Campbell, November 30, 1989; Murray Israel, August 3, 1989; and Silvia Pizitz, April 13, 1989.

172. Valentine card, 1957, Diller Estate Archives/LaCrone. Grace's lack of understanding persisted, as indicated by the false pride she took in Diller's never having used a ruler and her confusion about his WPA experience—she told Philip Larson that Diller had done WPA murals, and that they had been removed from public buildings because a government official saw a "hammer and sickle lurking among Diller's red and black bands"; Kenneth Prescott, interview with the author, July 1989; Philip Larson, *Burgoyne Diller: Paintings, Sculptures, Drawings*, exhibition catalogue (Minneapolis: Walker Art Center, 1971), p. 9.

173. Lawrence Campbell, interview with the author, November 30, 1989.

174. Wolff, "Recollections of Burgoyne Diller," p. 10.

175. Leon Polk Smith, interview with the author, May 25, 1989.

176. Irving Sandler, notes taken after a 1959 interview with Diller, collection of Irving Sandler.

177. Ibid.

178. Ibid. The Whitney Museum acquired *Third Theme*, 1946–48 (Fig. 112), as a gift from Mary Walters; The Museum of Modern Art acquired *Construction*, 1938, as a gift from Mr. and Mrs. Armand Bartos, and *First Theme*, 1942 (Fig. 104), as a gift from Silvia Pizitz.

Diller told Irving Sandler that seeing his *First Theme* in The Museum of Modern Art depressed him because it reminded him that he had not done any work recently.

179. Photocopy of Florence Maisel's notes taken during Diller's lectures, Diller files, Whitney Museum of American Art.

180. Undated notes taken by Lawrence Campbell during conversations with Diller, collection of Lawrence Campbell.

181. Rothko, Gottlieb, Newman, "Letter to the Editor," quoted in Sandler, *The Triumph of American Painting*, p. 62.

182. Rothko's remark is quoted in Lawrence Alloway and John Coplans, "Talking with William Rubin: 'Like Folding Out a Hand of Cards,'" *Artforum*, 13 (November 1974), p. 51.

183. Undated notes taken by Lawrence Campbell during conversations with Diller.

184. Sidney Tillim, "Month in Review," *Arts*, 35 (May-June 1961), p. 78.

185. Stuart Preston, "Modern Sculpture Turns the Body into Art," *The New York Times*, May 14, 1961.

186. Perhaps misunderstanding Diller's medical condition, Grace Diller believed that her husband was afraid to go to sleep because he thought that if he did he would die; as recalled by her son, William LaCrone, interview with the author, December 1, 1989.

187. The first quotation comes from Carl Holty, January 19, 1963, entry in unpublished notebook, collection of Milton Brown; the second is from Richard Bellamy, telephone interview with the author, November 1989.

188. The discussion of Diller's theory of trinity and unity of matter is drawn from Diller notebook, AAA. Although undated, it contains material which suggests a post-1946 date.

189. Ibid.

190. Ibid.

191. Ibid.

192. The passage beginning the paragraph is from undated notes taken by Lawrence Campbell during conversations with Diller, collection of Lawrence Campbell; the longer quotation is from Diller notebook, undated, AAA.

193. Gurin, "Interview of Burgoyne Diller," pp. 8,9.

194. Dore Ashton, "New York Commentary," *Studio*, 165 (March 1963), p. 118.

195. Diller notebook, undated, AAA.

196. Clement Greenberg, "The New Sculpture," *Partisan Review*, 6 (June 1949), p. 641.

197. Donald Judd, "In the Galleries," *Arts Magazine*, 37 (January 1963), p. 52.

198. L[awrence] C[ampbell], "The Ruling Passion," *Art News*, 67 (October 1968), p. 59.

199. Hans Hofmann, "Excerpts from the Teaching of Hans Hofmann," in *The Search for the Real and Other Essays*, eds. Bartlett H. Hayes, Jr., and Sara T. Weeks (Cambridge: The MIT Press, 1967), p. 67.

200. J[ane] H[arrison], "In the Galleries," *Arts Magazine*, 38 (May-June 1964), p. 33.

201. Judd, "In the Galleries," p. 52.

202. Ibid.

203. Lawrence Campbell, "Reviews and Previews," *Art News*, 67 (May 1968), p. 12.

204. Diller notebook, undated, AAA.

205. Hilton Kramer, "Art: Mondrian Extended," *The New York Times*, April 27, 1968, p. 34.

CHRONOLOGY

Compiled by Jane Niehaus

Only major exhibitions of Diller's work are included here; for a more detailed list, see the Selected Exhibition History.

Diller, June 1912

Battle Creek High School track team, 1924; Diller stands third from left

Diller at St. Mary's Lake, Michigan, c. 1925

1906

January 13. Burgoyne Andrew Diller born on Beck Street, the Bronx, New York, the second son of Mary Burgoyne and Andrew Diller (older brother, Robert, born 1900). Called "Bud" by family; as an adult, he is known as "Diller."

Late January. Baptized, St. Anselm's Church, Tinton Avenue, the Bronx, New York. Raised Roman Catholic.

c. 1908

Father dies of consumption.

1910

Due to strained family finances, Robert Diller is sent to Buffalo, New York, to live with his maternal grandfather, Robert L. Burgoyne, and aunts Genevieve and Letitia. Burgoyne remains in New York with mother.

1913

Moves to Buffalo with mother; lives with her at 502 West Avenue, along with grandfather, brother, and two aunts.

Fall. Enrolls in Holy Angels Elementary School, Buffalo. Attends this and Immaculate Conception Elementary School, Buffalo, through spring 1919.

Mother works for Henry W. Fox Co.

1915

May 10. Grandfather dies.

1918

September. Enters seventh grade at Battle Creek Junior High School; takes applied art and mechanical drawing.

1919

January 29. Mother marries Adrian Peel Adney, draftsman and inventor, in Buffalo.

April. Moves to 214 West Washington Street, Battle Creek, Michigan, with mother and stepfather; stepfather works as a draftsman and engineer for American Steam Pump Co. (later called American-Marsh Pumps, Inc.).

1920

Family moves to a house on St. Mary's Lake, near Battle Creek.

September. Enters Battle Creek High School.

1921

Spring. Takes only two classes at Battle Creek High School.

Fall. Does not attend school.

1922

Spring. Returns to Battle Creek High School; begins drawing classes; joins the track and cross-country teams.

Summer. Takes courses to make up for absences in 1921.

1924

Visits his brother, Robert, in Chicago. Sees a Cézanne still life at The Art Institute of Chicago, which initiates his interest in the expression of volume through color.

1925

Becomes captain of the track team (high jump) and a member of the cross-country team.

June. Graduates from Battle Creek High School.

Summer. Works at Rich Steel Products, Battle Creek.

Fall. Enrolls in Michigan State College of Agriculture and Applied Science, East Lansing, on a partial scholarship. Joins Sigma Alpha Epsilon fraternity. Receives letter in track, placing first in pole vault and high jump. Studies art with Arnold George (A.G.) Scheele through spring 1927.

Winter. During college recess, works at Kellog & Co., Battle Creek, doing machine work and taking inventory in stock room, and at Rich Steel Products, drilling Chrysler valves.

1926

January. Attends Michigan State College through spring term.

Summer. Unsuccessfully seeks employment in Buffalo. Visits his brother, Robert, in Chicago.

Fall. Does not attend Michigan State College. Works at Kellog & Co., Battle Creek.

1927

January. Returns to Michigan State College; remains through spring term.

Late spring. Leaves Michigan State College, having completed eighty-one of two hundred and ten credits necessary to graduate. Receives letter in track.

Summer. Moves to Buffalo; lives with his brother, Robert, who has moved back there, his sister-in-law, and two nieces through fall 1928.

Has a series of short-term, odd jobs: track coach; silkscreen printer with Buffalo Advertising Artists Co. (several months); mechanic with Buffalo Gasoline Motors (one month); window trimmer for Victor Furniture Co.; janitor in Buffalo Post Office; and machinist; works in hop and malt business (several months).

Studies art privately with Calogero Scibetta.

1929

January. Moves to New York City; lives at 411 West 49th Street. Enrolls at the Art Students League.

Diller, far right, at the dedication of James Michael Newell's WPA/FAP mural, *The Evolution of Western Civilization*, Evander Childs High School, New York, November 1938

Diller's mother and stepfather with Sally Conboy, Diller's first wife, mid-1940s

Takes life class for one month with George Bridgman. Works as a free-lance artist, painting signs for restaurants in exchange for meals, through June.

February. Takes life class with Boardman Robinson at the Art Students League.

June. Begins scholarship job in the Art Students League store; supported by scholarship through 1933. Moves to 301 West 13th Street. Takes life class with Kimon Nicolaides for two months.

August. Takes landscape class with William von Schlegell.

September. Moves to 180 Avenue A, near 11th Street.

October. Begins studying with Jan Matulka at the Art Students League.

1930

Continues studying with Jan Matulka at the Art Students League; during summer takes afternoon studio class there.

September 24. Marries Sarah (Sally) Bernadette Conboy. Moves to 7 West 20th Street.

1931

January. Studies lithography with Charles Locke at the Art Students League.

February. Studies with Jan Matulka, through spring.

1932

May. Participates in his first group show at G.R.D. Studio, New York.

June. Moves to 2635 4th Street, Astoria, Queens, New York. Lives in four-story house with Art Students League friends: Will Barnet, Stewart Klonis and his wife, and John Robertson and his wife. Lives here through December 1933.

Studies life drawing with George Grosz at the Art Students League.

July–August. Studies lithography with Harry Wickey.

October. Begins studying life drawing with Hans Hofmann at the Art Students League.

1933

January. Studies with Hans Hofmann, through April.

February. First one-artist gallery exhibition, at Contemporary Arts New York.

Summer. Studies lithography with George Picken at the Art Students League.

December. Loses job at the Art Students League store due to financial retrenchment at the League.

1934

January. Moves to 219 West 14th Street.

January 8. Applies and is accepted as artist, third class, in the easel division of the Public Works of Art Project (PWAP).

April 28. With imminent dissolution of PWAP, is hired by the Temporary Emergency Relief Administration (TERA) as a mural assistant to Eric Mose, who is designing *Abstraction of the Machine Age* for Samuel Gompers High School in the Bronx.

July. At Katherine Dreier's behest, organizes group of abstract artists for the purpose of discussing exhibitions and publications of American abstract art. Called "Group A," they agree to publish a portfolio which never materializes.

August 28. One-artist exhibition opens at Theodore A. Kohn & Son Gallery, New York.

Applies (unsuccessfully) for a John Simon Guggenheim Fellowship, with references supplied by Hans Hofmann, Jan Matulka, and A.G. Scheele.

1935

February. Designation on TERA changed from mural assistant to artist.

Left to right: Diller, Fritz Glarner, Carl Holty, Piet Mondrian, and Charmion von Wiegand at the opening of the exhibition, "Masters of Abstract Art," Helena Rubinstein's New Art Center, April 1, 1942.

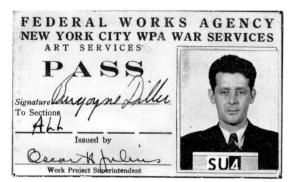

Diller's WPA War Services identification card, 1942

Diller, 1943

August 1. Inception of New York City Works Project Association/ Federal Art Project (WPA/FAP). Transferred from TERA to WPA/FAP, with initial status of artist.

Moves to 44 West 57th Street.

September 9. Promoted to assistant project supervisor, mural division, New York City WPA/FAP.

October 28. Promoted to co-head of mural division New York City WPA/FAP (with Lou Block). Diller supervises the design, execution, and installation of murals in public schools, high schools, colleges, libraries, and public and municipal buildings; Block is in charge of murals in hospitals. During Diller's tenure, he champions abstract art; of the more than two hundred murals produced under his jurisdiction, over thirty are abstract.

1936

October 2. Moves to basement apartment in four-story building at 226 West 21st Street.

1937

Appointed head of mural division, New York City WPA/FAP.

March 12. Officially invited to join the American Abstract Artists group. During the first year, serves on coordination, ways and means, publicity, architects, and cultural committees.

April 3–17. Participates in first exhibition of American Abstract Artists, Squibb Gallery, New York.

1939

Functions as liaison between National WPA and New York World's Fair Committee. Supervises the design, execution, and installation of twelve murals—four of which are abstract—for the National WPA building at the World's Fair.

Teaches "Design Synthesis" course at the Design Laboratory, a school of industrial design affiliated with the WPA until 1937.

September. Congress merges WPA/ FAP with Work Project Administration of the Federal Works Agency which is under state and local control. The art segment is now called the WPA Art Program of the Federal Works Agency. Funding is curtailed and more emphasis is placed on community service and crafts.

1940

Appointed assistant technical director of New York City WPA Art Program, with responsibility for all fine arts divisions.

August. Several mural projects under his jurisdiction are deemed to contain Communist propaganda by local WPA administrator Colonel Brehon B. Somervell.

October 7. Moves to apartment at 24 West 58th Street, across from the Plaza Hotel.

1941

April 9. Temporarily suspended from WPA (with eight other New York City WPA supervisors) pending an investigation by the FBI of alleged Communist affiliation. Investigation results in inconclusive evidence; reinstated in job by early June.

Dropped from American Abstract Artists for failure to participate in group exhibitions and pay dues.

Fall. WPA activities shift to producing visual aids to facilitate training Army and Navy personnel. Diller directs this phase of the WPA Art Program.

1942

Consultant to WPA Board of Education's Children's Book Program; consultant to WPA Museum Extension Educational Program.

March. WPA Art Program renamed Graphic Section of War Services Division.

1943

January 30. Enlists in US Navy; basic training at US Naval Training Station, Sampson, New York.

February 4. Termination of WPA.

April. Assigned to US Navy Training Aids Development Center, New York.

May–June. Invents hand-held blinker for training in the use of Morse code; more than 3,300,000 hand blinkers were eventually produced at a cost of 3¢ each.

December. Receives commissioned rank of ensign.

Diller's one-room studio, Sears Avenue, Atlantic Highlands, New Jersey, 1952

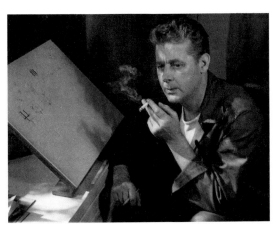

Diller, 1952

1945

May. Patent for "commercial and foreign right" issued for blinker training device. Patent purchased from Diller by Einson-Freeman Company, Long Island City, for $1,000.

October 1. Receives temporary appointment to rank of lieutenant (junior grade, student), in the US Naval Reserve (active shore duty).

November 15. Released from US Navy active duty; retained in US Naval Reserve.

1946

February. One-artist exhibition at Munson-Williams-Proctor Institute, School of Art, Utica, New York.

March. Hired on a temporary basis as an assistant professor in the design department at Brooklyn College.

June 11. Appointed full-time instructor at Brooklyn College.

December 16. One-artist exhibition opens at The Pinacotheca, New York, owned by Rose Fried. Shows paintings and three-dimensional constructions produced between 1934 and 1946.

1947

Fall. Promoted to assistant professor at Brooklyn College.

Reactivates membership in American Abstract Artists group.

1948

Designs a studio building near mother-in-law's home in Atlantic Highlands, New Jersey; spends summer months here.

1949

Granted tenure at Brooklyn College.

November 14. One-artist exhibition "Burgoyne Diller: Paintings, Constructions" opens at The Pinacotheca, New York.

1950

Moves to 24 West 58th Street.

July. Appointed lieutenant (permanent) in US Naval Reserve; remains in the US Naval Reserve until October 15, 1954.

1951

November–December. One-artist exhibition of paintings and constructions at Rose Fried Gallery, New York. First mention in print of his three visual themes.

1952

January 12. Included, for the first time, in a Whitney Museum Annual.

1953

January. "Diller Paints a Picture" by Elaine de Kooning published in Art News.

Fall. Takes position as visiting critic at Yale University, New Haven, through spring 1954.

November 2. Diller's wife, Sally, retires from The New York Times, after twenty-five years in the classified advertising department.

1954

February 2. Sally Diller dies at forty-five of cirrhosis of the liver.

Summer. Visits mother and stepfather at St. Mary's Lake, Michigan. Meets Grace Kelso LaCrone, who has separated from her husband and is living with her parents, friends of Diller's mother and stepfather.

Fall. Resumes teaching at Brooklyn College.

1955

July 22. Marries Grace Kelso LaCrone in Angola, Indiana. The couple moves into Diller's studio in Atlantic Highlands, New Jersey.

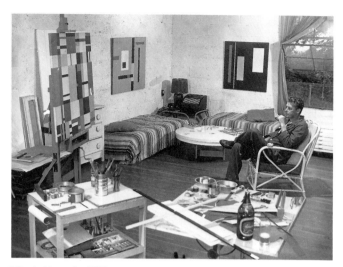

Diller in his studio, 1955

Diller, with his second wife, Grace Kelso LaCrone, May 1956

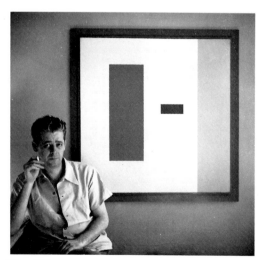

Diller, 1961

1956

Moves to suburban house at One Observatory Place, Atlantic Highlands, with Grace and her daughter, Suzanne.

Begins to take medication for chronic heart trouble and pulmonary edema; henceforth would go periodically into hospital for several days to drain fluid from lungs.

1958

October–November. Included in group show at the Galerie Chalette, New York, which begins to handle his work.

Grace's middle child, William, moves into Atlantic Highlands home.

1959

Spring. Storage room adjacent to Diller's studio in Atlantic Highlands floods, damaging many paintings and hundreds of drawings.

July. Begins giving weekly, informal classes in his New Jersey studio to eight local female artists.

1960

February. Takes leave of absence from Brooklyn College due to heart trouble, through June 7.

1961

May. One-artist exhibition of paintings, constructions, drawings, and watercolors at Galerie Chalette, New York.

September. Begins a one-year sabbatical leave from Brooklyn College.

1962

Promoted to associate professor at Brooklyn College.

November–December. Second one-artist exhibition at Galerie Chalette, New York.

1963

Spring. Takes leave of absence from Brooklyn College due to heart trouble, through fall 1964.

1964

March. One-artist exhibition at Galerie Chalette.

1965

January 30. Dies at French Hospital, New York. Buried at Fairview Cemetery, Red Bank, New Jersey.

1966

February. Retrospective exhibition, "Burgoyne Diller: 1906–1965," opens at the New Jersey State Museum, Trenton.

1971

December. Retrospective exhibition, "Burgoyne Diller: Paintings, Sculptures, Drawings," opens at the Walker Art Center, Minneapolis; show travels to Dallas and Pasadena, through July 1972.

SELECTED EXHIBITION HISTORY

One-artist exhibitions are indicated in bold face. Catalogues and brochures are cited within data on individual exhibitions; reviews mentioning Diller, indicated by a box (■), are listed immediately following each exhibition. Many reviews of Diller's exhibitions appeared in small newspapers across the country. Some of them exist in the form of clippings in museum and gallery files or in Diller's papers (now on deposit at the Archives of American Art, Smithsonian Institution, Washington, D.C.). In some cases bibliographically precise information could not be obtained. When the title of a review is unknown, the first words of the text are given.

1932

Cathedral Branch Library, New York. "Burgoyne Diller."

G.R.D. Studio, New York. "Exhibition of Paintings: Fifth New Group." May 2–14 (brochure).

■ "In the G.R.D. Gallery a group exhibition includes. . . ." 1932.

■ Shelley, Melvin Geer. "Around the Galleries." *Creative Art*, 10 (June 1932), pp. 471, 481.

1933

Art Students League, New York. "Members Group Exhibition." January.

■ Breuning, Margaret. *New York City Sun*, January 19, 1933.

■ [McBride, Henry]. "More Group Art Displays." *New York City Sun*, January 20, 1933, p. 16.

Nathaniel M. Vose Gallery, Providence, Rhode Island. "Exhibition by Ten Younger Artists from New York." January 9–21 (brochure, with introduction by John Sloan).

Contemporary Arts, New York. "Exhibition of Paintings by Burgoyne Diller." February 28–March 18 (catalogue, with text by Hans Hofmann).

■ Two unidentified reviews in Diller papers, Archives of American Art, Smithsonian Institution, Washington, D.C.

Montross Gallery, New York. "Fifty Paintings by American Artists." November 20–December 9 (brochure, with checklist).

1934

Contemporary Arts, New York. "First One-Man Introductions, 1931–1934." March 12–31 (checklist).

Uptown Gallery, New York. Group exhibition. Opened May 15.

Theodore A. Kohn & Son Gallery, New York. One-artist exhibition. August 28–September 29.

■ G[enauer], E[mily]. "Modern Art Lost in Haze of Unreality." *New York World-Telegram*, September 2, 1934.

1937

Squibb Galleries, New York. "American Abstract Artists." April 3–17 (brochure).

1940

Galerie St. Etienne, New York. "American Abstract Art." May 22–June 12 (brochure).

■ Devree, Howard. "A Reviewer's Notebook." *The New York Times*, May 26, 1940, p. X8.

■ Genauer, Emily. "Contemporary Show at the Fair." *New York World-Telegram*, May 25, 1940.

Fine Arts Galleries, New York. "American Abstract Artists Exhibition, 4th Annual." June 3–16 (checklist).

1941

Contemporary Arts, New York. "Annual Retrospection." April 14–May 3.

1942

Helena Rubinstein's New Art Center, New York. "Masters of Abstract Art." April 1–May 15.

1945

Graduate School of Design Gallery, Harvard University, Cambridge, Massachusetts. "Burgoyne Diller and José de Rivera."

1946

Munson-Williams-Proctor Institute, School of Art, Utica, New York. "Retrospective Exhibition of the Work of Burgoyne Diller." February 5–23.

Yale University Art Gallery, New Haven. "Contemporary Sculpture, Objects, Constructions." April 4–May 6 (bulletin, with text by George Heard Hamilton and checklist).

The Pinacotheca, New York. "Burgoyne Diller: Paintings, Constructions 1934–1946." December 16, 1946–January 18, 1947 (catalogue, with text by Charmion Wiegand).

■ Jewell, Edward Alden. "Two One-Man Shows." *The New York Times*, December 22, 1946, p. X12.

■ Lansford, Alonzo. "In Harmony with Mondrian." *The Art Digest*, 21 (January 1, 1947), p. 14.

■ M., A. "Art Notes," *New York Herald Tribune*, December 22, 1946, section 5, p. 8.

■ Reiner, Pearl. "Diller of Design Department Holds Fourth One-Man Art Exhibit." *Brooklyn College Vanguard*, January 10, 1947.

■ "Reviews and Previews." *Art News*, 45 (December 1946), pp. 52–53.

1947

The Pinacotheca, New York. "The White Plane." March 19–April 12 (brochure, with checklist and separate mimeographed text by Charmion Wiegand).

■ Jewell, Edward Alden. "Academy by Itself." *The New York Times*, March 23, 1947, p. X7.

The Art Institute of Chicago. "Abstract and Surrealist American Art." November 6, 1947–January 11, 1948.

The Pinacotheca, New York. Group exhibition, including "Drawings by Burgoyne Diller." December 10–31.

1948

Chinese Gallery, New York. "1948 Annual: American Abstract Artists." May 29–June 18 (checklist).

1949

Riverside Museum, New York. "American Abstract Artists: 13th Annual Exhibition." March 29–April 17 (checklist).

The Pinacotheca, New York. "Burgoyne Diller: Paintings, Constructions." November 14–December 30.

■ Preston, Stuart. "Diversely One by One." *The New York Times*, November 20, 1949, p. X8.

■ S[harp], M[arynell]. "Fifty-Seventh Street in Review: Dynamic Counterpart." *The Art Digest*, 24 (December 1, 1949), p. 13.

■ T[odd], R[uthven]. "Reviews and Previews." *Art News*, 48 (December 1949), p. 43.

1950

The New School for Social Research, New York. "American Abstract Artists: 14th Exhibition." March 15–31 (brochure, with list of artists).

The Pinacotheca-Rose Fried Gallery, New York. "American Abstract Artists: 15th Annual Exhibition." October 10–28 (brochure).

California Palace of the Legion of Honor, San Francisco. "4th Annual Exhibition of Contemporary American Painting." November 25, 1950–January 1, 1951 (catalogue).

1951

Rose Fried Gallery, New York. Group show. January 4–20 (checklist).

The Museum of Modern Art, New York. "Abstract Painting and Sculpture in America." January 23–March 25 (catalogue, with text by Andrew Carnduff Ritchie).

American-British Art Center, New York. "American Abstract Artists." March 12–April 1.

Riverside Museum, New York. "Danish, British, American Abstract Artists: Paintings and Sculpture." March 12–April 1 (checklist, with statement by G[eorge] L.K. M[orris]).

Rose Fried Gallery, New York. "Some Areas of Search from 1913 to 1951." May 2–June 8.

Rose Fried Gallery, New York. "Diller: An Exhibition of Paintings and Constructions." November 5–December 8 (brochure).

■ A[shton], D[ore]. "Fifty-seventh Street in Review: Burgoyne Diller." *The Art Digest*, 26 (November 15, 1951), p. 20.

■ P[orter], F[airfield]. "Reviews and Previews." *Art News*, 50 (December 1951), p. 50.

■ Preston, Stuart. "A French Theorist: Paintings by Paul Signac—New One-Man Shows." *The New York Times*, November 11, 1951, p. X9.

1952

Rose Fried Gallery, New York. "Coincidences." January 16–February 23 (brochure, with checklist).

Rose Fried Gallery, New York. "10 American Abstract Painters: 1912–1952." March 24–April 11.

Whitney Museum of American Art, New York. "1952 Annual Exhibition of Contemporary American Painting." November 6, 1952–January 4, 1953 (catalogue, with checklist).

1953

Walker Art Center, Minneapolis. "The Classic Tradition in Contemporary Art." April 24–June 28 (catalogue, with text by H.H. Arnason).

Whitney Museum of American Art, New York. "1953 Annual Exhibition of Contemporary American Art." October 15–December 6 (catalogue, with checklist).

Munson-Williams-Proctor Institute, Utica, New York. "Formal Organization in Modern Painting." November 1–29 (catalogue, with text by Harris K. Prior).

The Slater Memorial Museum, The Norwich Free Academy, Connecticut. "Travels in 20th-Century American Painting." November 8–29.

1954

Stable Gallery, New York. "3rd Annual Exhibition of Painting and Sculpture." January 27–February 20 (brochure, with checklist).

1955

Whitney Museum of American Art, New York. "Annual Exhibition: Paintings, Sculpture, Watercolors, Drawings." January 12–February 20 (catalogue, with checklist).

■ [Marko, Eleanor]. "Whitney Shows Burgoyne Diller." *Red Bank Register*, January 20, 1955.

School of Fine Arts, Yale University, New Haven. Works by visiting critics. April 1–30.

1956

Rose Fried Gallery, New York. "International Collage Exhibition." February 13–March 17 (catalogue, with text by Herta Wescher).

The Newark Museum, New Jersey. "Abstract Art: 1910 to Today." April 27–June 10 (catalogue, with text by William H. Gerdts).

Rose Fried Gallery, New York. "Group Show: 7 Artists." May 8–June 2.

Stable Gallery, New York. "5th Annual Exhibition of Painting and Sculpture." May 22–June 16.

1957

World House Galleries, New York. "The Struggle for New Form." January 22–February 23.

Contemporary Arts Museum, Houston. "The Sphere of Mondrian." February 27–March 24 (catalogue, with text by Rose Fried).

Poindexter Gallery, New York. "The '30s: Painting in New York." June 4–29. (catalogue, with text by Edwin Denby).

■ "Time past is not always time remembered. . . ." *The New York Times*, June 9, 1957.

1958

The Newark Museum, New Jersey. "Work by New Jersey Artists." April 25–June 8 (catalogue, with foreword by Mildred Baker).

■ Ashton, Dore. "Art: Across the Hudson." *The New York Times*, May 1, 1958.

■ "Atlantic Man Displays Art." *Atlantic Highlands Journal*, May 2, 1958.

Galerie Chalette, New York. "Sculpture by Painters." October 16–November 29 (catalogue).

■ "Burgoyne Diller, Professor. . . ." *Art Students League News*, 11 (November 1958), p. 3.

■ [Marko, Eleanor]. "Pioneer of Abstract Art." *The Red Bank Register*, December 18, 1958, p. 5.

1959

The Museum of Modern Art, New York. "Recent Acquisitions." December 2, 1959–January 31, 1960.

1960

The Newark Museum, New Jersey. "Recent Acquisitions." February.

■ [Marko, Eleanor.] "Newark Museum in its current show. . . ." *Red Bank Register*, February 19, 1960.

■ ———. "Palette Talk." *Red Bank Register*, March 19, 1960.

Galerie Chalette, New York. "Construction and Geometry in Painting: From Malevitch to 'Tomorrow.'" March 31–June 4 (catalogue, with text by Michel Seuphor).

■ C[rehen], H[ubert]. "To the Pure." *Art News*, 59 (April 1960), pp. 33, 60–61.

■ Kramer, Hilton. "Constructing the Absolute." *Arts*, 34 (May 1960), pp. 36–43.

Helmhaus, Zurich. "Konkrete Kunst." June 8–August 14 (catalogue, with text by Max Bill).

Stuttman Gallery, New York. "Pure Abstraction: The Classic Image." October 5–November 5.

■ D[e] M[ott], H[elen]. "In the Galleries." *Arts*, 35 (November 1960), p. 55.

1961

Galerie Chalette, New York. "Diller: Paintings, Constructions, Drawings, Watercolors." May 3–31 (catalogue).

■ Ashton, Dore. "Art Review." *Arts and Architecture*, 78 (July 1961), p. 5.

■ Campbell, Lawrence. "The Rule That Measures Emotion." *Art News*, 60 (May 1961), pp. 34–35, 56–58.

■ Genauer, Emily. "Where Is Personal Vision?" *New York Herald Tribune*, May 7, 1961, p. 18.

■ Tillim, Sidney. "Month in Review." *Arts*, 35 (May–June 1961), pp. 78–81.

The Museum of Modern Art, New York (organizer). "VI Bienal do Museu de Arte Moderna" (catalogue). Traveled to Museu de Arte Moderna, São Paulo, Brazil, September 10–December 31.

■ Canaday, John. *The New York Times*, August 27, 1961, p. X13.

■ G[enauer], E[mily]. "Brazil Biennial Postponed." *New York Herald Tribune*, September 10, 1961, section 4, p. 6.

■ [Marko, Eleanor]. "Opening Sunday, the Bienal will. . . ." *Red Bank Register*, September 1961.

1962

The International Program of The Museum of Modern Art, New York (organizer). "Abstract Drawings and Watercolors, U.S.A." Traveled to Museo de Bellas Artes, Caracas, Venezuela, January 14–February 24; Museu de Arte Moderna, Rio de Janeiro, Brazil, March 29–April 22; Museu de Arte Moderna, São Paulo, Brazil, May 8–31; Museo de Arte Moderno, Buenos Aires, Argentina, July 1–22; Salon of the

Municipal Governor of Montevideo, Uruguay, August 3–19; Reifschneider Gallery, Santiago, Chile, September 24–October 6; Instituto de Arte Contemporaneo, Lima, Peru, October 23–November 3; Casa de la Cultura Ecuadoriana, Guayaquil, Ecuador, November 10–16; Museo de Arte Colonial, Quito, Ecuador, November 23–30; Museo Nacional, Bogotá, Colombia, February 6–27, 1963; Instituto Panemeno de Arte, Panama City, March 11–26, 1963; Palacio de Bellas Artes, Mexico City, May 8–28, 1963.

Whitney Museum of American Art, New York. "Geometric Abstraction in America." March 20–May 13 (catalogue, with text by John Gordon).

■ Wasserman, Burt. *Art Education*, 15 (March 1962).

Art Gallery, Bosshart Hall, Glassboro State College, New Jersey. "Diller: Paintings, Constructions." March 24–April 18 (brochure).

The Art Institute of Chicago. "22nd Exhibit of the Society for Contemporary American Art." April 24–May 18.

The Newark Museum, New Jersey. "A Survey of American Sculpture." May 10–October 20 (catalogue, with text by William H. Gerdts).

Galerie Chalette, New York. "Diller: Color Structures." November 15–December 30.

■ Ashton, Dore. "New York Commentary." *Studio*, 165 (March 1963), pp. 118–19.

■ C[ampbell], L[awrence]. "Reviews and Previews." *Art News*, 61 (December 1962), p. 15.

■ J[udd], D[onald]. "New York Exhibitions: In the Galleries." *Arts Magazine*, 37 (January 1963), p. 52.

■ Marko, Eleanor. "Diller's Datum." *Red Bank Register*, November 29, 1962.

■ Sandler, Irving. "New York Letter." *Quadrum*, 14 (1962), pp. 115–24.

Whitney Museum of American Art, New York. "Annual Exhibition 1962: Contemporary Sculpture and Drawings." December 12, 1962–February 3, 1963 (catalogue, with checklist).

1963

The Corcoran Gallery of Art, Washington, D.C. "28th Biennial Exhibition of Contemporary American Painting." January 18–March 3 (catalogue).

■ Ahlander, Leslie Judd. "Corcoran Biennial Has New Look." *The Washington Post*, January 20, 1963, p. G9.

■ Marko, Eleanor. "Palette Talk: Ford Purchase." *Red Bank Register*, January 31, 1963.

The Corcoran Gallery of Art, Washington, D.C. "The New Tradition: Modern Americans Before 1940." April 27–June 2 (catalogue, with foreword by Hermann Warner Williams, Jr.).

The Washington Gallery of Modern Art, Washington, D.C. "Formalists." June 6–July 7 (brochure).

The Corcoran Gallery of Art, Washington, D.C. "Progress of an American Collection." October 26–December 29 (checklist).

Birmingham Southern College Art Gallery, Alabama. One-artist exhibition (brochure, with text by Virginia Rembert).

1964

Sidney Janis Gallery, New York. "The Classic Spirit in 20th Century Art." February 4–29 (catalogue).

The Art Institute of Chicago. "67th Annual American Exhibition: Directions in Contemporary Painting and Sculpture." February 28–April 12 (catalogue).

Galerie Chalette, New York. "Diller, Recent Work: Color Structures, Paintings, Drawings." March 2–31 (catalogue).

C[ampbell], L[awrence]. "Reviews and Previews." *Art News*, 63 (May 1964), p. 11.

Genauer, Emily, and John Gruen. "The Galleries, A Critical Guide: Upper Madison Avenue." *New York Herald Tribune*, March 14, 1964, p. 9.

H[arrison], J[ane]. "In the Galleries." *Arts Magazine*, 38 (May–June 1964), p. 33.

Preston, Stuart. "Seeing Things." *The New York Times*, March 15, 1964, p. X23.

Sandler, Irving. "In the Art Galleries." *New York Post*, April 12, 1964, p. 42.

Institute of Contemporary Art, University of Pennsylvania, Philadelphia. "The Atmosphere of '64." April 1–June 1.

Donahoe, Victoria. "Art News." *Today's World*, April 19, 1964.

Marlborough-Gerson Gallery, New York. "Mondrian, De Stijl, and Their Impact." April.

The Newark Museum, New Jersey. "Work by New Jersey Artists: 5th Triennial Statewide Juried Exhibition." April 23–May 26 (brochure).

Museum of Art, Carnegie Institute, Pittsburgh. "International Exhibition of Contemporary Painting and Sculpture." October 30, 1964–January 10, 1965.

Marko, Eleanor. "Palette Talk: Carnegie Show." *The Daily Register*, November 19, 1964, p. 26.

Galerie Chalette, New York. "Collage: 1912–1964." October 31–November 30.

The Art Gallery, Fairleigh Dickinson University, Madison, New Jersey. "New Jersey Art Today 1964." November 29, 1964–January 4, 1965.

Whitney Museum of American Art, New York. "1964 Annual Exhibition of Contemporary American Sculpture." December 9, 1964–January 31, 1965 (catalogue).

Hess, Thomas B. "The Disrespectful Hand-Maiden." *Art News*, 63 (January 1965), pp. 38–57.

1965

New Jersey State Museum, Trenton. "Recent Acquisitions." September–November 27.

"Center Dedicated." *The Newark Register*, September 30, 1965.

Marko, Eleanor. "It's impossible to exhaust the topic. . . ." *The Daily Register*, September 30, 1965.

San Francisco Museum of Art. "Colorists: 1950–1965." October 15–November 21 (catalogue).

The Newark Museum, New Jersey. "Selected Works by Contemporary New Jersey Artists 1965." Exhibition dedicated to Diller, with section devoted to his works. November 18, 1965–January 2, 1966 (brochure).

"Diller's Work Is Featured." *Newark News*, November 26, 1965.

1966

New Jersey State Museum, Trenton. "Burgoyne Diller: 1906–1965." February 11–April 3 (catalogue, with text by Kenneth Prescott).

"Diller Art Exhibition at Museum." *New Brunswick Home News*, February 13, 1966.

"Diller Paintings to Be Exhibited in Trenton Center." *Easton Express*, February 11, 1966.

"Diller Work Next at State Museum." *Jersey City Journal*, February 10, 1966.

Marko, Eleanor. "Museum Honors Art Pioneer." *Red Bank Register*, February 10, 1966.

Monmouth Museum, New Jersey. "Twenty Years of American Sculpture, 1946–1966." May 8–June 12 (held at the Rotunda, Asbury Park).

Smith College Museum of Art, Northampton, Massachusetts. "Lillian H. Florsheim Foundation for Fine Arts: A Selection of Abstract Art 1917–1965." May 11–June 7 (catalogue).

Whitney Museum of American Art, New York. "Art of the United States: 1670–1966." September 28–November 27 (catalogue).

1967

Marlborough-Gerson Gallery, New York. "The New York Painter, A Century of Teaching: Morse to Hofmann." September 27–October 14 (catalogue, with text by Ruth Gurin).

"Another distinguished show. . . ." *The Daily Register*, September 21, 1967, p. 15.

The Solomon R. Guggenheim Museum, New York. "Guggenheim International Exhibition, 1967: Sculpture from Twenty Nations." October 20, 1967–February 4, 1968 (catalogue, with text by Edward F. Fry).

Fry, Edward F. "The Issue of Innovation." *Art News*, 66 (October 1967), pp. 40–43, 71–72.

1968

American Federation of Arts, New York (organizer). "From Synchromism Forward: A View of Abstract Art in America." Traveled to Montclair Art Museum, New Jersey, February–March 17.

"Abstract Art Display Set." *Montclair Times*, February 21, 1968.

Albright-Knox Art Gallery, Buffalo. "Plus by Minus: Today's Half-Century." March 3–April 14 (catalogue, with text by Douglas MacAgy).

Noah Goldowsky Gallery, New York. "Burgoyne Diller." Part I: April 16–May 7; Part II: May 7–25.

C[ampbell], L[awrence]. "Reviews and Previews." *Art News*, 67 (May 1968), pp. 11–12.

"Exhibition of Diller at Gallery." *The Daily Register*, May 24, 1968.

F[eldman], A[nita]. "In the Galleries: Burgoyne Diller." *Arts Magazine*, 42 (May 1968), p. 56.

Kramer, Hilton. "Art: Mondrian Extended." *The New York Times*, April 27, 1968, p. 34.

Los Angeles County Museum of Art. "Burgoyne Diller 1906–1965." June 18–July 21 (brochure, with text by Jane Livingston).

Kassel, West Germany. "Documenta 4." June 27–October 6 (catalogue, with essays by Karl Branner, Arnold Bode, Max Imdahl, and Jean Leering).

Glueck, Grace. "Art Notes." *The New York Times*, July 14, 1968.

Whitney Museum of American Art, New York. "The 1930's: Painting & Sculpture in America." October 15–December 1 (catalogue, with text by William C. Agee).

1969

The Metropolitan Museum of Art, New York. "New York Painting and Sculpture: 1940–70." October 18, 1969–February 8, 1970 (catalogue, with text by Henry Geldzahler).

Noah Goldowsky Gallery, New York. Group show. January.

A[cconci], V[ito] H. "Reviews and Previews." *Art News*, 68 (January 1970), p. 12.

1971

Galerie Jean Chauvelin, Paris. "The Non-Objective World 1924–1939." June 1–30 (catalogue, with text by Eckhard Neumann). Traveled to Annely Juda Fine Art, London, July 7–September 30; Galleria Milano, Milan, October 15–November 15.

Galerie Denise René, New York. "23 Masters of Early Constructive Abstract Art." October.

Walker Art Center, Minneapolis. "Burgoyne Diller: Paintings, Sculptures, Drawings." December 12, 1971–January 16, 1972 (catalogue, with text by Philip Larson). Traveled to Dallas Museum of Fine Arts, February 16–March 26, 1972; Pasadena Art Museum, California, May 9–July 2, 1972.

- "La Critique des Expositions." *Gazette des Beaux-Arts*, 79 (January 1972), p. 15.

- "Geometry of Classicism." *Artweek*, 3 (May 20, 1972), pp. 1, 12.

- Pincus-Witten, Robert. "Minneapolis: Burgoyne Diller." *Artforum*, 10 (February 1972), pp. 58–60.

1972

San Francisco Museum of Art. "Mondrian and American Neo-Plasticism." January 25–February 13.

American Federation of Arts, New York (organizer). "American Geometric Abstractions—1930's." Traveled to Zabriskie Gallery, New York, June 1–14.

Annely Juda Fine Art, London. "The Non-Objective World: 1939–1955." July 6–September 8 (catalogue). Traveled to Galerie Liatowitsch, Basel, September 20–October 26; Galleria Milano, Milan, November 14–December 30.

Dallas Museum of Fine Arts. "Geometric Abstraction: 1926–1942." October 7–November 19 (catalogue, with text by John Elderfield).

Noah Goldowsky Gallery, New York. "Burgoyne Diller." November 1–30 (brochure, with checklist).

- Crimp, Douglas. "New York." *Art International*, 17 (February 1973), pp. 48–49, 68.

- Lubell, Ellen. "Gallery Reviews." *Arts Magazine*, 47 (November 1972) p. 75.

1973

Museum of Contemporary Art, Chicago. "Post-Mondrian Abstraction in America." March 31–May 13 (catalogue, with text by Robert Pincus-Witten).

- Burnham, Jack. "Mondrian's American Circle." *Arts Magazine*, 48 (September–October 1973), pp. 36–39.

Annely Juda Fine Art, London. "The Non-Objective World: 1914–1955." July 5–September 22 (catalogue). Traveled to University Art Museum, University of Texas at Austin, October 14–December 15.

Seattle Art Museum. "American Art: Third-Quarter Century." August 22–October 14 (catalogue, with text by Jan van der Marck).

1974

Lowe Art Museum, University of Miami, Florida. "Less Is More: The Influence of the Bauhaus on American Art." February 7–March 10 (catalogue, with text by Arlene R. Olson).

1975

The Museum of Modern Art, New York (organizer). "Color as Language." Traveled to Museo de Arte Moderno, Bogotá, Colombia; Museu de Arte, São Paulo, Brazil; Museu de Arte Moderno, Rio de Janeiro, Brazil; Museo de Bellas Artes, Caracas, Venezuela; Museo de Arte Moderno, Mexico City.

1976

Washburn Gallery, New York. "American Abstract Painting from the 1930s and 1940s." September 9–October 2.

Grey Art Gallery and Study Center, New York University, New York. "Inaugural Exhibition Part II." September 22–October 1.

1977

Art Museum, University of New Mexico, Albuquerque. "American Abstract Artists." February 27–April 3 (catalogue, with text by Thomas Tritschler).

Royal Scottish Academy, Edinburgh. "The Modern Spirit: American Painting 1908-1935." August 20–September 11 (catalogue, with text by Milton W. Brown). Traveled to Hayward Gallery, London, September 28–November 20.

Davis & Long Company, New York/ Robert Schoelkopf Gallery, New York. "Brooklyn College Art Department, Past and Present: 1942–1977." September 13–October 8 (catalogue, with introductory text by Mona Hadler and Jerome Viola).

- Campbell, Lawrence. "Brooklyn College." *Arts Magazine*, 52 (September 1977), p. 5.

- Kramer, Hilton. "Art: The Painter as Professor." *The New York Times*, September 16, 1977.

Marilyn Pearl Gallery, New York. "American Geometric Abstract Painting of the 1950's." October 4–29 (brochure).

1978

Washburn Gallery, New York. "Burgoyne Diller. An Exhibition of Drawings." April 18–May 20 (catalogue).

- Ffrench-Frazier, Nina. "Arts Reviews: Burgoyne Diller." *Arts Magazine*, 52 (June 1978), p. 29.

- Russell, John. "Burgoyne Diller." *The New York Times*, May 5, 1978.

Annely Juda Fine Art, London. "The Non-Objective World: Twenty-Five Years 1914–1939." June 28–September 30 (catalogue).

The Newark Museum, New Jersey. "Geometric Abstraction and Related Works." October 12–April 1979 (checklist).

1979

Meredith Long Contemporary, New York. "Burgoyne Diller 1938–1962: Paintings, Drawings, and Collages." January 27–February 21 (catalogue, with text by Kenneth W. Prescott). Traveled to Meredith Long & Company, Houston, March 28–April 21.

- Burnside, Madeleine. "Burgoyne Diller." *The New York Times*, February 2, 1979.

- ———. "New York Reviews." *Art News*, 78 (May 1979), p. 167.

- Crossley, Mimi. "Review: Burgoyne Diller." *The Houston Post*, April 6, 1979, p. E8.

- Gibson, Eric. "New York Letter: Burgoyne Diller." *Art International*, 23 (April 1979), p. 44.

- Marko, Eleanor. "History May Be Catching Up to Diller." *The Sunday Register*, March 4, 1979.

- Moser, Charlotte. "Burgoyne Diller Rediscovered." *The Houston Chronicle*, March 25, 1979.

- ———. "Artist's Work Exploits Three Minimal Themes." *The Houston Chronicle*, March 31, 1979.

Washburn Gallery, New York. "Abstract Art in America—From 1930 to 1940: Influence and Development." June 6–July 20 (catalogue).

Städtische Kunsthalle, Düsseldorf. "2 Jahrzehnte Amerikanische Malerei: 1920–1940." June 10–August 12 (catalogue, with texts by Peter Selz and Dore Ashton). Traveled to Kunsthaus, Zurich, August 23–October 28; Palais des Beaux-Arts, Brussels, November 10–December 30.

Marilyn Pearl Gallery, New York/ Betty Parsons Gallery, New York. "American Abstract Artists: The Language of Abstraction." June 19–August 3 (catalogue, with text by Susan C. Larsen). Works from the 1930s and 1940s at Marilyn Pearl; works from the 1950s, 1960s, and 1970s at Betty Parsons.

■ Rosenthal, Deborah. "American Abstraction." *Arts Magazine*, 54 (October 1979), p. 5.

Yale University Art Gallery, New Haven. "Mondrian and Neo-Plasticism in America." October 18–December 2 (catalogue, with text by Nancy J. Troy).

1980

Sid Deutsch Gallery, New York. "American Abstract Artists: The Early Years, Part 1." March 1980–April 1981 (catalogue, with text by Barbara Rose). Traveled to Telfair Academy, Savannah, Georgia; Cummer Gallery, Jacksonville, Florida; Hunter Museum of Art, Chattanooga, Tennessee; Weatherspoon Art Gallery, University of North Carolina at Greensboro; Birmingham Museum of Art, Alabama; University of Virginia Art Museum, Charlottesville; New Jersey State Museum, Trenton.

Rosa Esman Gallery, New York/Marilyn Pearl Gallery, New York. "Geometric Tradition in American Painting: 1920–1980." April 8–May 17 (checklist). Works from 1920 to 1944 at Marilyn Pearl; works from 1944 to 1980 at Rosa Esman.

Meredith Long Contemporary, New York. "Burgoyne Diller: Constructions, Related Drawings, and Paintings." April 23–May 10 (catalogue, with text by Harry Rand). Traveled to Meredith Long & Company, Houston, June.

■ Buonagurio, Edgar. "Arts Reviews: Burgoyne Diller." *Arts Magazine*, 55 (September 1980), p. 34.

1981

Whitney Museum of American Art, New York. "Decade of Transition: 1940–1950." April 30–July 12 (brochure, with text by Patterson Sims).

Stamford Museum and Nature Center, Connecticut. "Classic Americans: 20th-Century Painters & Sculptors." June 14–September 7 (brochure, with checklist).

Whitney Museum of American Art, Fairfield County, Stamford, Connecticut. "Pioneering the Century: 1900–1940." July 14–August 26 (brochure, with checklist).

Sewall Art Gallery, Rice University, Houston. "CIBA–GEIGY Collects: Aspects of Abstraction." September 8–October 24 (catalogue, with texts by Esther de Vécsey and Markus Löw).

André Emmerich Gallery, New York. "Burgoyne Diller: Paintings, Sculpture, Collages, Drawings, 1938 to 1964." September 10–October 3 (catalogue, with text by Kenneth Prescott).

■ Henry, Gerrit. "New York Reviews: Burgoyne Diller." *Art News*, 80 (December 1981), p. 190.

Whitney Museum of American Art, New York (organizer). "Amerikanische Malerei: 1930-1980" (catalogue, with texts by Tom Armstrong and Bernd Growe). Traveled to Haus der Kunst, Munich, November 14, 1981–January 31, 1982.

1982

Galerie Gimpel-Hanover, Zurich/Galerie André Emmerich, Zurich. "Burgoyne Diller: Paintings, Drawings, Collages from the Years 1938–1964." January 16–February 20 (brochure).

■ "Art in Zurich: Burgoyne Diller." *Neue Zürcher Zeitung*, January 16, 1982.

Galerie Gimpel-Hanover, Zurich/Galerie André Emmerich, Zurich. "Burgoyne Diller." March–April (catalogue, with texts by Willy Rotzler and Kenneth Prescott).

■ Anker, Valentina. "Lettre de Suisse." *Art International*, 25 (May–June 1982), pp. 66–71.

Randolph-Macon Woman's College Art Gallery, Lynchburg, Virginia. "Quilts & Collages: American Art in Pieces." March 21–April 11 (brochure, with checklist).

Galerie Reckermann, Cologne, West Germany. "Burgoyne Diller." May 4–28.

Contemporary Arts Museum, Houston. "The Americans: The Collage." July 11–October 3 (catalogue, with text by Linda L. Cathcart).

Walker Art Center, Minneapolis. "De Stijl: 1917–1931, Visions of Utopia." January 30–March 28 (catalogue, with texts by Manfred Bock, Kees Broos, Martin Filler, et al.). Traveled to Hirshhorn Museum and Sculpture Garden, Smithsonian Institution, Washington, D.C., April 20–June 27; Rijksmuseum Kröller-Müller, Otterlo, The Netherlands, August 8–October 3.

1983

Museum of Art, Carnegie Institute, Pittsburgh. "Abstract Painting and Sculpture in America 1927–1944." November 5–December 31 (catalogue, edited by John R. Lane and Susan C. Larsen). Traveled to San Francisco Museum of Modern Art, to March 25, 1984; Minneapolis Institute of Arts, April 15–June 3, 1984; Whitney Museum of American Art, New York, June 28–September 9, 1984.

■ Carrier, David. "American Apprentices: Thirties Abstraction." *Art in America*, 72 (February 1984), pp. 108–14.

New Jersey State Museum, Trenton. "Beyond the Plane: American Constructions 1930–1965." October 24–December 31 (catalogue, with introduction by Joan Marter, with ten texts). Traveled to The Art Gallery, University of Maryland, College Park, January 26–March 18, 1984.

Independent Curators Incorporated, New York (organizer). "Concepts in Construction: 1910–1980" (catalogue, with text by Irving Sandler). Traveled to Tyler Museum of Art, Texas, February 12–March 27; Norton Gallery and School of Art, West Palm Beach, Florida, June 25–August 14; Bass Museum of Art, Miami Beach, Florida, September 4–October 16; Cincinnati Art Museum, November 8–December 18; Alberta College of Art Gallery, Calgary, Canada, January 12–February 15, 1984; Norman MacKenzie Art Gallery, University of Regina, Saskatchewan, Canada, March 2–April 8, 1984; Anchorage Historical and Fine Arts Museum, Alaska, May 6–June 17, 1984; Long Beach Museum of Art, California, September 24–November 2, 1984; Palm Springs Desert Museum, California, November 15–December 30, 1984; Neuberger Museum, State University of New York, College at Purchase, January 27–March 31, 1985.

1984

André Emmerich Gallery, New York. "Burgoyne Diller: Drawings 1945 to 1964." February 9–March 3 (catalogue).

■ Marko, Eleanor. "Interest Is High on Works of Diller." *Monmouth: The Magazine of The Sunday Register*, February 26, 1984.

Meredith Long & Company, Houston. "Burgoyne Diller: Drawing and the Abstract Tradition in America." May 15–June 2 (catalogue, with text by William C. Agee).

■ Agee, William C. "Burgoyne Diller: Drawing and the Abstract Tradition in America." *Arts Magazine*, 59 (October 1984), pp. 80–83.

Marilyn Pearl Gallery, New York. "American Post War Purism." May 31–September 8 (brochure, with checklist).

National Museum of Modern Art, Tokyo. "Constructivism and the Geometric Tradition: Selections from the McCrory Corporation Collection." September 22–November 11 (catalogue, with text by Willy Rotzler). Traveled to Hokkaido Museum of Modern Art, Japan, November 20–December 21.

1985

Usdan Gallery, Bennington College, Vermont. "Crossovers: Artists in Two Mediums." March 12–April 4.

Museum of Contemporary Art, Chicago. "Selections from the William J. Hokin Collection." April 20–June 16 (catalogue, with foreword by I. Michael Danoff).

Margo Leavin Gallery, Los Angeles. "American Abstract Painting 1960–1980." June 19–August 24 (brochure, with checklist).

The Museum of Modern Art, New York. "Contrasts of Form: Geometric Abstract Art 1910–1980." October 7, 1985–January 7, 1986 (catalogue, with text by Magdalena Dabrowski).

- Perl, Jed. "Geometry Lessons at MOMA." *The New Criterion*, 4 (December 1985), pp. 34–41.

Marilyn Pearl Gallery, New York. "The Severe and the Romantic: Geometric Humanism in American Painting, 1950's and 1980's." December 10, 1985–January 4, 1986 (checklist).

1986

André Emmerich Gallery, New York. "Burgoyne Diller: Studies for the 3 Themes." May 8–June 6 (catalogue).

John C. Stoller & Co., Minneapolis. "Ten on Paper." June 27–September 10 (checklist).

Washburn Gallery, New York. "15th Anniversary." October 1–November 1 (brochure).

- Raynor, Vivien. "15th Anniversary (Washburn Gallery). . . ." *The New York Times*, October 24, 1986, p. C27.

1987

Harcourts Modern and Contemporary Art, San Francisco, in conjunction with ART WALK and the San Francisco Art Dealers Association. "The Paintings and Drawings of Burgoyne Diller." February 13–March 15 (brochure).

Margo Leavin Gallery, Los Angeles. "Burgoyne Diller: Paintings, Drawings, and Sculpture." February 14–March 14 (brochure, with text by Susan C. Larsen).

Whitney Museum of American Art at Equitable Center, New York. "Generations of Geometry: Abstract Painting in America Since 1930." June 17–August 26 (catalogue).

Gallery Association of New York State, Hamilton (organizer). "Art Students League: Selections from the Permanent Collection" (catalogue, with texts by Ronald G. Pisano and Beverly Rood). Traveled to eleven state universities, September 12, 1987–May 20, 1990.

Fred L. Emerson Gallery, Hamilton College, Clinton, New York. "Progressive Geometric Abstraction in America 1934–1955." September 26–November 7 (catalogue). Traveled to Mead Art Museum, Amherst College, Massachusetts, March 31–May 1, 1988; Terra Museum of American Art, Chicago, October 1–November 27, 1988; The Palmer Museum of Art, Pennsylvania State University, University Park, February 12–April 9, 1989; Fisher Gallery, University of Southern California, Los Angeles, September 5–October 28, 1989.

1988

Marilyn Pearl Gallery, New York. "American Exploration in Geometry: Color and Surface in the 1950s & 1960s." June 7–July 1 (checklist).

IBM Gallery of Science and Art, New York. "American Paintings from Three New Jersey Museums." December 13, 1988–February 25, 1989.

1989

Meredith Long & Company, Houston. "Burgoyne Diller: Paintings, Drawings and Sculpture." May 9–June 2.

Whitney Museum of American Art, New York. "Art in Place: Fifteen Years of Acquisitions." July 28–October 15 (catalogue, with text by Susan C. Larsen).

Marilyn Pearl Gallery, New York. "From Mondrian to Minimalism: American Constructivism 1945–1965." October 26–November 21 (checklist).

Susan Teller Gallery, New York. "Matulka's Class of '29." November 14–December 30 (brochure, with text by Susan Teller).

Albright-Knox Art Gallery, Buffalo. "Abstraction, Geometry, Painting: Selected Geometric Abstract Painting in America since 1945." September 17–November 5 (catalogue, with text by Michael Auping). Traveled to Center for the Fine Arts, Miami, Florida, December 15, 1989–February 25, 1990; Milwaukee Art Museum, Wisconsin, April 1–June 1, 1990; Yale University Art Gallery, New Haven, July 1–August 30, 1990.

SELECTED BIBLIOGRAPHY

Burgoyne Diller

Agee, William C. *Burgoyne Diller: Drawing and the Abstract Tradition in America* (exhibition catalogue). Houston: Meredith Long & Company, 1984; reprinted, as "Burgoyne Diller: Drawing and the Abstract Tradition in America." *Arts Magazine*, 59 (October 1984), pp. 80–83.

Archives of American Art, Smithsonian Institution, Washington, D.C. Contains the Burgoyne Diller Papers, 1926–68: five notebooks, five brochures, newspaper clippings, letter from José Gutierrez, and undated Christmas card, box 080583.

————. Contains Burgoyne Diller printed material, 1932–61: exhibition announcements, catalogues, and magazine and newspaper articles, roll 062382.

Campbell, Lawrence. "The Rule That Measures Emotion." *Art News*, 60 (May 1961), pp. 34–35, 56–58.

————. "Reviews and Previews." *Art News*, 61 (December 1962), p. 15.

————. "The Ruling Passion." *Art News*, 67 (October 1968), pp. 36–37, 59–61.

De Kooning, Elaine. "Diller Paints a Picture." *Art News*, 51 (January 1953), pp. 26–29, 55–56.

Ellis, Anita J. "Burgoyne Diller: A Neo-Plasticist." M.A. thesis, University of Cincinnati, 1975.

Gurin, Ruth. "Tape-recorded Interview of Burgoyne Diller." Unpublished manuscript, March 21, 1964, Archives of American Art, Smithsonian Institution, Washington, D.C., roll 3418.

Johnson, David Hoyt. "The Early Career of Burgoyne Diller: 1925–45." M.A. thesis, University of Arizona, Tucson, 1978.

Larson, Philip. *Burgoyne Diller: Paintings, Sculptures, Drawings* (exhibition catalogue). Minneapolis: Walker Art Center, 1971.

Phillips, Harlan. "Burgoyne Diller Talks with Harlan Phillips." *Archives of American Art Journal*, 16, no. 2 (1976), pp. 14–21.

Pincus-Witten, Robert. "Minneapolis: Burgoyne Diller." *Artforum*, 10 (February 1972), pp. 58–60.

Prescott, Kenneth W. *Burgoyne Diller: 1938–1962, Paintings, Drawings, and Collages* (exhibition catalogue). New York: Meredith Long Contemporary, 1979. Reprinted in condensed form in *Burgoyne Diller: Paintings, Sculpture, Collages, Drawings, 1938 to 1964* (exhibition catalogue). New York: André Emmerich Gallery, 1981.

Rand, Harry. *Burgoyne Diller: Constructions, Related Drawings, and Paintings* (exhibition catalogue). New York: Meredith Long Contemporary, 1980.

Tillim, Sidney. "Month in Review." *Arts*, 35 (May–June 1961), pp. 78–81.

WPA/FAP

Archives of American Art, Smithsonian Institution, Washington, D.C. Contains the Holger Cahill Papers (rolls 1105–1110); the Francis V. O'Connor Papers: administrative records, personnel transcripts, and artists' files of New York City WPA/FAP (rolls 1084–1089); photograph collection of WPA/FAP art projects (rolls 1160–1179); WPA/FAP correspondence and photographs of New York City mural painting (rolls ND1, NDA18).

Berman, Greta. *The Lost Years, Mural Painting in N.Y. City Under the WPA Federal Art Project, 1935–1943*. New York and London: Garland, 1978.

————. "Abstraction for Public Spaces, 1935–1943." *Arts Magazine*, 56 (June 1982), pp. 81–86.

Contreras, Belisario R. *Tradition and Innovation in New Deal Art*. Lewisburg, Pennsylvania: Bucknell University Press; London and Toronto: Associated University Presses, 1983.

Federal Art Gallery, New York. "Murals for the Community." New York: WPA/FAP, September 1938. Mimeographed catalogue with location and description of twenty-five selected murals, produced in conjunction with the exhibition at Federal Art Gallery.

Macmahon, Arthur Whittier, John D. Millet, and Gladys Ogden. *The Administration of Federal Work Relief*. Chicago: Public Administration Service, 1941; reprinted, New York: Da Capo Press, 1971.

McCoy, Garnett. "The Artist Speaks, Part Five: Poverty, Politics and Artists 1930–1945." *Art in America*, 53 (August–September 1965), pp. 88–108.

McDonald, William F. *Federal Relief Administration and the Arts: The Origins and Administrative History of the Arts Projects of the Works Progress Administration*. Columbus: Ohio State University Press, 1969.

McKinzie, Richard D. *The New Deal for Artists*. Princeton: Princeton University Press, 1975.

The National Archives, Washington, D.C. Contains the National PWAP and WPA/FAP administrative records (record groups 69, 121); photographic documentation of PWAP and WPA/FAP (record groups 69, 121).

The Newark Museum, New Jersey. *Murals Without Walls: Arshile Gorky's Aviation Murals Rediscovered* (exhibition catalogue), 1978. Texts by Ruth Bowman, Arshile Gorky, Francis V. O'Connor, Frederick T. Kiesler, and Jim M. Jordan.

O'Connor, Francis V., ed. *Art for the Millions: Essays from the 1930s by Artists and Administrators of the WPA Federal Art Project.* Greenwich, Connecticut: New York Graphic Society, 1973.

————. *Federal Art Patronage: 1933 to 1943* (exhibition catalogue). College Park, Maryland: University of Maryland Art Gallery, 1966.

————. *Federal Support for the Visual Arts: The New Deal and Now.* 2nd ed. Greenwich, Connecticut: New York Graphic Society, 1971.

————, ed. *The New Deal Art Projects: An Anthology of Memoirs.* Washington, D.C.: Smithsonian Institution Press, 1972.

Park, Marlene, and Gerald E. Markowitz. *New Deal for Art: The Government Art Projects of the 1930s with Examples from New York City & State* (exhibition catalogue). Hamilton, New York: Gallery Association of New York State (organizer), 1977.

————. *Democratic Vistas: Post Offices and Public Art in the New Deal.* Philadelphia: Temple University Press, 1984.

Parsons School of Design, New York. *New York City WPA Art: 1934–1943 and . . . Now 1960–1977* (exhibition catalogue), 1977. Texts by Norman Barr, Audrey McMahon, Emily Genauer, and Greta Berman.

Rubenstein, Erica Beckh. "Tax Payers' Murals." Ph.D. dissertation, Harvard University, Cambridge, Massachusetts, 1944.

American Abstract Art

American Abstract Artists, New York. *American Abstract Artists 1938.* New York: Privately printed, 1938. Texts by Charles G. Shaw, Albert Swinden, George L.K. Morris, Robert Jay Wolff, Harry Holtzman, Alice Mason, Rosalind Bengelsdorf, Ibram Lassaw, Ralph M. Rosenborg, Frederick Kann, and Balcomb Greene.

————. *American Abstract Artists 1939.* New York: Privately printed, 1939. Text by George L.K. Morris.

————. *American Abstract Artists 1946.* New York: The Ram Press, 1946. Texts by Josef Albers, A.E. Gallatin, Karl Knaths, Ferdinand Léger, Piet Mondrian, László Moholy-Nagy, and George L.K. Morris.

————. *American Abstract Artists 1936–1966.* New York: The Ram Press, 1966. Introduction by Ruth Gurin.

————. *The Art Critics—! How Do They Serve the Public? What Do They Say? How Much Do They Know? Let's Look at the Record!* New York: Privately printed, June 1940. Twelve-page pamphlet with typography by Ad Reinhardt.

————. *The World of Abstract Art.* New York: George Wittenborn, 1957. Texts by Michel Seuphor, Victor Pasmore, E. Pillet, Erich Buchholz, Hans Richter, Piero Dorazio, Charmion Wiegand, Sabro Hasegawa, Gyula Kosice, Naum Gabo, Will Barnet, Kyle Morris, Grace L. McCann Morley, George L.K. Morris, and Jean Arp.

Archives of American Art, Smithsonian Institution, Washington, D.C. Contains the American Abstract Artists official records, 1937–66: minutes, members' listings, officers' correspondence, catalogues of the group's exhibitions, and clippings, rolls N69–N137, D359.

Elderfield, John. "The Paris-New York Axis: Geometric Abstract Painting in the Thirties." In Dallas Museum of Fine Arts, *Geometric Abstraction: 1926–1942* (exhibition catalogue), 1972, n.p.; revised and expanded as "American Geometric Abstraction in the Late Thirties." *Artforum,* 11 (December 1972), pp. 35–42.

Larsen, Susan C. "The American Abstract Artists Group: A History and Evaluation of Its Impact upon American Art." Ph.D. dissertation, Northwestern University, Evanston, Illinois, 1975.

————. *American Abstract Artists: The Language of Abstraction* (exhibition catalogue). New York: Marilyn Pearl Gallery/Betty Parsons Gallery, 1979.

Lizza, Richard William. "The American Abstract Artists: Thirties' Geometric Abstraction as Precursor to Forties' Expressive Abstraction." Ph.D. dissertation, The Florida State University School of Visual Arts, Tallahassee, 1985.

McNeil, George. "American Abstract Artists Venerable at Twenty." *Art News,* 55 (May 1956), pp. 34–35, 65–66.

Museum of Art, Carnegie Institute, Pittsburgh. *Abstract Painting and Sculpture in America 1927–1944* (exhibition catalogue), 1983. Edited by John R. Lane and Susan C. Larsen.

Museum of Contemporary Art, Chicago, *Post-Mondrian Abstraction in America* (exhibition catalogue), 1973. Text by Robert Pincus-Witten.

New Jersey State Museum, Trenton. *Beyond the Plane: American Constructions 1930–1965* (exhibition catalogue), 1983. Introductory text by Joan Marter, edited by Jennifer Toher.

Rose, Barbara. *American Abstract Artists: The Early Years, Part 1* (exhibition catalogue). New York: Sid Deutsch Gallery, 1980.

Slobodkina, Esphyr. *American Abstract Artists: Its Publications, Catalogs and Membership.* Great Neck, New York: Urquhart Slobodkina, 1979.

Tritschler, Thomas. "The American Abstract Artists, 1937–1941." Ph.D. dissertation, University of Pennsylvania, Philadelphia, 1974.

————. *American Abstract Artists* (exhibition catalogue). Albuquerque, New Mexico: Art Museum, University of New Mexico, Albuquerque, 1977. Copy in Library, Whitney Museum of American Art, with handwritten corrections by Rosalind Bengelsdorf Browne.

Troy, Nancy J. *Mondrian and Neo-Plasticism in America* (exhibition catalogue). New Haven: Yale University Art Gallery, 1979.

WORKS IN THE EXHIBITION

Dimensions are in inches, followed by centimeters; height precedes width precedes depth.

Still Life, 1932
Oil on canvas,
18 × 40 (45.7 × 101.6)
Collection of Victoria M. LaCrone

Still Life, 1932
Oil on canvas,
20¼ × 16 (51.4 × 40.6)
Art Students League, New York

Still Life, 1932
Lithograph, 12 × 9 (30.5 × 22.9)
Meredith Long & Company, Houston

Untitled, 1933
Oil on canvas,
30½ × 24 (77.5 × 61)
Collection of Fayez Sarofim

Untitled, 1933
Watercolor and ink on paper,
12 × 9 (30.5 × 22.9)
Meredith Long & Company, Houston

Untitled, 1934
Linocut, 6 × 4 (15.2 × 10.2)
Meredith Long & Company, Houston

Untitled, 1934
Oil on canvas
36 × 28 (91 × 71.1)
Albright-Knox Art Gallery, Buffalo;
Gift of Seymour H. Knox

Abstraction, 1934
Oil on canvas,
20 × 34 (50.8 × 86.4)
Colletion of Jane and Ron Lerner

Construction, 1934
Painted wood and fiberboard,
24 × 24 × 1¾ (61 × 61 × 4.5)
Hirshhorn Museum and Sculpture
Garden, Smithsonian Institution,
Washington, D.C.; Gift of Joseph
H. Hirshhorn

Construction, 1934
Painted wood and masonite,
24 × 24 × 1 (61 × 61 × 2.5)
Hirshhorn Museum and Sculpture
Garden, Smithsonian Institution,
Washington, D.C.; Gift of Joseph
H. Hirshhorn

Early Geometric, 1934
Tempera on canvas,
20 × 24 (50.8 × 61)
Meredith Long & Company, Houston

Early Geometric, 1934
Tempera on canvas,
30 × 34 (76.2 × 86.4)
Meredith Long & Company, Houston

Early Geometric, 1934
Tempera on masonite,
19½ × 15½ (49.5 × 39.4)
Harcourts Modern and
Contemporary Art, San Francisco

Early Geometric, 1934
Tempera on canvas,
20 × 24 (50.8 × 61)
Harcourts Modern and
Contemporary Art, San Francisco

Early Geometric, 1934
Pencil and watercolor on paper,
6 × 9 (15.2 × 22.9)
Collection of S. Ronald Stone

Second Theme, 1934
Tempera on canvas,
54 × 42 (127.2 × 106.7)
Harcourts Modern and
Contemporary Art, San Francisco

Untitled, 1934
Oil on canvas,
15 × 19½ (38.1 × 24.1)
Collection of Mr. and Mrs. Keith S.
Wellin

Second Theme, 1937–38
Oil on canvas,
30⅛ × 30 (76.5 × 76.2)
The Metropolitan Museum of Art,
New York; George A. Hearn Fund

Construction, 1938
Painted wood
11½ × 9½ × 2 (29.2 × 24.1 × 5.1)
Private collection

Construction, 1938
Painted wood, 14¾ × 12½ × 2½
(37.5 × 31.8 × 6.4)
Harriet Griffin Fine Arts, New York

Construction #16, 1938
Painted wood, 31⅞ × 27¾ × 5⅛
(81 × 70.5 × 13)
The Newark Museum, New Jersey;
Purchase 1959 The Celeste and
Armand Bartos Foundation Fund

First Theme, 1938
Oil on canvas,
30¹/₁₆ × 30¹/₁₆ (76.4 × 76.4)
Whitney Museum of American Art,
New York; Purchase, with funds
from Emily Fisher Landau 85.44

Second Theme, 1938
Pencil and crayon on paper,
12½ × 12¾ (31.8 × 32.4)
Whitney Museum of American Art,
New York; Purchase, with funds
from The List Purchase Fund 79.5

Second Theme, 1938
Oil on canvas,
34 × 34 (86.4 × 86.4)
Collection of Fayez Sarofim

Untitled, 1938
Woodcut, 10 × 10 (25.4 × 25.4)
Meredith Long & Company, Houston

Second Theme, 1938–39
Oil on canvas, 24 × 24 (61 × 61)
Collection of Anne and William J.
Hokin

**Untitled (Composition with One
Vertical)**, 1939
Pencil and crayon on tracing paper,
8⅜ × 7³/₁₆ (21.3 × 18.3)
Yale University Art Gallery, New
Haven; Gift of Katherine S. Dreier
for the Collection Société Anonyme

Construction, 1940
Oil on wood and masonite,
24 × 24 × 3¹/₁₆ (61 × 61 × 7.8)
Yale University Art Gallery, New
Haven; Gift of Katherine S. Dreier
for the Collection Société Anonyme

**Untitled (Composition with Red
Rectangle)**, 1941
Pencil and gouache on tracing
paper, 16⅛ × 13¾ (41 × 35)
Yale University Art Gallery, New
Haven; Gift of Katherine S. Dreier
for the Collection Société Anonyme

First Theme, 1942
Oil on canvas,
42 × 42 (106.7 × 106.7)
The Museum of Modern Art, New
York; Gift of Silvia Pizitz

Second Theme, 1942
Oil on canvas,
34 × 34 (86.4 × 86.4)
Collection of Cornelia and
Meredith J. Long

Untitled, c. 1942
Tempera, pencil, and crayon on
paper, 11 × 10 (27.9 × 25.4)
The Skye Wood Collection

Untitled, c. 1942
Pencil and crayon on paper,
16½ × 12¼ (41.9 × 31.1)
Meredith Long & Company, Houston

First Theme, 1942–43
Oil on canvas,
42 × 42 (106.7 × 106.7)
Private collection

Untitled, 1942–43
Pencil and crayon on paper,
17½ × 17⅞ (44.5 × 45.4)
Meredith Long & Company, Houston

Third Theme, 1942–44
Oil on canvas,
48 × 48 (121.9 × 121.9)
Collection of Fayez Sarofim

First Theme, 1943
Oil on canvas,
33 × 34 (83.8 × 86.4)
Collection of Fayez Sarofim

**Interplay (Number 3, Second
Theme)**, c. 1943
Oil on canvas,
42¼ × 42⅛ (107.3 × 107)
Hirshhorn Museum and Sculpture
Garden, Smithsonian Institution,
Washington, D.C.; Gift of the
Joseph H. Hirshhorn Foundation

Untitled, c. 1943
Pencil and crayon on paper,
11¾ × 11¾ (29.8 × 29.8)
Collection of Fayez Sarofim

Untitled, 1944
Pencil and crayon on paper,
8¼ × 8¼ (21 × 21)
Private collection

Diagonal Variation, c. 1944
Pencil and crayon on paper,
14 × 17 (35.6 × 43.2)
André Emmerich Gallery, New York

Third Theme, c. 1944
Pencil and crayon on paper,
14½ × 13⅞ (36.8 × 35.2)
The Skye Wood Collection

Untitled, c. 1944
Pencil and crayon on paper,
7 × 7 (17.8 × 17.8)
Collection of Nicole and Istvan
Schlégl

Second Theme (Composition),
1944–46
Oil on canvas,
42 × 42 (106.7 × 106.7)
Private collection

Third Theme, 1945
Pencil and crayon on paper,
16¾ × 13¾ (42.5 × 34.9)
André Emmerich Gallery, New York

Third Theme, 1945
Oil on canvas,
36 × 42 (91.4 × 106.7)
Collection of Sue and David
Workman

**Untitled (Composition with
Cross, with Blue-Gray Band)**, 1945
Pencil and crayon on paper,
17 × 13⅞ (43.2 × 35.2)
Yale University Art Gallery, New
Haven; Gift of Katherine S. Dreier
for the Collection Société Anonyme

Third Theme, 1946–48
Oil on canvas,
42 × 42 (106.7 × 106.7)
Whitney Museum of American Art,
New York; Gift of May
Walter 58.58

Collage for Wall Sculpture, 1948
Watercolor, pencil, and crayon on
paper, 16⅞ × 13⅞ (42.9 × 35.2)
Meredith Long & Company, Houston

Second Theme, 1948
Oil on canvas,
20 × 20 (50.8 × 50.8)
Collection of Natalie and Irving
Forman

Third Theme, c. 1948–49
Oil on canvas,
42 × 42 (106.7 × 106.7)
Meredith Long & Company, Houston

Construction, 1948–60
Painted wood, 23⁵⁄₁₆ × 23¼ × 2⅝
(59.2 × 59.1 × 6.7)
The Baltimore Museum of Art;
Given in Memory of Marion Priest
Joslin, by exchange, and Edward
Joseph Gallagher III Memorial Fund

Untitled, 1949–50
Painted wood, 62 × 29 × 2
(157.5 × 73.7 × 5.1)
Collection of Mr. and Mrs. Louis
Gardner

Third Theme, 1950–53
Oil on canvas,
55½ × 55½ (141 × 141)
Private collection

Second Theme, 1953–55
Collage, pencil, and crayon on
paper, 9 × 8½ (22.9 × 21.6)
Collection of Mr. and Mrs.
Alexander K. McLanahan

Second Theme, 1954
Pencil and collage on paper,
11½ × 11½ (29.2 × 29.2)
André Emmerich Gallery, New York

First Theme, 1955–60
Oil on canvas,
42 × 42 (106.7 × 106.7)
Collection of Natalie and Irving
Forman

First Theme, 1956–60
Oil on canvas,
54 × 38 (137.2 × 96.5)
Collection of Edward and Betty
Harris

First Theme, 1959–60
Oil on canvas,
42 × 42 (106.7 × 106.7)
Collection of Anne and William J.
Hokin

First Theme, 1959–60
Oil on canvas, 50 × 50 (127 × 127)
Collection of Mr. and Mrs. Keith S.
Wellin

First Theme, 1961
Oil on canvas,
42 × 42 (106.7 × 106.7)
Collection of Mrs. Donald A. Petrie

Untitled, 1961
Pencil, crayon, and pastel on paper,
16½ × 13¾ (41.9 × 34.9)
André Emmerich Gallery, New York

First Theme, 1961–62
Collage, pencil, and crayon on
paper, 10 × 7¾ (25.4 × 19.7)
Collection of Mrs. Paul M.
Hirschland

Second Theme, 1961–62
Oil on canvas,
42 × 42 (106.7 × 106.7)
Collection of Dr. and Mrs. John R.
Lane

First Theme, 1962
Crayon on paper,
14 × 17 (35.6 × 43.2)
Meredith Long & Company, Houston

First Theme, 1962
Pencil and crayon on paper,
13⅞ × 16¾ (35.2 × 42.5)
Private collection

First Theme, 1962
Oil on canvas,
42 × 42 (106.7 × 106.7)
Collection of Mrs. Robert M.
Benjamin

First Theme, 1962
Oil and acrylic on canvas,
72 × 72 (182.9 × 182.9)
Collection of Mr. and Mrs. William
Wetsman

First Theme, 1962
Oil on canvas,
42 × 42 (106.7 × 106.7)
Collection of Erling Neby

Number 47, 1962
Oil on canvas,
48⅛ × 48¼ (122.2 × 122.6)
The Newark Museum, New Jersey;
Purchase 1970 Newark Museum
Purchase Fund

Study for Color Structure, 1962
Crayon on paper, 9¾ × 10
(24.8 × 25.4)
André Emmerich Gallery, New York

Untitled, 1962
Pencil and crayon on paper,
16½ × 14 (41.9 × 35.6)
André Emmerich Gallery, New York

Untitled, 1962
Pencil, colored pencil, and collage
on paper,
10¼ × 7¾ (26 × 19.7)
André Emmerich Gallery, New York

First Theme, c. 1962
Oil on canvas,
50¼ × 50⅛ (127.6 × 127.3)
Collection of Emily Fisher Landau

Collage Study for Sculpture,
1963
Pencil, crayon, and collage on
paper,
11 × 8½ (27.9 × 21.6)
Harcourts Modern and
Contemporary Art, San Francisco

Colored Formica Construction,
1963
Formica on wood, 104 × 23 × 7
(264.2 × 58.4 × 17.8)
Meredith Long & Company, Houston

Colored Formica Construction,
1963
Formica on wood,
84 × 45 × 9 (213.4 × 114.3 × 22.9)
Meredith Long & Company, Houston

Colored Structure, 1963
Formica on wood, 71 × 44 × 15
(180.3 × 111.8 × 38.1)
André Emmerich Gallery, New York

First Theme, 1963
Oil on canvas,
78⅞ × 68 (200.3 × 172.7)
Yale University Art Gallery, New
Haven; Gift of Richard Brown
Baker, B.A. 1935

First Theme, 1963
Pencil and crayon on paper,
7 × 7 (17.8 × 17.8)
Collection of Anne and William J.
Hokin

First Theme, 1963
Collage and crayon on paper,
6¾ × 6¾ (17.2 × 17.2)
Collection of Mrs. Robert M.
Benjamin

First Theme, 1963
Oil on canvas,
90 × 38 (228.6 × 96.5)
The Cleveland Museum of Art;
Andrew R. and Martha Holden
Jennings Fund

First Theme: Number 10, 1963
Oil on canvas,
72 × 72 (182.9 × 182.9)
Whitney Museum of American Art,
New York; Purchase, with funds
from the Friends of the Whitney
Museum of American Art 64.26

Number 5—Second Theme, 1963
Oil on canvas,
42 × 42 (106.7 × 106.7)
Museum of Fine Arts, Springfield,
Massachusetts; The James Philip
Gray Collection

Project for Granite, Number 5,
1963
Formica on wood,
85½ × 28¼ × 18
(217.2 × 71.8 × 45.7)
New Jersey State Museum, Trenton;
Gift of the Grad Foundation and
Purchase

Untitled, 1963
Collage, pencil, and crayon on
construction paper,
12⅜ × 10 (31.4 × 25.4)
André Emmerich Gallery, New York

Untitled, 1963
Pencil and crayon on paper,
17 × 13¾ (43.2 × 34.9)
André Emmerich Gallery, New York

First Theme, 1963–64
Oil on canvas,
71¾ × 71½ (182.2 × 181.6)
Albright-Knox Art Gallery, Buffalo;
Gift of Seymour H. Knox

First Theme, 1963–64
Oil on canvas,
72 × 72 (182.9 × 182.9)
Walker Art Center, Minneapolis;
Gift of the Grandchildren of Archie
D. and Bertha H. Walker

First Theme, 1964
Oil on masonite, 24 × 24 (61 × 61)
Collection of Mrs. Robert M.
Benjamin

Second Theme, 1964
Pencil, crayon, and pastel on paper,
10½ × 8¼ (26.7 × 21)
André Emmerich Gallery, New York

Untitled, 1964
Pencil, crayon, and construction
paper on paper,
11 × 9⅞ (27.9 × 25.1)
André Emmerich Gallery, New York

Untitled, 1964
Oil on canvas,
22 × 22 (55.9 × 55.9)
Collection of Rebecca J. LaCrone

This publication was organized at the Whitney Museum of American Art by Doris Palca, Head, Publications and Sales; Sheila Schwartz, Editor; Madeleine Nicklin, Andrew Purchuk, Associate Editors; Martha Lee, Production Assistant, and Aprile Gallant, Assistant.

Design: Katy Homans
Typesetting: Trufont Typographers, Inc.
Printing: South China Printing Co.

Photograph Credits

Benjamin Blackwell: p. 134
Jacob Burckhardt: pp. 19 (top right), 21
Richard W. Caspole: p. 86
Chisholm-Rich Associates, Houston: pp. 16, 17 (left), 18, 19, (top right), 24 (top right), 25 (top right), 26 (top right), 27, 28, 29, 30, 34 (bottom), 40 (top left), 46 (bottom), 49, 50 (top left, bottom right), 83 (right), 84, 88, 89, 95, 102 (bottom), 106 (bottom), 107, 109, 110, 130, 136, 142, 143, 146 (top left), 154 (right)
Geoffrey Clements: p. 50 (bottom left)
Ken Cohen: p. 17 (right)
Pierre DuPuy: p. 97
Richard Eells: p. 148
D. Felton: p. 82
Spencer Freeman: pp. 20, 54 (top), 155
J. Goell: p. 66 (top, bottom right)
Paul Hester: pp. 32, 92, 94, 96
Margo Leavin Gallery: p. 144
Robert E. Mates: pp. 56, 57, 67, 123
Marvin Newman: p. 91
Elton Pope-Lance: p. 141
Lee Stalsworth: pp. 65, 66 (bottom left), 67, 68, 69, 70, 71, 72, 73, 74, 80
Jim Strong: pp. 102 (top), 124, 138
Michael Tropea: p. 46
Charles Uht: p. 26 (top right)
Malcolm Varon: p. 48 (bottom left)
Sarah Wells: p. 58